Private Lives, Imperial Virtues

EVE D'AMBRA

Private Lives, Imperial Virtues

THE FRIEZE OF THE FORUM
TRANSITORIUM IN ROME

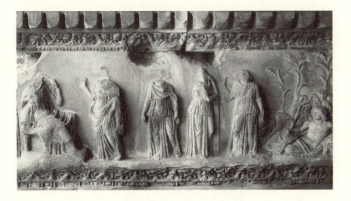

PRINCETON UNIVERSITY PRESS

PRINCETON · NEW JERSEY

Library of Congress Cataloging-in-Publication Data

D'Ambra, Eve, 1956-
Private lives, imperial virtues : the frieze of the Forum Transitorium
in Rome / Eve D'Ambra.
p. cm.
Includes bibliographical references and index.
ISBN 0-691-04097-4
1. Forum of Nerva (Rome, Italy) 2. Friezes—Italy—Rome. 3. Arachne
(Greek mythology)—Art. 4. Rome—Moral conditions. I. Title.
DG609.D35 1993
937'.6—dc20 92-11126

This book has been composed in Bembo
by Princeton University Press Printers

Princeton University Press books are printed on acid-free paper,
and meet the guidelines for permanence and durability of the
Committee on Production Guidelines for Book Longevity of the
Council on Library Resources

Printed in the United States of America

10 9 8 7 6 5 4 3 2 1

Designed by Laury A. Egan

FOR MY PARENTS AND FRANC

CONTENTS

LIST OF ILLUSTRATIONS

1. Le Colonnacce. DAI.

2. Imperial Fora. J. C. Anderson, Jr., *Historical Topography of the Imperial Fora, CollLatomus,* vol. 182 (Brussels, 1984), pl. 1. Photo: Naomi J. Norman.

3. Plan of Forum Transitorium. Photo: Heinrich Bauer.

4. Bartoli's engraving of Frieze, sections 5 and 6. P. S. Bartoli, *Admiranda Romanarum Antiquitatum . . . Notis Io. Petri Bellorii illustrata* (Rome, 1693), pl. 35.

5. Le Colonnacce. DAI.

6. Aula Regia. W. L. McDonald, *The Architecture of the Roman Empire,* vol. 1: *An Introductory Study* (New Haven and London 1986), fig. 6.

7. Le Colonnacce, detail. DAI.

8. Sima. Fototeca Unione.

9. Sima Recta, Attic. Fototeca Unione.

10. Soffit of Ressauts. Fototeca Unione.

11. Sangallo the Younger, plan of temple. P. H. von Blanckenhagen, *Flavische Architektur und ihre Dekoration, untersucht am Nervaforum* (Berlin, 1940), pl. 9, ill. 30.

12. Palladio, plan of Forum Transitorium. A. Palladio, *I quattro libri di architettura* (Venice, 1570), pt. 4, ch. 8.

13. Von Blanckenhagen, plan of Forum Transitorium. P. H. von Blanckenhagen, *Flavische Architektur und ihre Dekoration, untersucht am Nervaforum* (Berlin, 1940), pl. 47.

14. Marble Plan. G. Carettoni et al., *La pianta marmorea di Roma antica* (Rome, 1960), pl. 20, no. 15, 16a.

15. Du Perac, view of temple and forum. E. Du Perac, *I vestigi dell'antichità di Roma* (Rome, 1575), pl. 6

16. Dosio, view of temple. G. A. Dosio, *Urbis Romae aedificiorum illustri-umque supersunt reliquiae* (Rome, 1569), pl. 13.

17. Dosio, view of temple flank. G. A. Dosio, *Urbis Romae aedificiorum illustriumque supersunt reliquiae* (Rome, 1569), pl. 14.

18. Temple of Minerva. H. Kähler, *The Art of Rome and her Empire*, trans. J. R. Foster (New York, 1965), fig. 21.

19. Core of the Podium of Temple of Minerva. Photo: Franc Palaia.

20. Remains of Porticus Absidata. Photo: Franc Palaia.

21. Plan of the Imperial Fora from the medieval period to the middle of the sixteenth century. R. Lanciani, "Le escavazioni del Foro," *BullComm* 29 (1901), fig. 1.

22. Le Colonnacce before the excavations. Fototeca Unione.

23. Le Colonnacce at the turn of the century. Istituto Centrale per il Catalogo e la Documentazione.

24. Plan of the Porticus Divorum. G. Carettoni et al., *La pianta marmorea di roma antica* (Rome, 1960), pl. 31, no. 35.

25. Plan of Vicus Longus. R.E.A. Palmer, "Roman Shrines of Female Chastity from the Caste Struggle to the Papacy of Innocent I," *RivStorAnt* 4 (1974), ill. 1.

26. The Quirinal, Alta Semita, and environs. R.E.A. Palmer, "Jupiter Blaze, Gods of the Hills, and the Roman Topography of *CIL* VI, 377," *AJA* 80 (1976), ill. 1.

27. Ludi Saeculares Sestertius. H. Mattingly, *Coins of the Roman Empire in the British Museum*, vol. 2 (London, 1930), 393, no. 424, pl. 78.5.

28. Pietas Augusti Denarius. H. Mattingly, *Coins of the Roman Empire in the British Museum*, vol. 2 (London, 1930), 312, no. 65, pl. 61.9.

29. Apotheosis Aureus. H. Mattingly, *Coins of the Roman Empire in the British Museum*, vol. 2 (London, 1930), 311, no. 62, pl. 61.6.

30. Hartwig Relief. Soprintendenza Archeologica di Roma.

31. Hartwig Relief, detail. Soprintendenza Archeologica di Roma.

32. Corinthian Aryballos. G. D. Weinberg and S. S. Weinberg, "Arachne of Lydia at Corinth," in S. S. Weinberg, ed., *The Aegean and the Near East, Studies Presented to H. Goldman* (New York, 1956), 262–67, fig. 1.

33. Denarius depicting Minerva Chalcidica. W. Schürmann, *Typologie und Bedeutung der stadtrömischen Minerva-Kultbilder, RdA*, Supp. 2 (Rome, 1985), pl. 16b.

34. Astragal Players. Courtesy, Museum, of Fine Arts, Boston, 01.7798, 01.7799.

35. Votive relief of Athena Ergane. C. A. Hutton, "Votive Reliefs in the Acropolis Museum," *JHS* 17 (1897), fig. 1.

36. Drunken Woman. DAI.

37. Sestertius of Faustina the Younger depicting Pudicitia. American Numismatic Society.

38. Sestertius of Sabina depicting Pudicitia. American Numismatic Society.

39. Domitianic As depicting Moneta. American Numismatic Society.

40. Palazzo Rondanini Relief. L. Salerno and E. Paribeni, *Palazzo Rondanini* (Rome, 1965), fig. 120.

41. Relief of Minerva in a carpenter's workshop. Archivio Fotografico Antiquarium Comunale.

42. Funerary relief of a fuller. G. Zimmer, *Römische Berufsdarstellungen, AF* 12 (Berlin, 1982) 129, kat. no. 43.

43. Tomb painting from Rome. T. Ashby, "Drawings of Ancient Paintings in English Collections," *PBSR* 7 (1914), pl. 3.

44. Hildesheim Plate. Antikenmuseum Berlin, Staatliche Museen Preussischer Kulturbesitz, 3779.1

45. Sections of Frieze. DAI.

46. Section 1, Frieze. Photo: Franc Palaia.

47. Section 1. Archivio Soprintendenza Archeologica di Roma. Photo: Pasquale Rizzi.

48. Section 1. Archivio Soprintendenza Archeologica di Roma. Photo: Pasquale Rizzi.

49. Section 2. Fototeca Unione.

50. Section 3. DAI.

51. Section 3. Archivio Soprintendenza Archeologica di Roma. Photo: Pasquale Rizzi.

ACKNOWLEDGMENTS

M Y INTEREST in the frieze of the Forum Transitorium began in a seminar on the topography of Rome given by Susan B. Downey at the University of California at Los Angeles in 1981. I was drawn to this topic because of the depiction of the Arachne myth and women weaving; my master's thesis on the funerary reliefs from the Isola Sacra Necropolis in Ostia focused on the representation of occupations and crafts but in a very different milieu. The topic was developed into a doctoral dissertation submitted to Yale University in 1987. Diana E. E. Kleiner was instrumental in seeing the project through to the end, and she consistently provided guidance and encouragement. The dissertation committee, Jerome J. Pollitt, Sarah Morris, and Gordon Williams, advised me on the various problems of interpretation and made suggestions for revisions.

Fellowship support and travel funds were granted by Yale University from 1982–1984. The initial research of the dissertation could not have progressed smoothly without the support of the Kress/American Academy in Rome Fellowship in Classical Art and Archaeology in 1984–1986, and I owe much to the Academy community and to the tranquillity of its library. Vassar College has also provided funds for travel and photography from the Salmon Fund in 1991. A Travel to Collections grant from the National Endowment for the Humanities enabled me to return to Rome, also in 1991.

Karin Einaudi of the Fototeca Unione has been assisting me in obtaining photographs over the years. The photographs taken by the late Barbara Bini for the Fototeca Unione offer the most complete and detailed record of the frieze so far, and I shall miss her lively company and unflagging curiosity about old stones.

Of course, I am indebted to Soprintendente Adriano La Regina, Giangiacomo Martines, and Cinzia Conti of the Soprintendenza Archeologica di Roma for initially granting me permission to climb the scaffolding, which covered the frieze, and then graciously offering me access to their archives. The photographs of the cleaned frieze are published here with their kind permission. The German Archaeological Institute in Rome also provided photographs.

[xv]

Natalie B. Kampen has shared my interests in *women's work*; she has read the manuscript in several versions and given valuable advice. I've learned much from Barbara Kellum, whose conversation is always refreshing. My friend Judith Barringer was always ready to listen to new ideas, to discuss Greek sources, and to pore over the manuscript when I didn't want to do it. Chuck Slovenski, whose enthusiasm for Roman walks is boundless, also went over the manuscript at a critical stage. I've gained much from the friendship of C. Brian Rose and Carole Paul, who is a mine of information for all things Roman. James C. Anderson, Jr., and Robert E. A. Palmer generously read chapters and made many useful suggestions for improvement. I would also like to thank the readers for the Press, Miranda Marvin and Fred S. Kleiner, for their comments and criticisms.

However, most of all, I have depended on my husband, Franc Palaia. He is a tireless travel companion and photographer, whose work enhances this book (Gabriel Catbagan printed the photos). Without his help, the book would not be in this form. Finally, I thank my parents for taking me to Italy for the first time.

ABBREVIATIONS OF

FREQUENTLY CITED WORKS

Anderson (1984)
J. C. Anderson, Jr. *The Historical Topography of the Imperial Fora,*
CollLatomus 182. Brussels, 1984.
ANRW
H. Temporini, ed. *Aufstieg und Niedergang der römischen Welt.* Berlin,
1972–.
von Blanckenhagen
P. H. von Blanckenhagen. *Flavische Architektur und ihre Dekoration,*
untersucht am Nervaforum. Berlin, 1940.
BMCRE
H. Mattingly, *Coins of the Roman Empire in the British Museum.* 1–.
London, 1923–.
CIL
Corpus Inscriptionum Latinarum.
DAI
Deutsches Archäologisches Institut, Römische Abteilung
Grelle
F. Grelle. "La 'correctio morum' nella legislazione flavia," *ANRW*
2.13 (1980): 340–65.
Gsell
S. Gsell. *Essai sur le règne de l'empereur Domitien.* Paris, 1894.
Koeppel (1980)
G. Koeppel. "Fragments from a Domitianic Monument in Ann Ar-
bor and Rome." *Bulletin of the Museums of Art and Archaeology, Uni-*
versity of Michigan 3 (1980): 14–29.
LIMC
Lexikon Iconographicum Mythologiae Classicae. Zurich and Munich,
1974–.
Palmer (1974)
R.E.A. Palmer. "Roman Shrines of Female Chastity from the Caste
Struggle to the Papacy of Innocent I," *RivStorAnt* 4 (1974): 113–59.

Picard-Schmitter (1961)
M.-T. Picard. "Quelques observations au sujet de la frise du 'Forum de Nerva' à Rome." *Atti del settimo Congresso internazionale di archeologica classica*, 2 (Rome, 1961): 433–50.

Picard-Schmitter, *Sur le châtiment d'Arachnè* (1965)
M.-T. Picard-Schmitter. "Sur le 'châtiment d'Arachnè': A propos d'une frise du Forum de Nerva, Rome." *RA* 1 (1965): 47–63.

Picard-Schmitter, *Recherches* (1965)
M.-T. Picard-Schmitter. "Recherches sur les métiers à tisser antiques: à propos de la frise du Forum de Nerva, à Rome." *Latomus* 24 (1965): 296–321.

Picard-Schmitter (1966)
M.-T. Picard. "La frise du Forum de Nerva, à Rome et l'iconographie latine des Parques." *CollLatomus* 44 (1966): 607–16.

Platner-Ashby
S. B. Platner and T. Ashby, *A Topographical Dictionary of Ancient Rome* (London, 1929).

RM
Mitteilungen des Deutschen Archäologischen Instituts, Römische Abteilung.

Schürmann
W. Schürmann, *Typologie und Bedeutung der stadtrömischen Minerva-Kultbilder, RdA*, Supp. 2. Rome, 1985.

Scott
K. Scott. *The Imperial Cult under the Flavians.* Stuttgart and Berlin, 1936.

Zanker (1988)
P. Zanker. *The Power of Images in the Age of Augustus.* Trans. A. Shapiro, Ann Arbor, 1988.

The abbreviation of journals follows that used by the *American Journal of Archaeology*, vol. 95 (1991): 4–16.

Private Lives, Imperial Virtues

Domitian and Minerva

A PARTIALLY EXTANT FRIEZE decorates the Forum Transitorium, one of the imperial fora in Rome, which was erected by Domitian in the last two decades of the first century A.C. (fig. 1).[1] Domitian's Forum Transitorium was rather long and narrow in plan (about 160 by 46 m) because it was inserted in the space among older and venerable buildings, the forum of Julius Caesar and that of Augustus on one side and Vespasian's Templum Pacis on the other (fig. 2). It is often called the Forum of Nerva because Domitian was assassinated in A.D. 96 before work was completed and his successor dedicated it in late 97 or early 98 (the architrave of the Temple of Minerva in the Forum was inscribed with Nerva's dedication, but the Renaissance engravings depicting the inscription show only one office held by Nerva that is useful in dating the monument and that indicates the period between September 18 of 97 and January 25 of 98).[2] Yet, Forum Transitorium seems to have won acceptance as its name because the Forum included one stretch of a major thoroughfare, the Argiletum, in its plan (fig. 2). The Argiletum was part of an ancient route connecting the Tiber to the Esquiline, and Domitian took the opportunity to redevelop the street in its passage through a strategic area.[3] Although the oblong Forum provided an enclosed piazza for its Temple of Minerva, it also gave access to the center of the city, the Forum Romanum, from the teeming, squalid quarter of the Subura beyond its walls and, in this aspect, maintained the site's original function as a street.

Domitian may have chosen to perpetuate the memory of the old street by the location of the shrine of Janus Quadrifrons, probably a small arched structure with four faces, in his Forum (fig. 3). Although the shrine no longer exists, the contemporary poets, Martial and Statius, express reverence for its antiquity and indicate that Janus was incorporated

[1] See chapter 1. All dates are A.C. unless otherwise noted.
[2] Schürmann, 97 n. 112.
[3] Anderson (1984), 119–21, 129–31.

into the plan of the new Forum.[4] Janus heralded the *golden age* of Domitian whose reign (81–96) was also marked by the celebration of the Secular Games in 88, festivities that were held on the Augustan precedent and that signaled Domitian's intent to reshape Roman society, to return to the moral code and traditional values that had fortified its citizens in the simpler days of the rustic past.[5]

The years immediately preceding the Secular Games also saw the planning, along with the initial stages of construction, of the Forum Transitorium. In an epigram published in 85–86 (1.2.7–8), Martial mentions the Forum as a landmark from which one could find the way to his bookseller's stall.[6] No doubt, the plans for Domitian's addition to the imperial fora were well-publicized early in his reign.

The extant remains of the Forum are sparse: the foundations of the Temple of Minerva; a section of the precinct wall with its marble colonnade, known as Le Colonnacce, bearing the frieze; and the foundations of the Porticus Absidata, a monumental entranceway outside the Forum's walls and facing the Subura, the neighboring working-class quarter (figs. 19, 1, and 20). The remains are located at the northeast end of the Forum (the extant colonnade and its frieze were located alongside the porch of the temple); the rest is covered by the via dei Fori Imperiali, originally named the via del Impero by Mussolini in 1932 and built to connect his quarters in the Palazzo Venezia to the imperial fora and the Colosseum (the Flavian Amphitheater). The cursory excavations done in conjunction with the Fascist project have not been sufficiently published. Furthermore, excavations begun in the eighties in the southwest corner of the Forum have not yet resolved the difficulties of the fragmentary evidence.[7] I have drawn on accounts of the excavations, views depicted in Renaissance engravings, and historical sources for the following.

The centerpiece of the Forum was its Temple of Minerva (fig. 18). Domitian preferred Minerva above all deities. Besides her role in the Capitoline triad, Minerva's prominence has been attributed to the origin of her cult in the Sabine region, the ancestral home of the Flavian dynasty, or to her association with the *palladium*, the symbol of the transmission of power and eternity of Rome.[8] As the third Flavian, after the reigns of

[4] For example, Mart. *Epigr.* 10.28.3–6; Stat. *Silv.* 4.1.12–21; 4.3.9–10. See chapter 1 for the problems of locating the shrine.

[5] Gsell, 77.

[6] J. P. Sullivan and P. Whigham, *Epigrams of Martial Englished by Divers Hands*, 6. P. Howell, *Commentary on Book I of the Epigrams of Martial*, 5–6.

[7] J. Packer, "Politics, Urbanism, and Archaeology in 'Roma Capitale': A Troubled Past and Controversial Future," *AJA* 93 (1989): 137–41.

[8] Scott, 185–86. J.-L. Girard, "Domitien et Minerva: une prédilection impériale," *ANRW* 2.17.1 (1981): 233–45.

his father Vespasian (69–79) and his brother Titus (79–81), Domitian depended on the dynastic right to rule, and one way to convey the inherent worth and stability of the dynasty was through the building of temples dedicated to the goddess who protected the Flavian house.

The fire of 80 that damaged the Palatine, the Capitoline, and the Campus Martius gave Domitian the opportunity to remap Rome, to leave the Flavian mark on the most historically resonant sites by rebuilding hallowed shrines in the name of religious revival or by gracing prestigious Augustan monuments with Flavian additions to ensure that the second dynasty was linked to the first.[9] The Forum was part of a wider building program intended to launch Domitian's role as the restorer of the city and of the piety of its citizens. Although Domitian's incessant building answered the urgent need for urban renewal in the first decade of his reign, it also served as a policy of cultural renewal, that is, a program of moral and social reform attempting to revive traditional modes of behavior and to restrict other illicit acts, for example, by reenacting the Augustan marriage legislation with its strict measures against adultery.[10] An appeal to the ancestral virtues, the *mores maiorum*, was deemed necessary to fulfill the destiny of the empire and to avert the taint of allegedly declining standards.

The return to the Augustan themes of piety and cultural renewal has to be understood against the background of the Flavian rise to power. Vespasian's ascent during the civil war of 69 is attributed to his skills as a military commander in Judaea, where he was aided by his son Titus who captured Jerusalem in 70. The son of a tax collector of equestrian rank from Reate, modern Rieti, in the Sabine country, Vespasian gained the support of the troops and the public (and even maintained it later when he had to increase taxes, especially in the provinces, to replenish the funds spent by Nero) by his unaffected style, his homespun ways, and, most importantly, his adept and effective approach to administration.[11] The senatorial aristocracy, however, was made uneasy by his insistence that his two adult sons would succeed him: although the foundation of the Flavian dynasty would ensure that the chaos following Nero's death would not recur, the accession of Vespasian and establishment of a new dynasty required the trappings of divine approbation that were conveyed through well-publicized omens and miraculous events.[12] Although Titus had already distinguished himself through his military command abroad,

[9] R.E.A. Palmer, "Jupiter Blaze, Gods of the Hills, and the Roman Topography of *CIL* VI 377," *AJA* 80 (1976): 52, on the fire. See chapter 1 on the building program.

[10] Grelle, 346.

[11] K. H. Waters, "The Second Dynasty in Rome," *Phoenix* 17 (1963): 198–218.

[12] For the omens, see Scott, 4–5, and 17.

he was also prepared for his future role by serving his father as fellow censor and as a praetorian prefect in Rome. Vespasian was careful to put Domitian in the public eye as well, and to keep the public careers, the offices and honors, of his two sons apace.

To set the tone for his regime, Vespasian dissociated himself from the excesses of Nero's reign through measures such as his populist building projects. The unbridled extravagance of Nero's Domus Aurea was countered by Vespasian's emphasis on the utility of art and architecture in creating civic pride. Nero's private collection of art was publicly displayed in Vespasian's Templum Pacis, and the lake of the Domus Aurea was drained to make way for the Flavian Amphitheater.[13] The building program complemented policies against indecent and anti-social behavior, against *luxus* and *libido*, that Vespasian initiated, and Domitian's plans to reinvigorate morals should be seen as a development of this.[14] In foreign affairs, Vespasian showed prudence by securing the eastern borders and by developing the imperial administration of Spain.

The reign of Vespasian brought peace and stability, while the brief reign of his forty-year old son Titus was ushered in by the eruption of Vesuvius at Pompeii in 79 and ended after the plague and fire in Rome in 80. Domitian, now thirty years old, took control in 81 during the aftermath of the crisis and, by all accounts—even despite the unfounded attacks on his education and training as inadequate in comparison to the splendid record of his older brother—took the situation in hand.[15] His task of rebuilding the damaged sectors of the city provided jobs and restored or expanded the urban amenities that Romans had come to expect: the stadium and the odeum in the Campus Martius, and the aqueducts, among others. Public morale was buoyed by the repair of damaged monuments that received elaborate reconstruction, such as the Temple of Jupiter Optimus Maximus on the Capitoline. By spending freely on games, shows, public banquets, and largess, some of which were activities associated with the religious revival, he also endeared himself to the masses.

In military affairs, of which there is no evidence of his prior experience, Domitian immediately set out on a course of expansion, probably to win the senate's approval and to demonstrate his mastery in the field. His campaign against the Chatti in Germany in 83 resulted in victory. The Dacian (Romanian) wars of 85–87, however, were settled with an honorable peace treaty in 89 after two defeats (yet Domitian celebrated a double triumph in 89). Earlier in the same year, Saturninus, the Roman com-

[13] Joseph. *BJ* 7.5.7. Pliny *HN* 34.84; 36.27; 36.58; 35.102; 35.104. Suet. *Vesp.* 9.

[14] Grelle, 352–59.

[15] B. W. Jones, *Domitian and the Senatorial Order. A Prosopographical Study of Domitian's Relationship with the Senate*, A.D. 81–96, 8–12.

mander of the Upper Rhine, revolted with two legions supported by the Chatti and others.[16] The insurrection of his own men was quickly put down but it was said to have alerted Domitian to the possibility of rebellion even in the capital, although there is nothing to point to senatorial involvement in the revolt. There was also an African expedition ending in 85 or 86, and speculation about a planned Parthian campaign that Domitian never had the chance to undertake.[17] His policy was one of consolidating previous holdings and fortifying the contested frontiers (he had withdrawn troops from Britain in 84–85 and transferred them further east). Despite these setbacks—no doubt viewed as temporary—Domitian appears to have been an able administrator and skilled general, particularly in the Sarmatian war of 92 along the Danube, yet the historical tradition compares him unfavorably to his father and brother in these aspects and others.

The problem of evaluating Domitian's achievements lies in the ancient sources, particularly in the accounts of Suetonius, Dio, Tacitus, and Pliny the Younger, that are thought to reflect senatorial opinion in their hostility to him. The sources, however, most likely reflect the Trajanic propaganda that sought to vilify Domitian as the last member of the Flavian dynasty (just as Vespasion did with Nero, the last Julio-Claudian), to quell outrage at his assassination, and to legitimize the new regime by asserting a clear break from the Flavian house. The evidence for contemporary attitudes towards Domitian does not support the historical sources: although he suffered a *damnatio memoriae* that was realized by the destruction or recutting of his inscriptions and statuary, only 37 percent of his extant inscriptions in the entire empire show evidence of recutting and there are no deliberately defaced portraits in the round of Domitian in Rome or elsewhere; evidently, the senatorial decree could not ensure that his name was erased nor his portraits smashed (the evidence, however, varies according to province: in Asia Minor over 80 percent of Domitian's inscriptions appear to have been recarved).[18] Furthermore, his successor, Nerva, was known as a colleague and supporter of the assassinated emperor. Was the otherwise undistinguished senator put forward as *princeps* to satisfy the Domitianic faction in the senate? If this is true, then the claims of the senatorial oppositon were greatly exaggerated.

A case can be made for Domitian's attempts to win the support of the

[16] Gsell, 176, 197, and 249. R. Syme, "Flavian Wars and Frontiers," *CAH* 11 (1936): 172–77.

[17] Gsell, 232–37.

[18] Jones (supra n. 15), 4–5. F. Grosso, "Aspetti della politica orientale di Domiziano, I," *Epigraphica* 16 (1954): 117–19. Conversation with Eric Varner, July 29, 1991, based on research for his forthcoming Yale dissertation.

senate.[19] Early in his reign, his consular and senior appointments were conservative in the sense that they followed Vespasian's policy. Those who were owed promotions or honors for their service received them. Yet, members and supporters of the Flavian house did not monopolize the prestigious offices as they had under Vespasian and Titus, and even opponents were offered suffect consulships later in his reign.

However, in the mid 80s, Domitian took steps that weakened senatorial privileges as part of his effort to undermine the traditional power of that institution and to assign it a new role. More significantly, Domitian controlled the membership of the senate and, under his charge, its character changed: he took the office of *censor perpetuus* in 85 and admitted notable provincials, particularly those from the Greek east, into the senate in greater numbers while he restricted the possibilities of advancement for the old guard, the patricians of Italian descent, and particularly those among them who lacked military and administrative skills. In their place, he promoted men of equestrian rank on the basis of their capabilities to contribute to an efficient and well-run government. By passing over the members of Rome's old families for talented newcomers, Domitian launched a system that preferred merit and performance over birth and connections. The changes in the system of promotion and privileges set members of the old senatorial aristocracy squarely against him although he did attempt to win their support through other measures, such as his military campaigns and their appointment to other offices.

Domitian also displayed his autocratic ambitions without discretion. Although he was a model of familial piety, honoring his father and brother with monuments such as the Temple of the Deified Vespasian and Titus in the Forum Romanum and the Arch of Titus opposite it, and organizing an imperial cult, he tended to lavish the most attention on the buildings that also commemorated himself: the house in which he was born on the Quirinal was dedicated as the Temple of the Flavian Dynasty and dutifully celebrated by the poets, and his residence, the palace on the Palatine, radiated imperial majesty and became the official dwelling of subsequent emperors.[20] Even the passage of time was harnessed for the benefit of imperial authority by changing the names of the months of September and October to Germanicus and Domitianus, probably in 88. September was the month in which he took the *imperium* that led to his victory over the Chatti in Germany, and October was the month of his

[19] Jones (supra n. 15), 21–29 and 43–45. In the following I rely on Jones. Also, J. Nichols, *Vespasian and the Partes Flavianae*.

[20] See chapter 1 on the Temple of the Flavian Dynasty and the *pietas* expressed by Domitian's building program. On the Palatine palace: W. L. MacDonald, *The Architecture of the Roman Empire*, 1:47–74.

birth.[21] After all, according to the senatorial sources, this was the emperor who insisted on being addressed as lord and master, *dominus et deus*, and although such accounts were either exaggerated or contrived in the smear campaign that followed his murder, these reports serve, at least, to indicate the anger provoked by a haughty, aloof, and efficient emperor who pursued his vision with a vengeance.[22] The image of Domitian dominated both space, the civic quarters and monumental zones of the capital, and time, the reckoning of the official calendar.

Domitian is portrayed as changing in mid-reign into a cruel and malevolent fiend, and this view is only beginning to lose credibility. Evidence for the early disintegration of Domitian's character is adduced in his execution of three Vestal Virgins in 82 or 83 for violating their vows of chastity and, at about the same time, his murder of the actor who was reputedly the lover of his wife, Domitia Longina.[23] The harsh but traditional punishments may have been called for by the program of moral reform; the sexual transgressions among the Vestals, the priestesses entrusted with the safekeeping of the state hearth, had to be made examples of (and they were even allowed to choose the type of execution they would undergo). The alleged infidelity of Domitia, however, bears a close resemblance to accounts of the disreputable activities of other imperial women, and serves as a device of political invective. The scandal was probably invented by the Trajanic faction to discredit Domitian as the emperor who attempted to regulate the sexuality of his citizenry but could not control that of his wife.[24] The story points to pervasive deceit and hypocrisy in the imperial court.

The real failure of the marriage was the absence of an heir: the only child, a son, was born to Domitia in 73 or 74 and died at a very early age.[25] Their divorce probably resulted from Domitian's desire for a son who would continue the dynasty, and the subsequent reconciliation was due to Domitia's popularity and her clout as the daughter of Cn. Domitius Corbulo, an astute military commander and superb tactician whose brilliant reputation only improved after Nero forced him to commit suicide.[26] After the divorce, Domitian is reported to have seduced Julia, his niece and Titus's daughter, and then forced his pregnant mistress to have

[21] Scott, 158–65.

[22] Suet. *Dom.* 13. Dio Cass. 67.4.7.

[23] M. P. Vinson, "Domitia Longina, Julia Titi, and the Literary Tradition," *Historia* 38 (1987): 431–50. There is no certainty about the exact date of the Vestals' trial nor that of the divorce, see Grelle, 345 n. 21, and Scott, 83 and 187.

[24] Vinson (supra n. 23), 444–50.

[25] Suet. *Dom.* 3. Scott, 74.

[26] H. Castritius, "Zu den Frauen der Flavier," *Historia* 18 (1969): 492–502.

an abortion that resulted in her death (in 89). Again, this roughly coin-
cides with another attack on the sanctity of the Vestal Virgins: in late 89–
91, the chief priestess Cornelia was condemned to death and buried alive
for her sexual activities. Cornelia's execution is well documented, but the
story of Julia's affair with the emperor again rings false and appears to
have been created to be compared with that of the Vestal (Julia died in 89
but from other causes). The stories share a certain symmetry, with two
women punished for their sexual liaisons by gruesome deaths, but the
emperor's role as the seducer of Julia tends to discredit him as a judge of
Cornelia's behavior. Behind the tales of Domitian's sexual misconduct
are implications of political misdeeds and the assurance that Domitian's
assassination was well deserved.[27]

In the period known as the Terror (93–96), Domitian's increasing par-
anoia was said to have fueled the persecution of philosophers and led to
the trials, banishments, and executions of prominent individuals, along
with the confiscation of their property. The Terror, again, is only a myth
created afterwards by the Trajanic faction to condemn Domitian and to
conceal the reality that Trajan continued Domitian's policies.[28] Trajan
was only more circumspect in his dealings with the senate, and he also
had the benefits of having a relative as an heir, who would protect his
reputation among other duties. Yet, it seems unjust to fault Domitian for
his paranoia when, after all, he was murdered in a palace plot in 96.

From the beginning of his reign to the end, when Minerva appeared to
Domitian in a dream that portended his death, the goddess and the em-
peror were reputedly close: he worshipped her at a shrine in his bed-
room.[29] The imperial cult also served to assert the claim of their relation-
ship to the public. Philostratus tells of a man imprisoned in Tarentum
after a public sacrifice because he hadn't concluded his prayers with a ref-
erence to Domitian being the son of Minerva.[30]

Minerva was eminently suitable to convey the emperor's concerns: she
was the martial goddess, armed with a gleaming shield, spear, and hel-
met, leading the fray; and she protected the marital domain, instructing
matrons in their domestic duties, exemplified by spinning and weaving.
In other words, Minerva portrayed civic responsibility abroad and at
home. Her chaste body, armed by her bronze gear and the gruesome Me-
dusa's head on her aegis, defended both the borders of the empire and the

[27] This account follows Vinson (supra n. 23), 434–38, but I opt for greater latitude
in the dates: Grelle, 347 n. 28, and Scott, 178.

[28] K. H. Waters, "Traianus Domitiani Continuator," *AJPh* 90 (1969): 385–405. Jones
(supra n. 15) 87.

[29] Suet. *Dom.* 15. Dio Cass. 67.16.1.

[30] Philostr. *VA* 7.24.

passage of young women into adulthood. Minerva's role was highly am-
biguous because she was feminine in form, yet masculine in her military
role and demeanor; she was maternal in her relationship to Domitian yet
she had no mother and bore no children; she was cunning and ruthless
yet she taught young women the domestic arts so that they were docile
and subservient in their roles as wives and mothers; finally she was the
virginal goddess, born from her father and barren, yet she ruled over the
social institution of the family and its patriarchal organization.[31]

Domitian honored the goddess with many temples, and one of those
most prominent was the temple in his new forum. The marble-faced
Temple of Minerva, raised on a high podium with six Corinthian col-
umns on its porch, dominated the narrow piazza and the diminutive
shrine of Janus opposite it (figs. 3 and 18).[32] The temple facade loomed
over the Forum, and the effect was enhanced by the curving engaged
walls that screened the view of the temple's flanks and anchored the tem-
ple to the perimeter walls on the northeast end (the cella was located be-
yond the cross walls).

No doubt the temples dedicated to Minerva provided backdrops for
the celebration of her festivals, the Panathenaia and the Quinquatrus.
Processions of worshippers bearing offerings would have congregated at
the temples on feast days. The poets describe the more elaborate celebra-
tions held in the seclusion of Domitian's estate in the Alban hills that
included contests in poetry and oratory, performances of plays, battles
among gladiators, and wild beast hunts.[33] Although the poets were more
enthusiastic in reporting the prizes that they won while in the emperor's
audience, urban versions of the rites and entertainments were held in
Rome. The Quinquatrus attracted craftsmen and professionals, shoe-
makers and schoolteachers, because Minerva was also the favorite of
those who worked with their hands and their heads.[34]

One aspect of the craftsmen's goddess in particular, Minerva Ergane,
involved women's work, and domestic tasks, primarily woolwork, were
synonomous with the activity of the industrious, upstanding, and virtu-
ous matron. Minerva Ergane is significant for Domitian because the
frieze of the Forum Transitorium depicts scenes from the Arachne myth,
flanked by representations of women weaving and deities in landscape
settings. Given Domitian's predilection for the goddess and his program
of moral and religious revival, the choice of subject matter seems inge-
nious.

[31] M. Warner, *Monuments and Maidens*, 96 and 118.
[32] See chapter 1.
[33] Suet. *Dom.* 4.4. Stat. *Silv.* 3.5.28–9.
[34] Ovid *Fasti* 3.809–48.

The Arachne myth is appropriate because it is the story of a defiant young woman whose exceptional talents at the loom allow her to imagine that she can rival Minerva.[35] Arachne is bold and reckless enough to challenge Minerva to a weaving contest, even after the goddess, appearing in the disguise of an old woman, tries to warn Arachne. After the contest, Minerva destroys Arachne's cloth because she is enraged by both its superb quality and its figured design that depicts the erotic escapades of the gods. She strikes Arachne and then stops her from hanging herself by inflicting an even more fitting punishment: she transforms the young woman into a spider, a shrunken headless body spinning webs in darkened corners. Pitting youth against its elders, a lowborn mortal against the divine weaver, the myth affirms Minerva's supremacy and the fate of the upstart Arachne.

The use of the Arachne myth is also unique: this is the only extant depiction of the theme in Roman state art. It has no parallel in the art of the other imperial fora nor in any other public monument in the empire. As Paul Zanker has observed, the themes of moral and religious revival are not ideally suited for visual display, especially in monumental sculpture, and the Augustan designers made use of a few motifs in various combinations.[36] In the Augustan period, the female figure was often a sign of fertility, the mother of the new generation born into peace and prosperity as depicted in the "Tellus" panel of the Ara Pacis (fig. 86).[37] Female subjects had limited roles, usually as divinities or personifications, but the type of the fertile and productive mother was also balanced by grim representations of mythological or legendary heroines who transgressed or violated the social code. Although the Arachne myth was not represented in Augustan art, other myths with female protagonists were depicted in state art for their value as cautionary examples. These are discussed in chapter 3.

A counterpart to the frieze's mythological subject is found in the context of funerary art, portraits and reliefs, commissioned to commemorate matrons whose epitaphs indicate that they ranged in status from freedwomen to senatorial wives or daughters. The matron's life was symbolized by her spindle, distaff, and woolbasket.[38] Moral rectitude was demonstrated by a woman's diligent and industrious habits, particularly her talents at spinning and weaving, two skills commonly praised in epitaphs of matrons. In contrast to these paragons of virtue, the mythological anti-

[35] Ovid *Met.* 6.1–145.

[36] Zanker (1988), 159.

[37] See chapter 3.

[38] E. D'Ambra, "The Cult of Virtues and the Funerary Relief of Ulpia Epigone," *Latomus* 48 (1989): 392–400.

heroine Arachne served as an *exemplum impietatis*, a woman whose weaving became a weapon to subvert the social order.

Yet only a fraction of the entire frieze is extant: approximately 21 meters are in situ on one bay of the colonnade from the original length of over 160 meters for each long side (the 46 meters of the remaining short side opposite the Temple of Minerva may not have been colonnaded). The frieze actually extends beyond the extant bay to the length of about another half bay; in contrast, the frieze in its entirety may have run the length of 38 bays, estimated from the plan of the two long walls. It is difficult to calculate the length of the non-extant frieze because the entablature of the semi-engaged colonnade is bracketed out from the perimeter wall to the columns instead of running continuously above them (fig. 18). Rather than a rectangular open space bounded by high walls providing porticoes as corridors or shelters, the Forum's piazza was a long narrow forecourt framed by decorative colonnades. The uninterrupted vista of the long perimeter walls was broken by a string of niches bearing relief sculpture in the frieze; and, in the attic story, a series of focal points was established by the tall reliefs crowning each bay. The one extant attic relief depicts the militant Minerva (fig. 83).

Scholarly publications of the Forum's frieze have appeared infrequently and the number of interpretations that have been proposed are even fewer. In part this is due to its fragmentary and poorly preserved condition. It may also result from its unusual subject matter. The frieze's iconography, the rarely depicted Arachne myth and its scenes of weaving, seems incongruous for the decoration of an imperial forum. For example, the friezes from the fora of Julius Caesar and Trajan are composed of symmetrically arranged putti with trophies and of Victories slaying bulls, and friezes of the Forum of Augustus and its Temple of Mars Ultor depict vegetal ornamentation and garlands.[39] The motifs connoting military triumph and imperial dominion are conventional in these contexts. In comparison, not only is the iconography of the frieze of the Forum Transi-

[39] On the Forum of Julius Caesar: R. B. Ulrich, *The Temple of Venus Genetrix in the Forum of Caesar in Rome: the Topography, History, Architecture, and Sculptural Program of the Monument* (Diss. Yale University, 1984). On the Forum of Trajan: C. Leon, *Die Bauornamentik des Trajansforums und ihre Stellung in der früh-und mittelkaiserzeitlichen Architekturdekoration Roms*. In the forum's atrium, a frieze with griffins and putti also decorated the entablature of the enclosure walls. P. Zanker, "Das Trajansforum in Rom," *AA* (1976): 499–544. On the Forum of Augustus: P. Zanker, *Forum Augustum* 10–11; V. Kockel, "Beobachtungen zum Tempel des Mars Ultor und zum Forum des Augustus," *RM* 90 (1983): 435, and 437, ill. 17; pl. 115, 1, 5, and 6. A frieze that depicted garlands supported by female figures decorated the forum of the Temple of Mars Ultor. J. Ganzert and V. Kockel, "Augustusforum und Mars-Ultor-Tempel," in M. Hofter et al., eds., *Kaiser Augustus und die verlorene Republik* 149–99.

torium anomalous, but its composition lacks obvious continuity and coherence through its juxtaposition of mythological representations, genre subjects, and iconic deities in sacred sites.

Although no ancient accounts of the frieze are available, the representation of the Arachne myth may have inspired Statius (*Silvae* 4.1.22), who envisions Janus hailing Domitian and urging him to assume his historic role, to take his place among the gods, with the protection of Minerva who has woven a *toga praetexta* for him.[40] Minerva's performance of a domestic (and maternal) task for Domitian sets the highest example, and it implies that Domitian, like Minerva, is a guardian of ancestral customs. Glorifying Domitian's rebuilding of Rome and the construction of the new Forum, the poem suggests that the urban fabric and moral fiber of the city are closely linked.

The reception of the frieze in post-Renaissance scholarship merits attention because the problems of interpretation are readily apparent in it. Seventeenth-century antiquarians included the frieze in published sets of engravings of ancient monuments. Although they aimed to record the monuments' appearance, the antiquarians perpetuated an image of classical antiquity that was informed by the taste of their own period. In 1693 Pietro Santi Bartoli published his *Admiranda Romanarum Antiquitatum Ac Veteris Sculpturae Vestigia*, which consists of his engravings of ancient monuments, including the frieze of the Forum Transitorium, supplemented by Giovanni Pietro Bellori's notes.[41] It is known that Bartoli did not faithfully reproduce the details of the works that he copied and, often, rearranged figures or supplied ones that are non-extant to make the works appear complete.[42] This is evident in one of his engravings of the frieze (fig. 4, compare with the frieze itself, fig. 66).

Apart from the engravings, this volume provides the first commentary on the frieze in the form of Latin captions for each engraving. Bellori's captions describe what he viewed as the process of spinning and weaving under the guidance of Minerva. Listing citations of relevant passages from Roman poets in his captions, Bellori saw the frieze's iconography as illustrative of literary *topoi*.

It may seem odd that an antiquarian failed to recognize a subject from classical mythology, Minerva's punishment of Arachne. Yet ancient depictions of the Arachne myth are very rare, as mentioned above. In fact,

[40] Picard-Schmitter (1961), 450, for the correlation of the poem to the frieze.

[41] P. S. Bartoli, *Admiranda Romanarum Antiquitatum Notis Io. Petri Bellorii illustrata*, pl. 35–42.

[42] These reservations were first expressed by Hugo Blümner (infra n. 48) 8.

the frieze is only one of two extant representations of the theme, and these attributions are controversial.[43]

Instead, Bellori describes the central scene as the goddess appearing before the young women whom she is teaching to spin and weave (fig. 58), and Minerva is shown primarily as the guardian of young women because of her *studiosa pudicitia*.[44] It is with this observation that Bellori has made a contribution, neglected in later studies. Realizing that the scenes of women spinning and weaving were not realistic representations of the craft of weaving, he placed them in the context of established values and feminine ideals to be cultivated among the *virgines Minervae*.

In a few, carefully selected phrases Bellori has evoked a moral climate in which the spindle, distaff, and loom signify the duties of the Roman matron. The models for matrons are legendary figures such as Lucretia whose exemplary habit of spinning late at night with her slaves brought her husband honor.[45] In Bellori's view, the frieze represents Minerva who instructs young women in the duties that lie ahead, which are summoned by the imagery of spinning and weaving.

Although Bellori describes the scenes as depicting the process of making cloth, he identifies one figure, for example, as a personification of the Alban lake, the site of Domitian's villa (figs. 47 and 48).[46] The reclining, half-naked male figure conforms to the type of the river god in ancient art.[47] The iconography of the figure will be discussed in chapter 2, but it is worth noting here that Bellori identified it as a personification. He recognized the idealized character of the frieze with its landscape elements and its figures derived from established types. The discrepancies among the genre scenes, the landscape features, and the personification figures are already apparent in Bellori's notes on the frieze.

Other scholars, Emil Braun and Hugo Blümner, recognized the depiction of the Arachne myth in the central panel of the bay surrounded by scenes of women weaving (figs. 57 and 58).[48] Blümner proposes that the other non-extant panels depicted Minerva in her various aspects and that the Arachne myth is only part of a wider program.

In a brief note, Eugen Petersen accepted the identification of the

[43] *LIMC* 2.1, 470–71 (J. G. Szilagyi).

[44] Bartoli (supra n. 41) caption to pl. 35: "Mulier sedens velata dea est pudicitia cuius studiosa admodum Minerva credebatur . . ."

[45] Livy, 1.57.9–10. See chapter 3.

[46] Bartoli (supra n. 41) caption to pl. 35: ". . . Iuvenis iacens cum urna aquae geni est forte Albani lacus cum in Albano Domitianus quinquatria et ludos celebraret . . ."

[47] B. Kapossy, *Brunnenfiguren der hellenistischen und römischen Zeit*. R. M. Gais, "Some Problems of River God Iconography," *AJA* 82 (1978): 355–70.

[48] E. Braun, *Handbook of the Ruins and Museums of Rome*, 18. H. Blümner, "Il fregio del portico del Foro di Nerva," *AnnInst* (1877), 5–36.

Arachne myth and, furthermore, considered this to be a depiction of Minerva in her aspect of Ergane.[49] He also identified the eighth panel as another mythological scene, an assembly of muses and Minerva on Mt. Helicon (figs. 73–81). The significance of Petersen's proposal, like Blümner's above, is his suggestion that the frieze depicts scenes of the goddess's diverse talents and domains. Rather than a continuous narrative, the representation of related themes or variations on a theme seems to link the frieze's panels.

Peter Heinrich von Blanckenhagen, in his book *Flavische Architektur und ihre Dekoration, untersucht am Nervaforum*, offers the most extensive and detailed analysis of the frieze so far.[50] He views the frieze as depicting the local craftsmen's celebration of Minerva's festival, the Quinquatrus. The Arachne myth is appropriate to this event because it depicts weaving and Minerva's mastery of the craft. Besides the mythological panel and those which represent the weavers' preparations for the festival, several panels portray the deities worshipped by the craftsmen and other inhabitants of the neighboring Subura. The frieze's subject matter is seen to be particularly relevant to its site on the old Argiletum.

The most significant aspect of von Blanckenhagen's thesis is its emphasis on the rituals of craft *collegia* or associations. The Forum Transitorium's continuing use as a monumental thoroughfare distinguished it from other imperial fora, yet its use for private cult rather than state ceremony departs from the functions of an imperial forum (typically, the imperial fora provided places for the senate to conduct its business; for the foreign office with its diplomatic and military concerns; and for the city government, the offices of the *praetors* and *praefectus urbani*, with their archives).[51] Von Blanckenhagen does not discuss the question of Domitian's patronage of *collegia* nor of Minerva's role as the preferred deity of Domitian.

Given its position in the center of the bay below the attic relief of Minerva, the depiction of the Arachne myth is significant for the frieze (fig. 58). As mentioned above, its illustration of Minerva as the divine weaver is appropriate. However, von Blanckenhagen does not consider the implications of the mythological scene any further. For example, the central scene shows Minerva punishing Arachne, and this portrayal of the goddess's wrath may have had particular meaning in relation to the flanking figures.[52]

[49] E. Petersen, "Athena unter den neun Musen im Fries des Nervaforums," *RM* 4 (1889): 88.
[50] Von Blanckenhagen, 118–27.
[51] Anderson (1984), 197–80.
[52] See chapter 2.

Although I will take issue with von Blanckenhagen's conclusions in chapter 2, the merits of his thesis should be pointed out. His most significant contribution is his attempt to relate the panels thematically around the weaving motif. The Arachne myth, however, is seen as only one element of this and, in fact, is subordinated to the theme of Minerva's patronage of craftsmen. In the same way, the personifications and deities identified with local cults support the theme of the weavers' worship of their goddess, but often the presence of the personifications undermines his interpretation of the scenes as activities typical of the weavers' festivals.

In several articles, Marie-Thérèse Picard-Schmitter argues that Minerva is depicted before a group of weavers to display her skill and to receive their homage.[53] She rejects the identification of the Arachne myth depicted in the center of the bay, and instead interprets the figure as a weaver supplicating Minerva who has suddenly appeared in the workshop. Yet the pose of the goddess's raised arm and the figure's gesture in response suggest a more dramatic situation, such as that of the Arachne myth (fig. 58).

Picard-Schmitter proposes that the weavers are shown involved in the complicated process of working a horizontal drawloom (figs. 59, 80 and 81). This cannot be supported by the visual evidence, a loop carved over the upper frame of the vertical loom in the fourth panel, and such technical details are inconsistent with the frieze's repetition of figures and use of stock motifs.[54] The typical viewers of the frieze most likely were not weavers with a professional knowledge of the craft, and a more general meaning should be assumed.

Wolfgang Schürmann, in his book on the cult images of Minerva in Rome, finds evidence for an underlying conceptual organization in the Forum's sculptural decoration.[55] The various aspects of Minerva and her cults were represented in each of the bays. The extant long section represents Minerva as the guardian of women and their work through its depiction of Minerva punishing Arachne. Other panels may have shown Minerva Hygieia or Promachos. Thus, the decorative program of the Forum Transitorium serves as a compendium for Minerva's domains from the battlefield to the *domus*. Blümner had proposed this type of program, and Petersen's brief remarks can be construed to indicate this.[56] Schür-

[53] Picard-Schmitter (1961). Picard-Schmitter, *Sur le châtiment d'Arachnè* (1965). Picard-Schmitter, *Recherches* (1965). Picard-Schmitter (1966).

[54] J. P. Wild, *Textile Manufacture in the Northern Roman Provinces*, 69 n. 3, *contra* Picard-Schmitter.

[55] Schürmann, 11–13.

[56] Petersen (supra n. 49), 88. Blümner (supra n. 48), 34.

mann's proposal differs in his exclusion of any other gods besides Minerva from the program. According to Schürmann, the Minerva who is the patroness of Domitian embraces every aspect of her cult in her worship in the Forum Transitorium.

In summary, one tendency in the scholarship has been to focus on Minerva's patronage of the craft of weaving. The studies of von Blanckenhagen, Picard-Schmitter, and Schürmann fall into this category. Only Picard-Schmitter rejects the identification of the Arachne myth for the central scene, although she nonetheless intreprets it as a scene of weavers paying homage to their goddess. Schürmann considers the Arachne myth as an appropriate vehicle to illustrate Minerva's patronage of domestic crafts but the weaving motif is of no greater interest to him.

The antiquarians, Bellori and Braun, view the weaving scenes as moralizing exempla. Without recognizing the mythological subject, Bellori finds the motifs of the spindle and the distaff evocative of the feminine ideal. Braun alludes to the didactic character of the scene of the punishment of Arachne. Blümner follows them in these interpretations while Petersen identifies another aspect of Minerva to complement that of Minerva Ergane.

Yet, in all these interpretations, the problem of the relationship among the panels remains unexplained. Without a continuous narrative or a repeated decorative scheme, the frieze's juxtaposition of genre-like weaving scenes and those depicting personifications or deities in landscape settings is difficult to understand.

CHAPTER ONE

Architecture and Topography

A N INTERPRETATION of the sculptural decoration of the Forum Transitorium in Rome is incomplete without a consideration of the structure to which it belongs. Although very little of the Forum is extant besides one bay of a colonnade of the southern lateral enclosure wall (Le Colonnacce), which supports the frieze (fig. 1), and the foundations of the Temple of Minerva (fig. 19), its architectural plan and site can be reconstructed to some extent with the help of a fragment of the Marble Plan, medieval records, sixteenth- and seventeenth-century views of the ruins, and literary accounts. Rodolfo Lanciani's study of 1883 was the first to gather the historical sources, and excavations in 1913, 1926–1928, and 1932–1941 yielded measurements of the extant columns and uncovered the foundations of the temple and the perimeter wall.[1]

More recently, in the early 1980s, the imperial fora have been the focus of public attention with controversial proposals to remove the via dei Fori Imperiali and to create an archaeological park from the imperial fora to the Baths of Caracalla.[2] In order to encourage the removal of the street, Ferdinando Castagnoli began preliminary excavations at the southwest end of the Forum Transitorium.[3] For political reasons, the plan to take up the street was halted in 1983, and the fate of the archaeological park has also met with opposition. This, however, has not stopped the progress of the individual excavation with a narrower focus. An excavation was begun in the Forum Transitorium in 1988, and the first phase was com-

[1] R. Lanciani, "L'aula e gli uffici del senato romano: appendice 1: del foro transitorio," *MemLinc* 11 (1882–1883): 22–26. C. Morselli and E. Tortorici, eds., *LSA* 14,1. *Curia, Forum Iulium, Forum Transitorium*, 53–68, on the early excavations, with bibliography.

[2] J. Packer, "Politics, Urbanism, and Archaeology in 'Roma capitale': A Troubled Past and a Controversial Future," *AJA* 93 (1989): 137–41.

[3] F. Castagnoli, E. Tortorici, and C. Morselli, "Progetto per lo scavo di un settore dei Fori di Cesare e di Nerva," 245–71, in A. M. Biettti Sestieri et al., eds., *LSA* 6.1. *Roma. Archeologia nel centro.*

pleted in 1989.[4] Without further excavations, I can only draw a tentative plan of some aspects of the Forum, although enough evidence remains to indicate its most important elements.

The names associated with the Forum are telling: Martial mentions the Forum Palladium, suggesting that the Forum was known for its Temple of Minerva (Statius never refers to it by a specific name other than the new forum); and in the fourth century it is called both Forum Pervium and Forum Transitorium, evidently because it continued to serve as a street through the incorporation of the Argiletum into its plan (fig. 2).[5] Some authors identified it as the Forum of Nerva because of the inscription on the architrave of the temple (dedicated after Domitian's assassination) but its designation as the Forum Transitorium is prevalent in the Late Antique sources.[6]

The Forum's plan is long and narrow (about 160 by 46m) because of its situation among the pre-existing fora and along the route of the Argiletum (figs. 2 and 3).[7] It connected the fora of Julius Caesar and Augustus with the Templum Pacis although the location of doors or corridors among the monuments is not known. Yet, the Forum conforms to the tradition exemplified by the adjacent imperial fora.[8] A temple dominates a rectangular open space bounded by high walls that provide porticoes as passageways or shelters. The Forum, however, differs from this plan by the articulation of its perimeter walls into a series of shallow bays rather than walkways. As mentioned above, the ressaut or entablature of the decorative colonnade is bracketed out at right angles from the perimeter wall to join the columns (fig. 5). The columns were placed only about 1.75 meters in front of the wall that was decorated with a flat pilaster corresponding to each column.[9] Above the columns, the projecting en-

[4] C. Morselli et al., *Il Foro di Nerva. Uno scavo archeologico nel centro di Roma*. The work has been jointly conducted by the Decima Ripartizione of the Comune di Roma and the University of Rome.

[5] Mart. *Epigr.* 1.2.7–8. Stat. *Silv.* 4.1.14–5. Aurel. Vict. *Caes.* 12.2. SHA *Alex. Sev.* 36.2.

[6] Nerva's dedication of the temple (*CIL* 6.953) in 97–8 after Domitian's assassination in 96.

[7] C. Morselli et. al. (supra n. 4). Anderson (1984) 138 gives the dimensions as 150 by 45 m.

[8] P. Zanker, *Forum Augustum*. J. Ganzert and V. Kockel, "Augustusforum und Mars-Ultor-Tempel," in M. Hofter et al., eds., *Kaiser Augustus und die verlorene Republik*, 149–99. R. B. Ulrich, *The Temple of Venus Genetrix in the Forum of Caesar in Rome: the Topography, History, Architecture, and the Sculptural Program of the Monument* (Ph.D. diss. Yale University, 1984).

[9] Anderson (1984), 134–35. W. L. MacDonald, *The Architecture of the Roman Empire*, 2:185–86. MacDonald, 201, states that the colonnade of the Forum seems to have been the first monumental example of a nonfunctional colonnade.

tablature supported spur walls to the height of the attic. Rather than forming corridors along the length of the Forum, the columns in this arrangement may have created the illusion of spaciousness without actually taking up much space at all. This variation from the traditional plan probably resulted from the awkward and constricted site.

There are precedents for this use of ressauts to transform walls into a rhythmic series of bays. One model may have been the facade of the adjacent Templum Pacis, which, however, was then probably altered during the building of the Forum Transitorium. The reconstruction of the Templum Pacis by Italo Gismondi shows six semi-engaged columns with the entablature bracketed out from the facade.[10] It is worth noting that the Arch of Nero, which once stood on the Capitoline hill, had bracketed entablatures on free-standing columns.[11] Previously the courtyard facade at Palestrina and the Porta Marzia at Perugia also employed the motif of ressauts.[12]

Yet, in these examples, the walls are treated as sculptural surfaces with columns not merely standing before them but attached to them through the use of pedestals or the broken entablature. The adaptation of this motif to the Forum Transitorium may have reduced the perception of the extreme length and narrow width of the site. An uninterrupted vista of the long perimeter walls was broken by a columnar screen and its articulation into bays (figs. 3 and 18). The bracketing of the entablature and columns also activates the marginal space (also decorated with sculpture), which was usually utilized as a passageway. By following the rhythm of the bays, the viewer's eye would be led to the Temple of Minerva without being disturbed by the Forum's proportions.

However, the architect countered this aspect by having the long lateral walls converge towards the northeast, an effect that would magnify both the temple facade and length of the Forum in the viewer's eye.[13] The contrasting elements of the walls' division into the smaller, repeated units of the bays to create an impression of a wider space and the orientation of the corridor-like piazza framed by long walls leading to the theatrical temple facade was inspired. As James Anderson has observed, the Forum is defined by three opposing axes: the dominant axis between the two

[10] Anderson (1984), 109. However, Anderson suggests that a row of *tabernae* ran along the exterior of the Templum Pacis facing the Argiletum. A. M. Colini, "Forum Pacis," *BullComm* 65 (1937): 7–40, pl. 4.

[11] F.S. Kleiner, *The Arch of Nero in Rome*, 69–70.

[12] R. Delbrueck, *Hellenistische Bauten in Latium*, 1:52. R. Stillwell et al., eds., *PECS*, 735–36 (L. Richardson, Jr., on Praeneste) and 693 (U. Ciotti on Perusia). Anderson (1984), 135.

[13] H. Bauer, "Kaiserfora und Janustempel," *RM* 84 (1977): 319–20.

temples, the cross axis probably alligned to the entrances to the Templum Pacis and corridor between the other fora, and a diagonal axis between the route giving access to the Argiletum in the southwest to the northeast corners.[14]

The broken entablature of the Forum Transitorium can also be seen in the Aula Regia of Domitian's palace on the Palatine, which was built by 92 (fig. 6).[15] Ornamental rather than functional columns that support spurs or ressauts projecting from the walls are a prominent element of the design of the throne room. *Aediculae* are placed in alternately curved or rectangular recesses, and the decoration of the large hall is composed of smaller projecting or recessed units rather than expanses of unarticulated flat surfaces. Martial distinguishes the Palatine palace as the work of the architect Rabirius and he was probably also responsible for the Forum Transitorium.[16] Although it is likely that Rabirius's name is preserved to us because of his association with the Palatine palace and that he was only one of several architects carrying out Domitian's projects, the signature style of the screened wall, its division into bays or aediculae, and certain details of the ornament suggest the control of one dominant personality.

There are extant two Corinthian columns and capitals of Le Colonnacce in front of the southeast enclosure wall, which was alongside the porch of the temple (figs. 1 and 5). The columns, which rest on tall bases measuring 1.08 m in diameter, are 10.18 m high with the capitals (the intercolumniation is 5.30 m). The wall stands 15.84 m high and the height of the rest of the architectural members is as follows: architrave .775 m, frieze .775 m, cornice .98 m, and attic 3.13 m (fig. 7).[17] The columns are proportionately slender and deeply channeled.[18] Of course, the thin columns were not intended to support anything except the ressauts and attic. Its relationship to the marble-revetted peperino wall was purely ornamental. The carving of the Corinthian capitals is deeply undercut like the work of the ornate entablature above.

[14] Anderson (1984), 138.

[15] F. Bianchini, *De palazzo de' Cesari. Opera postuma*, chap. 5. Von Blanckenhagen, 64–76. W. L. MacDonald, *The Architecture of the Roman Empire*, 1:53–54.

[16] Mart. *Epigr.* 7,56; 10,71. On the similarities between the architectural detail of the Forum and the palace: E. Du Perac, *A Topographical Study in Rome in 1581; A Series of Views by Etienne Du Perac*, ed. T. Ashby, 101, n. 1; G. Lugli, "Nuove forme dell'architettura romana nell'età dei Flavi," *Atti del III convegno nazionale di storia dell' architettura*, 95–102. The two small stone rings between the dentil blocks of the entablatures of many Flavian buildings may not necessarily be a kind of architect's signature, but may merely indicate the presence of the same craftsmen.

[17] Anderson (1984), 135.

[18] W.-D. Heilmeyer, *Korinthische Normalkapitelle: Studien zur Geschichte der römischen Architekturdekoration RM-EH* 16, 134–36.

The ornamentation of the entablature has been studied in detail by von Blanckenhagen, and I simply summarize his conclusions here.[19] Von Blanckenhagen has characterized the Forum's architectural ornamentation as displaying principles of variation, alternation, and the subordination of individual motifs to a general design. The vinescroll designs are the prevalent motifs no doubt because of the Augustan precedent (figs. 8 and 9). Variation occurs in the *sima recta* of the attic that represents a frieze of dolphins, a motif that signified naval victory for Augustus and appeared on Domitianic *denarii* of 81 (a dolphin was depicted coiled around an anchor on the coins, e.g., *BMCRE* 2, 297, no. 3, pl. 59.3), perhaps also to augur success on the sea (fig. 9).

Another example of the combination of vegetal and organic motifs is found in the soffit of the ressauts. This section is decorated with Gorgoneia framed by designs of calyxes and vine tendrils (fig. 10). Although the ground is almost completely obscured by the depiction of lush vegetation, the Gorgoneion dominates as the central motif. The head of the Medusa is usually seen on Minerva's aegis as a protective device. This motif is appropriate given Minerva's role as the tutelary deity of Domitian, as the recipient of the Forum's temple, and as the subject of the attic relief and frieze.

The white marble used for the columns, capitals, revetments, and architectural decoration came from Luni (near Carrara).[20] The quarries at Luni were first exploited under Augustus when less costly sources of marble were needed to meet the demands of his immense building program in Rome. Used throughout the first century A.C., *marmor lunense* was the material of choice for Domitian's building projects with a few exceptions. The Arch of Titus was constructed of imported Pentelic marble, perhaps to display that no expense was spared for Domitian's commemoration of his brother (the small scale of the Arch may also have been a consideration in the selection of the extravagant marble).

The Forum, with its colonnaded walls, provided a forecourt for the Temple of Minerva. The siting of the temple in relationship to the perimeter walls can be seen in the sixteenth-century drawings. In particular, the walls that close the ends of the Forum are significant. Lanciani published the plans of Sangallo the Younger (1483–1546) and Peruzzi (1481–1536)

[19] Von Blanckenhagen, 51–57. The classicism of the ornament of the Forum Transitorium probably reflects that of the Augustan precedent. Zanker (1988), 179–83.

[20] L. Lazzarini et al., "Determination of the Provenance of Marbles used in some Ancient Monuments in Rome," in N. Herz and M. Waelkens, eds. *Classical Marble: Geochemistry, Technology, Trade*, 403, for both the Forum Transitorium and the Arch of Titus.

that both indicate symmetrical curving walls (fig. 11).[21] In Peruzzi's plan, the wall on the southwest end is shown with engaged columns like the long walls. A plan by Palladio (1508–1580), however, better illustrates the responsion between the two walls (fig. 12).[22]

Disregarding this, von Blanckenhagen had arranged the attachment walls asymmetrically on either side of the temple in his plan (fig. 13).[23] Yet this is implausible. The engaged walls flanking the temple were probably intended to echo the curve of the opposite wall, and von Blanckenhagen's plan would undermine this effect. In 1938, during restoration of the Curia, the foundation of the southwest wall of the Forum was uncovered and it conforms to Palladio's plan.

The wall attached to the temple on the east side is indicated by a trace on the ground.[24] The fifteenth- and sixteenth-century views indicate that an arch, probably the Arcus Aurae mentioned in the Ordo Benedicti, opened this cross wall.[25] One could pass through the Forum to the Argiletum by means of the Porticus Absidata, a monumental entranceway, which is discussed below. Access was blocked on the other side of the temple by the *exedra* of the Forum of Augustus behind it.

It is not clear how one entered the Forum on the opposite end: von Blanckenhagen shows one door in the southwestern corner in his plan while Palladio depicts three openings, one axially aligned with the temple and the other two flanking it (figs. 12 and 13).[26] The latter may be correct if the adjacent Basilica Aemilia in the Forum Romanum was open to the north and gave access to the Forum Transitorium.[27] The problem of access is also related to the position of the Forum's shrine of Janus Quadrifrons, also discussed below.

The symmetrical appearance of the design disguises the irregularities of the site. The cross walls joining the temple to the perimeter walls anchor the building in place and, together with the its facade, form a screen that unifies and emphasizes this area. The adjacent exedra of the Forum of Augustus is hidden by one wall that frames the temple. The other effectively detaches the temple's facade from its flank, the view of which is

[21] Lanciani (supra n. 1), pls. 1 and 2. C. Huelsen, ed., *Il libro di Giuliano da Sangallo, Codice Vaticano Barberiniano Latino 4424.*

[22] A. Palladio, *I quattro libri di architettura,* pt. 4, ch. 8.

[23] Von Blanckenhagen, pl. 47.

[24] Anderson (1984), 133. It is still visible.

[25] H. Egger, *Codex Escurialensis,* pl. 57, 142. Marten van Heemskerck (1498–1574) also depicted the temple and extant perimeter wall. Von Blanckenhagen, 22–24, for a list of all the views.

[26] Palladio (supra n. 22), pt. 4, ch. 8. Von Blanckenhagen, pl. 47.

[27] T. P. Wiseman, review of Anderson, *JRS* 75 (1985): 232. Wiseman states that communication between the Basilica Aemilia and the Forum Transitorium was likely.

blocked from the Forum. The temple's porch would seem to loom above the Forum because of its appearance as a facade without a structure behind it (the temple's cella is located beyond the walls framing the facade).

The Forum's focal point was the Temple of Minerva; however, only the concrete core of its foundations are extant. The temple is not described or illustrated by any ancient source except in a fragment of the Severan Marble Plan of Rome (fig. 14).[28] The only later evidence is provided by the twelfth-century guide book of Magister Gregorius and the sixteenth-century views of its ruins (figs. 15–17).[29] From this information, it appears to have been a marble-faced Italic temple raised on a high podium (fig. 18). Although the front of the temple cannot be accurately measured today, its estimated width varies from 16.95 m to 22.95 m.[30] The facade was Corinthian hexastyle with either two or three columns, perhaps of Phrygian or Africano marble, and an *anta* on each side of the porch.[31] The podium was revetted with marble orthostats, one of which still stands on the southeast flank. The podium was about three meters wider than the cella, no doubt because of the limited space in this area (fig. 19).

Heinrich Bauer, who has worked extensively on the architecture of the Forum, has proposed that there were two stages of construction; the first temple to be erected was substantially rebuilt as the plan was altered and refined.[32] What he observes from the evidence of the remains of the foundations and pavement is a widening of the podium of the temple, a change in the placement of the columns on the porch (the central intercolumniation and those of the corners were widened as well), and a shift in the arrangement of the curving walls that flank the temple facade. Von Blanckenhagen had previously suggested that Vespasian had built a temple, with an unusual plan on a low platform, on this site, but there is no evidence for such a temple.[33] He had based his conclusions on the presence of several marble slabs that show cuttings for column plinths and may have served as a stylobate. James Anderson has taken the same mar-

[28] G. Carettoni et. al., *La pianta marmorea di Roma antica*, 20, 16a. E. Rodriguez-Almeida, *Forma urbis marmorea: aggiornamento generale 1980*, pls. 12, 95.

[29] H. Cock, *Praecipua aliquot romanae antiquitatis ruinarum monumenta*, pl. 169. G. A. Dosio, *Le antichità di Roma*, pls. 14 and 16. E. Du Perac, *I vestigi dell'antichità di Roma*, pl. 6. G. Rushforth, "Magister Gregorius de Mirabilibus Urbis Romae: A New Description of Rome in the Twelfth Century," *JRS* 9 (1919): 14–58.

[30] Anderson (1984), 132.

[31] Also partially visible in several of the sixteenth-century views. For example, see Du Perac (supra n. 29), pl. 6.

[32] H. Bauer, "Der Urplan des Forum Transitorium," *Bathron. Beitrage zur Architektur und verwandten Künsten für Heinrich Drerup zu einem 80 Geburtstag*, 41–57.

[33] Von Blanckenhagen, 33, pl. 45.

ble slabs as evidence for a Vespasianic renovation of the Argiletum as a colonnaded street (prompted by the building of the facade of his Templum Pacis), which was then dismantled under Domitian.[34] Bauer, however, proposes that changes in the course of construction were brought about by the peculiarities of the site and the architect's attempts to integrate the Forum with its surroundings. The historical sources are silent about the possibility that Nerva ordered changes in the plan of the Forum in its final phases of construction. An excavation that would uncover the rest of the Forum beneath the via dei Fori Imperiali is needed to sort out the sequence and chronology of the building phases.

A reconstruction of the temple is an easier task because of the conservative character of such structures and the evidence of the Marble Plan. Von Blanckenhagen has suggested that engaged columns or pilasters may have decorated the walls of the temple's flank because there was no room for columns along the sides of the exterior.[35] The interior of the temple is indicated in a fragment of the Marble Plan, FUR 16a, that shows a cella lined with lateral colonnades and ending in an apse, most likely with a niche for a cult statue (fig. 14).[36] This plan is similar to that of the Temple of Venus Genetrix and the Templum Pacis (fig. 2).

The sculptural decoration of the temple is known only through the twelfth-century description recorded by Magister Gregorius.[37] He tells of a headless statue of Minerva placed in the apex of the pediment and heaps of broken statues at the site.

Sculptural fragments have been discovered in the Forum and its vicinity; however, it is likely that the works belong to the adjacent fora. In fact, a colossal statue of Mars Ultor was found on the northwest side of the Forum Transitorium, and this probably was the cult statue of the Temple of Mars Ultor in the Forum of Augustus that was replaced by Domitian.[38]

The extant works that seem to have been part of Domitian's sculptural program are few in number and poorly preserved. Besides the figured frieze and attic relief in situ on Le Colonnacce, some fragments have been found, although these may very well have belonged to the colossal statues erected by Alexander Severus. In his restoration of the Forum Transito-

[34] Anderson (1984), 127–29.

[35] Von Blanckenhagen, 36.

[36] G. Carettoni et. al. (supra n. 28), 20, 16a. Rodriguez-Almeida (supra n. 28), pls. 12, 95. Colini (supra n. 10), 31 n. 50.

[37] Rushforth (supra n. 29), 30.

[38] Stuart Jones, vol. 1, no. 40, 39–40, pl. 7. H. G. Martin, "Die Tempelkultbilder," in M. Hofter et al. eds., *Kaiser Augustus und die verlorene Republik*, 256, fig. 151, on the Domitianic figure of Mars erected as a replacement of the cult statue.

rium in the third century (222–235), Alexander Severus erected colossal statues of deified emperors who were identified by *tituli* on bronze columns.[39] This ensemble was modeled on the statues of *summi viri* in the niches of the exedrae and porticoes of the Forum of Augustus.[40] The best preserved elements of the Forum's original sculptural program are the frieze and attic relief of Le Colonnacce, and these are examined in the following chapter.

Within the Forum stood the shrine of Janus Quadrifrons, most likely a small arch with openings on each of its four sides.[41] Its exact location as well as its form is not known. Although the literary evidence is confusing (and the lack of archaeological evidence is not surprising given the state of the Forum), one can evaluate the various testimonies and traditions with caution.

Scholars have suggested two locations for the shrine. Von Blanckenhagen places it in the center of the Forum with its lateral openings aligned with the forum's doorways to the Templum Pacis on one side, and to a corridor running between the fora of Augustus and Julius Caesar on the other (fig. 13).[42] The name of the shrine implies that it was located on a cross-axis or served as a gateway among the fora.

Lawrence Richardson and James Anderson suggest an alternative site for the shrine of Janus Quadrifrons. They locate it on the end near the entrance to the Forum Romanum (figs. 2 and 3).[43] It is aligned with the Temple of Minerva dominating the Forum opposite it, yet it does not block the path of the Argiletum from the Forum Romanum on the southwest corner. Bauer also locates the shrine here, although his reconstruction renders an unlikely Ionic or Corinthian temple, and suggests that the entrance to the Forum from the Forum Romanum was a propylon attached to a narrow corridor, a *vicus Jani*, which gave access to the Forum of Julius Caesar as well as to the adjacent Basilica Aemilia.[44]

If the latter view is correct and the shrine of Janus was in the southwest end, then one may question what was located in the center of the Forum.

[39] SHA, *Alex. Sev.*, 28.6.

[40] Zanker (supra n. 8), 16.

[41] Von Blanckenhagen, 46. Anderson (1984), 137. Also, L. Cozza, "Sul frammento 212 della Pianta marmorea," *JRA* 2 (1989): 117–19, on Janus *in medio*.

[42] Von Blanckenhagen, 45–46.

[43] L. Richardson, Jr., "Curia Julia and Janus Geminus," *RM* 85 (1978): 359–69. Anderson (1984), 137–38.

[44] H. Bauer, "Il Foro Transitorio e il tempio di Giano," *RendPontAcc* 49 (1976–1977): 117–49. Bauer (supra n. 13), 301–24, fig. 1. Anderson (1984), 136–37 n. 58, reports that Bauer's identification of a line of rubble as the rear of the shrine platform is mistaken because the rubble is on a higher level than the foundation of the southwest perimeter wall.

Bauer has suggested that the sewer, the Cloaca Maxima, was routed diagonally under the Forum to avoid a monument located in front of the temple (fig. 3).[45] Chiara Morselli proposes that this was a commemorative column, perhaps similar to the later Column of Trajan; Domitian, however, commemorated the final military conquest in Britain in 85 with a monumental quadrifrons in Richborough.[46] A more appropriate centerpiece for his forum in Rome would have been an equestrian statue since such statues were conventional components of triumphal displays (the columns were rarely erected).[47] One colossal equestrian statue of Domitian was erected in the center of the Forum Romanum near the Lacus Curtius, and another equestrian monument that was reworked into a statue of Nerva after the *damnatio memoriae* was found in a shrine of the Augustales in Misenum.[48] Although the statue in the Forum Romanum is not extant, Statius recounts that a personification of the Rhine, an allusion to the victory over the Chatti in 83, was placed under the hooves of Domitian's horse (and Minerva was, as always, present as a statuette held by the emperor).[49] Considering the proliferation of imperial and dynastic images in Domitian's Rome, it is probable that an equestrian statue adorned the Forum.[50]

Scholars have encountered many thorny problems in interpreting the literary sources for the shrine. It is frequently misidentified as the shrine of Janus Geminus, which stood farther down on the Argiletum in front of the Curia.[51] It has been argued that this shrine was taken down during the Domitianic rebuilding of the Curia and another Janus shrine was moved to the Forum Transitorium; Servius adds that a quadrifrontal

[45] Bauer, Il Foro Transitorio, fig. D.

[46] C. Morselli in C. Morselli and E. Tortorici, eds., *Curia, Forum Iulium, Forum Transitorium*, 68. Stilwell (supra n. 12) 777–78 (B. W. Cunliffe on Richborough or Rutupia). Another quadrifrons was erected in the Forum of Pozzuoli to commemorate the via Domiziana in 95. See Muscettola (infra n. 48) 63.

[47] For example, as in the fora of Augustus and Trajan. P. Zanker (supra n. 8), 12, on the triumphal *quadriga* featuring Augustus being crowned in victory that was placed in the center of the Forum. P. Zanker, "Das Trajansforum in Rom," *AA* 85 (1970): 499–544.

[48] Stat. *Silv.* 1.1. See also F. Ahl, "The Rider and the Horse: Politics and Power in Roman Poetry from Horace to Statius," *ANRW* 2.32.1, 91–124. S. A. Muscettola, "Una statua per due imperatori. L'eredità difficile di Domiziano," in E. Pozzi, ed., *Domiziano/Nerva. La statua equestre da Miseno. Una proposta di ricomposizione*, 39–66.

[49] Stat. *Silv.* 1.1.37–38,51.

[50] Suet. *Dom.* 13.

[51] H. Jordan, *Topographie der Stadt Rom im Altertum* 1.2.350, n. 53, on the separate identities of Janus Geminus in the Forum Romanum and Janus Quadrifrons in the Forum Transitorium.

statue of Janus was placed in the shrine that had been relocated.[52] According to Servius, the shrine had been originally established by Numa Pompilius, the legendary king who founded the state religion. By honoring Numa, Domitian would have enhanced his own reputation as a proponent of archaic cults. Yet the sources are contradictory, and it is probably wise to conclude that the shrine of Janus was a quadrifrontal arch in or near the entrance to the Forum Romanum. Its history and relationship to the Janus Geminus remains unclear.

Martial and Statius describe the Forum as providing a magnificent setting for the shrine of Janus Quadrifrons.[53] The Forum was constructed around Janus who, personified in the poems cited, not only witnesses the changes in the area but also preserves the original character of the old street as a crossroads (and, before that, as a water crossing when the Cloaca was a stream). As a deity who presided over passages, movement through both space and time, Janus was appropriate for the site on the old Argiletum and for Domitian's program of revival.

In the eighth book of Martial's *Epigrams*, published in 94 when the Forum was under construction, Janus is mentioned twice.[54] Janus, the god of entrances and beginnings, heralded the new golden age initiated by Domitian and already marked by the celebration of the Secular Games of 88, by the renaming of the months of September to Germanicus and October to Domitianus, probably in 88, and by the restoration of the Augustan sun dial, the Horologium Solarium Augusti, in the Campus Martius.[55] Not only was the past reclaimed by Domitian, but the future was to be under the sway of his fortune, his months.

Janus is also mentioned by the court poets to acclaim the achievement of justice under Domitian. More explicitly, Statius invokes the emperor as "he who encircles the warlike threshold of Janus with courts of law," and commands Janus to "swear allegiance to the laws of your Forum."[56] The Forum Transitorium as well as the fora of Augustus and Julius Cae-

[52] Richardson (supra n. 43), 359–69. Serv. *ad Aen.* 7.607. Johannes Lydus, *De mens.* 4.1. The four-faced image of Janus, brought as booty from Falerii, was standing in the shrine in the sixth century A.C., yet Servius does not state when the statue was brought to the Forum Transitorium. G. Lugli, *Fontes ad topographiam veteris urbis Romae pertinentes*, 5:280.

[53] Mart. *Epigr.* 10.28.3–6. Stat. *Silv.* 4.1; 4.3.9. L. A. Holland, *Janus and the Bridge*, 92–93, 95–96, 108–37, on the water crossing.

[54] Mart. *Epigr.* 8.2.1; 8.8.1–6.

[55] See introduction. E. Buchner, "Horologium solarium Augusti," in M. Hofter et. al. eds., *Kaiser Augustus und die verlorene Republik*, ill. 146, 242 and 244, on the Domitianic restorations.

[56] Stat. *Silv.* 4.3.9–10: 4.1.13–5.

sar were places where courts convened on a regular basis.[57] The shrine of Janus Geminus in the Forum Romanum marked the area where bankers, moneylenders, and lawyers had their places of business that, no doubt, became congested and required additional outlets in the imperial fora, especially for the courts.[58]

Corporal punishment was enacted here: Martial (2.17) tells of a public executioner's post near the Argiletum, and the *praefectus urbi* supervised an execution in the Forum in the reign of Alexander Severus (222–235).[59] Domitian was known for his vigilant policy against legal abuses, especially of corrupt city magistrates and imperial officials in the provinces, and perhaps the court in his Forum intended to make public examples of wrongdoers sentenced to capital punishment. Executions were known to be staged as public entertainments, with the condemned disguised as ill-fated mythological characters.[60] The sculptural decoration, the frieze depicting the punishment of Arachne, illustrates divine justice and retribution in heightened mythological terms.

The last structure to be discussed is one that is actually located beyond the Forum's walls, but because the Forum retains the form and features of the Argiletum, the entrance dividing the Forum from the continuing stretch of the old street is significant. Central to any discussion of the Forum Transitorium is its access to the district along the Argiletum, the Subura. The location of the Temple of Minerva and its engaged walls forces one's route off-axis around the eastern flank of the temple. Passing through the arch in the engaged wall, known as the Arcus Aurae in the medieval period, the pedestrian entered an irregularly shaped vestibule that led to a monumental entrance, the Porticus Absidata (figs. 2 and 20).[61]

As Anderson has noted, the name Porticus Absidata is found only in the Regionary lists and the *Ordo Benedicti*, very likely as a description of the portico in the shape of an apse.[62] The Marble Plan, FUR 16a, depicts

[57] Mart. *Epigr.* 3.38.3–4; 7.65.2. Stat. *Silv.* 4.9.15.

[58] Horace *Sat.* 2.3.18–20. B. Burchett, *Janus in Roman Life and Cult*, 42.

[59] SHA *Alex. Sev.* 36.2. Anderson (1984), 139.

[60] Suet. *Dom.* 8. B. Levick, "Domitian and the Provinces," *Latomus* 41 (1982): 50–73. K. M. Coleman, "Fatal Charades: Roman Executions Staged as Mythological Enactments," *JRS* 80 (1990): 44–73.

[61] Platner-Ashby, 419–20. Nash, 2:235–37. H. Bauer, "Forum Transitorium und Porticus Absidata," *RM* 90 (1983): 111–84, pl. F-H, for a reconstruction of the Porticus, which, however, warrants skepticism because of its elaboration of an intricately detailed plan from very sparse evidence.

[62] M. Blake, *Roman Construction in Italy from Tiberius through the Flavians*, 106, n. 105, on the problem of dating the Porticus. It seems to be a pendant to the Forum. Anderson (1984), 131, 133–34.

the portico behind the temple cella extending from the Templum Pacis to the fire wall of the Forum of Augustus (fig. 14). It also shows the Porticus Absidata as an arcaded rather than a colonnaded porticus, a design that enhances its curving form.[63] Passage is permitted into the Forum Transitorium and into the Templum Pacis through an opening.

Foundations in situ are still visible, and they correspond to the scheme of the Marble Plan fragment by continuing to the Templum Pacis (fig. 20). The "D" shape of the Marble Plan is likely, whether closed or open-ended, although in a drawing by Sangallo the Younger it appears semi-circular (fig. 11).[64] An analogy for the D-shaped portico may be found in the younger Pliny's description of his Laurentine villa where two D-shaped porticoes enclose a small courtyard. Although the context differs in this example from a private country residence to an imperial forum in Rome, the D-shaped portico seems to have been part of the architectural vocabulary of the late first and early second centuries.

Both the fragment and the remains demonstrate how an awkward transition among buildings is concealed by abutting three semicircular structures, the Porticus Absidata, the temple's apse, and the exedra of the Forum of Augustus.[65] The orchestration of curving walls and contrasting marble-revetted screens with spacious arcades seals the complex of imperial fora from the Subura.

While it formed a monumental entrance to the imperial fora and to the Forum Romanum beyond, the Porticus also faced the streets of the Subura.[66] As a vestibule it provided an inviting shelter sequestered from the congested intersection and shielded the Forum from the activity outside. Despite the facade of a monumental portal, the Porticus offered limited access to the Forum through the confined and indirect corridor along the temple's flank. The radial plan of the arcade channels traffic spilling out of the narrow throat of the Forum or, conversely, the Porticus figures as a catch basin for the pedestrians about to pass through the Forum.

The illustration on the fragment of the Marble Plan indicates a route to the Forum, which is set off-axis from the Argiletum (fig. 14). One proceeded along a turning path that was impossible to gauge from the out-

[63] Anderson (1984), 134.

[64] Nash 2:235, describes it as a semicircular building. Bauer (supra n. 61), 182, observes that the semicircular portico derives from monumental public architecture. Anderson (1984) 134, states that the D-shaped portico is unlikely here because there are no other examples so early. *Contra* Anderson, see Pliny *Ep*.2.17.4. H. Bauer, "Foro di Augusto e Porticus Absidata. Ricerche sul muro perimetrale e sul portico del Foro di Augusto," in A. M. Bietti Sestieri et. al. (supra n. 3).

[65] Anderson (1984), 133.

[66] Platner-Ashby, 311, on the vicus Lacus Fundani; 575, on the vicus Longus; and, 24, on the Clivus Orbius.

side. What Bauer considered a "free-style" plan, in contrast to the strict axiality of the other imperial fora, resulted from the Forum's insertion among the older fora along the Argiletum.[67]

The later history of the Forum is one of gradual disintegration and devastation. In the medieval period the district was known as *Li Pantani* because of the frequent flooding from the clogged Cloaca Maxima, which runs beneath the Forum (fig. 21).[68] The area to the southeast, the Campo Torrechiano, served as a market for livestock, and a street called the Fundicus Macellorum de Archanoe, lined with butcher shops and modest dwellings, corresponded with the site of the Forum. The church of S. Maria in Macello was located in or near the Forum.[69] References to an Archanoe or Arca Noe were associated with the site; these names may be a corruption of the Arcus Nervae, an entrance to the Forum in the north wall towards the fora of Augustus and Julius Caesar, or it may be that Arca Noe (Noah's Ark) referred to the Temple of Minerva because the cella had been converted into a granary or storehouse of the cardinals (sixteenth-century views show a two-story vaulted structure in the cella).

Quarrying of stone was conducted in the Forum from 1425 through 1527, and in 1576 the statuary not already removed was taken and sold to the Comune. The cannibalization continued when marble from the temple was stripped for St. Peter's in 1592 and then for the Borghese Chapel in S. Maria Maggiore. Pope Paul V razed the temple in 1606 to use the marble for his fountain, the Acqua Paola, on the Janiculum. The arch to the southeast of the temple, the Arcus Aurae, was also destroyed in the seventeenth century. There are no further notices until Lanciani, in 1882–1883, studied the extant colonnade at the corner of the old via Alessandrina and via della Croce Bianca and analyzed the historical sources, preliminary steps for drawing a plan of the Forum.[70] Le Colonnacce has come into popular usage as the name of the extant bay but it is difficult to determine precisely when this occurred (perhaps by the end of the medieval period). The streets and houses built into Le Colonnacce were cleared in Mussolini's building of the via dell'Impero in 1932 (figs. 22 and 23).

It has been proposed that Domitian united the imperial fora by building

[67] Bauer (supra n. 61), 182. Also, the side piers of the gates are visible beyond Le Colonnacce.

[68] R. Lanciani, *The Ruins and Excavations of Ancient Rome*, 308. G. Lugli, *Roma antica. Il centro monumentale*, 273–76. I rely on these accounts in the following.

[69] C. Huelsen, *Le chiese di Roma*, 311.

[70] Lanciani (supra n. 1), 22–26, pl. 1 and 2. L. Canina, *Esposizione storica e topographica del Foro Romano e sue adiacenze*, pl. 12, first identified the fragment of the Marble Plan, FUR 16a, as the Temple of Minerva in the Forum Transitorium.

in the space between the Forum of Augustus and the Templum Pacis.[71] Andreas Linfert has analyzed the plan as a symbolic map charting the dynastic rivalry of the Julio-Claudians and the Flavians. He interprets the sequence of high-walled, self-contained complexes as being built to imitate the previous fora and to surpass them (fig. 2). It is not insignificant that the monuments of the Flavians, the second dynasty, are adjacent to those of the Julio-Claudians. Vespasian and his sons modeled themselves on the founding dynasty through their building projects as well as through their calculated return to ancestral values.[72]

Although Linfert's method reduces complex monuments to a simple scheme of clashing slogans, it suggests how the Forum Transitorium became the central corridor for the fora complex. Of course, the Argiletum in this area may well have been run down, providing the opportunity for reconstruction along the strategic route from the Tiber to the Esquiline. By erecting the Forum Transitorium next to that of Augustus, Domitian implicitly refers to the city's first building program, which he aimed to equal, if not exceed. The Forum Transitorium bridges that of the Empire's founder and that of his father, the founder of the second ruling dynasty. The arrangement of the imperial fora, with the Forum Transitorium joining the monuments of the two Julio-Claudians with those of the two Flavians, demonstrates the Flavian dependence on the Augustan model.[73]

The extent of Domitian's building activity can be recovered despite the biased historical sources and the damnatio memoriae of 96. He completed buildings left unfinished by his father and brother, such as the Flavian Amphitheater and the Baths of Titus; he restored those ruined by the fire of 80 from the Capitol to the complex built by Agrippa in the Campus Martius; he undertook major projects on the Palatine such as the Flavian palace, on the Quirinal, and in the imperial fora, where he also may have begun repairing the Forum of Julius Caesar, damaged by fire.[74] One of his motives was to secure the lasting glory of the Flavian dynasty and their goddess, Minerva.

The dynastic theme of Flavian architecture is illustrated in the Porticus Divorum in the Campus Martius, which, unfortunately, is only known through the Marble Plan.[75] Inside a rectangular enclosure entered

[71] A. Linfert, "*Certamen Principium.* Über den propagandischen Zweck der Kaiserfora," *BJb* 179 (1979): 177–86.

[72] See introduction.

[73] Linfert (supra n. 71), 185.

[74] J. C. Anderson, Jr., "A Topographical Tradition in Fourth Century Chronicles: Domitian's Building Program," *Historia* 32 (1983): 93–105.

[75] Rodriguez Almeida (supra n. 28), pl. 26, no. 35.

through a triple arch, two small temples dedicated to the deified Vespasian and Titus faced one another, and an altar stood opposite them (fig. 24). The interior of the long sides and the far end contained porticoes, and the central area was probably planted in a formal manner similar to the Templum Pacis.

Richardson has proposed that the Porticus Divorum may have replaced the old Villa Publica that served as the marshaling grounds for triumphant processions.[76] In this way Domitian appropriated the site of an ancient institution for a monument to his family. The memory of the deified Vespasian and Titus was linked with the ideology of victory and triumph.

The site was adjacent to the Saepta Julia, the voting place for the plebs, which was finished by Agrippa and more frequently used as a setting for games and ceremonial events.[77] In the heart of the Augustan complex, Domitian built a Temple of Minerva Chalcidica on axis with the entrance to the Porticus Divorum. The temple appears to have been a small circular pavilion, perhaps like the Temple of the Flavian dynasty, with an outer and inner ring of columns.[78] Minerva is thus honored as the Flavian goddess and their goddess of victory as she appears in the attic relief of the Forum Transitorium.

Both the Porticus Divorum and the Forum Transitorium are high walled enclosures that are turned in upon themselves, yet they are significantly sited in relation to their surroundings. They are both inserted among Augustan buildings and are meant to unify the disparate structures by repeating and complementing forms and design motifs. It is clear that Domitian wanted to reshape entire quarters of the city not only for the sake of architectural unity but also to assert himself, like Augustus, as one who founded the city (again). The Flavian mark had to be left on the most historically significant sites, and this was often accomplished through projects that integrated the hallowed old monuments with the Flavian additions. The knitting together of the imperial fora is an example of this, and the Forum Transitorium was only part of Domitian's plan for the area.

Anderson, among others, has observed the evidence of Domitianic building on the site of the later Forum of Trajan.[79] Although it is impos-

[76] *CIL* 6.10234. L. Richardson, Jr., "The Villa Publica and the Divorum," *In Memoriam Otto J. Brendel*, ed. L. Bonfante Warren, 159–63. An idea articulated by Laura Rath in a paper, "Domitian's Building Program in the Campus Martius," for a seminar in Roman art held at Boston University, spring semester, 1989.

[77] Zanker (1988), 142–43.

[78] A denarius of 94–96 may depict the temple and its statue of Minerva: Mattingly, *BMCRE* 2, 346, no. 241, pl. 67.7.

[79] Blake (supra n. 62), 105. J. C. Anderson, Jr., "Domitian's Building Program:

sible to reconstruct Domitian's plans for the area, it seems that his project included excavating the slope of the Arx and the base of the Quirinal as the first stage of development. This may have been intended as another forum that would have crowned the sequence of imperial fora to the north at the edge of the Campus Martius. Domitian's aim in connecting the individual monuments of the fora through the siting of the Forum Transitorium would have been fulfilled by this plan. Perhaps the initial work at the base of the Quirinal would have been integrated with the development on the hill that commemorated the history of the imperial family at the site of Domitian's birth.

The incorporation of a major thoroughfare, the Argiletum, into the Forum's plan altered the city's traffic patterns and involved Domitian's extensive building program beyond the walls of the imperial fora.[80] The Forum Transitorium and the Quirinal are linked through the former's Temple of Minerva, dedicated to the Flavian patron deity and Domitian's proclaimed ancestor, and the latter's dynastic temple. As the site of the Sabine settlement of the early city, the Quirinal was appropriate for the Flavians, who were satisfied that their rustic Sabine origins provided them with the moral character required by the times.[81] The correspondences between the legendary heroes of early Rome and the personal history of the emperor is also supported by the testimony of the court poets, always ready to mythologize his achievements. Martial and Statius locate Domitian's buildings in relation to the founders of the city and of the empire, Romulus and Augustus.[82]

The major Domitianic monuments on the Quirinal, the dynastic temple and the Arae Incendii Neronis, point to a systematic rebuilding of the city into a Flavian capital by commanding strategic and historically evocative positions. The Arae Incendii Neronis, discussed later in this chapter, demonstrated Domitian's intent to repair the damage wrought by the fire of 64, not only by rebuilding, but also by propitiating the gods to protect Rome against repeated outbreaks of fire.[83] The reinstatement of archaic cults forms part of the *renovatio urbis* undertaken by Domitian. Piety towards the gods, particularly old and forgotten gods, and the personal

Forum Julium and Markets of Trajan," *ArchNews* 10 (1981): 46, on the brick stamps of Primigenius, a servant of the two Domitii, in the lower levels of the Market of Trajan. These stamps are of a Flavian date. Anderson (1984), 180.

[80] D. M. Robathan, "Domitian's Midas-Touch," *TAPA* 73 (1942): 130–44. F. C. Bourne, *The Public Works of the Julio-Claudians and Flavians*, 64–69. Also, G. Lugli, "La Roma di Domiziano nei versi di Marziale e di Stazio," *StudRom* (1961): 1–17.

[81] Scott, 185–86.

[82] For example, Mart. *Epigr.* 8.80.5–6.

[83] Infra n. 134.

aggrandizement of Domitian were the principles of his building program.[84] The neighboring vicus Longus, in particular, was significant in this regard.

The vicus Longus, the street leading to the imperial fora from the valley traversing the Quirinal and Viminal hills (fig. 25), was residential and included some small shrines or cult centers.[85] One of these, the shrine of Pudicitia Plebeia, Plebeian Chastity, was established by a patrician woman who had been excluded from the cult of Pudicitia Patricia in the Forum Boarium as a result of her marriage to a plebeian.[86] The altar was dedicated here in 296 B.C., officially recognized under Augustus, and very likely restored by Domitian as part of his program to repair the decaying temples and to instill respect for the institutions of marriage and the family.[87]

As a cult for matrons who were married once, *univirae*, the goddess Pudicitia personified the virtue of feminine chastity or, rather, continence. Domitian's revival of the Augustan *lex Julia* against adultery in 89–90 was coupled with Pudicitia by Martial: "Since the Julian law, Faustinus, was reenacted for the people, and Pudicitia was commanded to enter our homes . . ."[88] The *lex Julia de adulteriis coercendis* of 18 or 17 B.C. made a woman's adultery a criminal offense to be tried in a public court, a *quaestio perpetua*, established for this purpose (replacing the traditional assembly of relatives who had judged these matters). The related legislation, the *lex Julia de maritandis ordinibus* (together with provisions of the later *lex Papia Poppaea*) penalized unmarried citizens, rewarded those who married and had several children, and regulated marriage between the upper and lower social orders. Robert Palmer has also noted that there was a Julian law on chastity established by Augustus in 28 B.C. (although it met with popular opposition and had little effect) and that the shrine of Pudicitia Plebeia was restored by Livia, who was the first of the imperial women to be associated with Pudicitia as an inspirational model for their subjects.[89] The institution of the family was key for the idea of moral renewal, and the cult of Pudicitia was one vehicle to strengthen it.

Domitian's legislation attempted to maintain the distinctions among

[84] Suet. *Dom.* 5. The following discussion does not cover all the monuments of Domitian's building program in Rome.

[85] Platner-Ashby, 575. M. Santangelo, "Il Quirinale nell'età classica," *AttiPontAcc* 5 (1941): 141. Palmer (1974), 128.

[86] Livy, 10.23.1–10. Palmer (1974), 123–42.

[87] Festus *Gloss. lat.* 237.

[88] Mart. *Epigr.* 6.7.1–2. Suet. *Dom.* 7–8. Dio Cass. 67.2–3. Palmer (1974), 141. Grelle, 340–65.

[89] Palmer (1974), 138–39.

the social orders so that his subjects would respect their rank, privileges, and obligations; thus his laws were aimed at the entire social spectrum. The elite had a role to play in setting moral standards, particularly when the composition of the senatorial order was changing due to the induction of new men from the provinces, especially the Greek east, who had to be steeped in Roman traditions. Another law reinforced by Domitian ensured that equestrians, the second order below senatorial status, were distinguished by rank in public. The *lex Roscia Theatralis* reserved fourteen rows of seats in the theater to separate status-conscious equestrians from the mob. Outside of the elite circles, ex-slaves, freedmen, may have benefited from a revival of the Augustan measures that released them from obligations owed to their *patroni*, their former owners (although, at the same time, the marriage laws enforced social divisions by forbidding senators and their children to wed freedmen and freedwomen, and by prohibiting other citizens from marrying actors, actresses, women condemned for adultery, prostitutes, and others considered to be marginal). At the bottom of society, the slave market was closely regulated.[90]

Martial approves of Domitian's campaign against moral corruption in other instances. In *Epigram* 6.4,1, published in 91, Domitian is lauded as "Censor maxime principum," the office that, among all those that he monopolized from the senatorial order, he carried out with zeal. He assumed the office *in perpetuo* in 85. The poem begins by addressing Domitian with this title, recounts a brief list of his activities in office, and ends by circling back to the office with which the poem commences: "plus debet tibi Roma quod pudica est" (yet more Rome owes you, in that she is chaste).

The frequency with which such moralizing themes appear in Martial indicates their topicality.[91] The cult of Plebeian Chastity was revived by Domitian as a vehicle to cultivate proper conduct among married women, *matronae*. Its shrine stood on the vicus Longus between the fora and the Alta Semita (fig. 25), and Juvenal's mockery of it suggests that it functioned in the early second century as well.[92] Its proximity to the Templum Gentis Flaviae affirmed the moral basis of the Flavian ascendancy through its reverence for the founding principles of the Empire.

The other cults along the vicus Longus are more obscure and, like that of Pudicitia, they tend to the domestic life of the quarter's residents. The

[90] Mart. *Epigr.* 5.8. Grelle, 354.

[91] Mart. *Epigr.* 6.2, on the law against castration; 9.6.3–9, on the decreasing birth rate as a result of the practices of castration and prostitution. Suet. *Dom.* 7. Dio Cass. 67.2. Grelle, 343 n. 14, on the *terminus ante quem* for the law against castration as the publication date of the second book of Martial's *Epigr.* 85–86. Books 6 and 9 were published in 91 and 94, respectively.

[92] Juvenal *Sat.* 6.306–13.

Temple of Fortuna Bonae Spei was adjacent to the shrine of Pudicitia.[93] Many of the Fortuna cults tend to promote feminine ideals, such as that of Fortuna Virgo whose temple held a veiled statue that could be touched only by univirae. Other cults on the street include that of the goddess Febris and of Diana Plancianae.[94] Possibly these cults attracted the same audience, married women of the lower social strata who lived in the quarter. In this worship they would perhaps receive moral instruction or guidance, show respect for legendary historical figures like Verginia who founded the shrine of Pudicitia Plebeia, or renew their faith in the vicissitudes of fortune. Worship at these shrines was probably conducted by priestesses for the matrons on feast days or to mark rites of passages such as marriage or the birth of a child.

On the Quirinal the character of the temples and the residences changes. The temples on the Alta Semita (fig. 26) were more famous than the local cults on the vicus Longus. Similarly, the dwellings tend to be large and luxurious. As the most northerly of the traditional seven hills of Rome, the Quirinal consists of several ridges, the collis Latiaris, collis Mucialis, collis Salutaris, and the collis Quirinalis, the last of which designated the entire hill. Antiquarians claimed that the name was derived either from the Sabine town, Cures, the home of the Quirinal's early settlers, or from Romulus who experienced apotheosis and became the god Quirinus.[95] In any case, the hill was generally associated with the god Quirinus, whose temple was on the Alta Semita near the Porta Quirinalis.

Starting on the collis Mucialis, one reached the Temple of Semo Sancus Dius Fidius. This Sabine cult was said to have been introduced into Rome by Titus Tatius, but the construction of the temple is attributed to the Etruscan king Tarquinius Priscus and was later dedicated in 466 B.C.[96] The deity belongs to a circle of minor deities associated with Jupiter, and is thought to have served as an intermediary between men and the gods in its role as the protector of treaties, vows, and promises. The temple housed a bronze statue of Tanaquil (or Gaia Caecilia), the wife of Tar-

[93] Dion. Hal. *Ant. Rom.* 4.27.7. Plutarch *De fort. Rom.*, 5. Platner-Ashby, 215–16. Palmer (1974), 128. E. Cantarella, *Pandora's Daughters*, 151–52, on the social classification of women as seen in the organization of cults for different groups (free or slave, *matronae* or prostitutes, patrician or plebeian).

[94] Val. Max. 2.5.6. Platner-Ashby, 206. S. Panciera, "Nuovi documenti epigrafici per la topografia di Roma antica," *RendPontAcc* 43 (1970–1971): 109–34.

[95] Varro *Ling.* 5.51. Ovid *Fasti* 2.511. Pliny *HN* 25. 119–26. *Festus Gloss. lat.* 10.51. Platner-Ashby, 436–38.

[96] Platner-Ashby 469–70. E. Evans, *The Cults of the Sabine Territory*, 30, on Semo Sancus as the great god of the Sabines, whose cult was probably introduced by King Numa Pompilius. Santangelo (supra n. 85), 123–26. Varro *Ling.* 5.60.

quinius Priscus, with her distaff and spindle displayed as relics, emblems of domestic virtue.

Even the wool spun by Tanaquil was preserved on her spindle and distaff, presumably to enhance the credibility of the didactic display.[97] The name, Gaia Caecilia, was invoked during weddings in honor of her industry and domesticity. As an explanation for the custom of carrying a spindle and distaff in wedding processions, Pliny notes that Tanaquil was the first to weave the *tunica recta* that brides prepare on the night before their wedding. The tradition of the spindle and distaff as symbols of virtue equates diligent work at the loom with moral purity.

Evidently Tanaquil served as a pillar of feminine virtue with her spindle and distaff enshrined in the temple.[98] Both the relics of Tanaquil and the shrine of Pudicitia affirm the homely ideal of domestic industry and chastity as the cornerstones of society. One needed only to inscribe *lanam fecit, domum mansit* on a matron's epitaph to summon her merit, her virtue. The moral connotations of women spinning and weaving are unambiguous in Roman poetry and historical writing, and the depiction of the Arachne myth in the frieze of the Forum Transitorium shares this meaning. In the frieze the women shown spinning and weaving under the tutelage of Minerva are the counterparts to the statue of Tanaquil in the Temple of Semo Sancus. The value of an inspirational model cannot be overestimated.

Furthermore, Pliny informs us that a pleated robe made by Tanaquil for her son-in-law, Servius Tullius, was kept in a shrine of Fortuna.[99] He does not specify which Fortuna shrine, but a local one such as that of Fortuna Bonae Spei on the vicus Longus was also erected by Servius Tullius. A worshipper could pay homage to Tanaquil by visiting her statue with the spindle and distaff in one temple, and then see the product of her industry, Servius's robe, in another temple.

The most significant monument for Domitian on the Quirinal was the Templum Gentis Flaviae. No archaeological evidence of the temple had been found, although a general description and approximate location is provided by Martial, Statius, and Suetonius.[100] Drawings by Flaminio

[97] Pliny *HN* 8.194. An ivory statue of a seated Athena Alea holding a distaff and a spindle may have been erected at an entrance to the Forum Augustum (Paus. 8.46.1, 4–5; 7.5.9). Suet. *Aug.* 73. Plutarch *Quaest. Rom.* 30. R. Lattimore, *Themes in Greek and Latin Epitaphs*, 295–96. J. Maurin, "Labor matronalis: aspects du travail féminin à Rome," in E. Lévy, ed., *La femme dans les sociétés antiques*, 139–55.

[98] E. Euing, *Der Sage von Tanaquil*, 11 and 13, on Tanaquil as the model of the stern matron, the mythical prototype of the modest and industrious housewife. She also aided her husband's political career by spurring him on to Rome and secured the throne for her son-in-law, Servius Tullius.

[99] Pliny *HN* 8.194. Ovid *Fasti* 6, 569ff. Plutarch *De Fort. Rom.* 5

[100] Mart. *Epigr.* 9.1.6–10; 9.3.12; 9.20; 9.34.2; 9.93.6. Stat. *Silv.* 4.3.18–19; 1.1.105. Suet. *Dom.* 1.

Vacca and Pirro Ligorio in the sixteenth century show, respectively, a *peripteral tempietto* and a circular porch, both reportedly based on the evidence of remains visible at the time.[101]

Excavations initiated during work at the construction site of a police barracks on the via XX Settembre near S. Susanna in the early 1980s revealed new evidence.[102] Coarelli has identified a *nymphaeum* uncovered there as belonging to the house of T. Flavius Sabinus, Vespasian's brother. If this attribution is correct, then one would expect that the site of the Flavian temple, built on the grounds of the house where Domitian was born is nearby. Accordingly, Coarelli had suggested that a large concrete podium adjacent to the nymphaeum's remains was the temple's podium. This alters the conventional siting of the temple farther to the west near S. Andrea al Quirinale or S. Carlo alle Quattro Fontane.[103]

The ancient sources report that the temple was locted on vicus ad Malum Punicum (Pomegranate Street), which intersected the vicus Longus and the Alta Semita (figs. 25 and 26).[104] It served as a mausoleum for the Flavians and must have been completed shortly before 94.[105] The ashes of the deified Vespasian and Titus were probably brought here, as well as those of the deified Julia.[106] As a funerary monument it had a noticeable emphasis on the current ruling member of the Flavian *gens*. Domitian honored the dynasty that culminated in his reign by erecting a monument on the site of his birth.

Martial and Statius describe the Flavian temple briefly. According to their testimony, it was a round structure covered by a dome to create the "Flavian heaven."[107] The idea of apotheosis apparently informed the design of the temple that sheltered the deified members of the imperial family. Martial portrays its splendor: "This spot of earth, which now lies wholly open, and is being covered with marble and with gold, knew our lord's infant years."[108] The monument commemorates the dynastic sequence by both its location at Domitian's birthplace and its function as a tomb for the deceased Flavians.

In another epigram, Martial tells of a woman worshipping the deified

[101] Santangelo (supra n. 85), 152.

[102] F. Coarelli, *Roma sepolta*, 146–55. Platner-Ashby, 197.

[103] Platner-Ashby, 247.

[104] Suet. *Dom.* 1. M. Torelli, "Culto imperiale e spazi urbani in età flavia," *CEFR* 98 (1987): 563–82.

[105] Gsell, 114–15, dates the temple to 89. Scott, 66, considers it to have been erected 94–95, based on the publication date of Martial's ninth book of *Epigrams* in 94.

[106] Suet. *Dom.* 17, for the burial of both Domitian's and Julia's ashes in the Temple. Santangelo (supra n. 85), 152.

[107] Stat. *Silv.* 4.3.18–19.

[108] Mart. *Epigr.* 9.20.1–2.

Julia, Titus's daughter and Domitian's niece, whose ashes were interred in the temple: "dum voce supplex dumque ture placabit matrona divae dulce Juliae numen" (suppliant with prayer and with incense, the matron shall propitiate the fair deity of Julia, now divine).[109] The next line of the poem affirms that "the towering glory of the Flavian line will endure," which suggests that Julia was worshipped at the Flavian Temple. The image of the devout matron is appropriate to any number of local cults in the area, Pudicitia Plebeia, Sancus, or Fortuna, although the object of her worship indicates the Templum Gentis Flaviae.

The scene of a woman worshipping at the dynastic shrine recalls the imagery of Domitian's Secular Games of 88. The festival consisted of the distribution of the items used for ritual purification, the presentation of the first fruits from the Aventine, and sacrifices performed for the Moirai, Eileithyiai, and Terra Mater, as well as for Juno, Jupiter, Apollo, Diana, and Latona.[110] Lasting throughout the night and day and staged in various cult sites from the Campus Martius to the Capitol, the ceremonies called on the gods to bless the Romans with victory, prosperity, and health, particularly in the form of increased fertility and children. A group of 110 distinguished matrons invoked the gods, and choruses of youth and girls sang the secular hymn originally written for Augustus by Horace in 17 B.C.

A *sestertius* commemorating the Secular Games depicts one of these activities, Domitian leading a group of three matrons in prayer to Juno (fig. 27).[111] Whether the object of their devotion is Juno or Julia as in the Epigram above (Julia assumed the identity of Juno in the depictions of another coin series), the image of the devout matron under the religious guidance of the *princeps pudicus* recalls the theme of the frieze of the Forum Transitorium.[112]

Domitian's ability to mobilize and orchestrate society for these elaborate spectacles suggests that the years of 88 and 89 brought stability and optimism (despite the revolt of Saturninus). In the eighties, he demonstrated a keen political sense in his hardheaded but pragmatic dealings with the senate, in judicial reforms, and in the affairs of the provinces. In an attempt to address accusations of corruption, he effectively reduced the power of the senate, particularly in regard to abuses in the eastern

[109] Mart. *Epigr.* 9.1.6–10.

[110] Gsell, 77. Zanker (1988), 167–72, on the Augustan precedent.

[111] Mattingly, *BMCRE* 2, xcv, 393, no. 424, pl. 78.5, for a sestertius of 88–89 commemorating the Ludi Saeculares.

[112] Scott, 47–48. P. V. Hill, "Notes on the Ludi Saeculares of A.D. 88," Atti congresso int'l. di numismatica (Rome, 1961), 275–82. P. di Manzano, "Note sulla monetazione dei Ludi secolari dell 88 d.c.," *BullComm* 89 (1984): 297–304.

provinces.[113] A more balanced assessment of the eighties has to include his extensive program of public works, his admittance of new men into the senate, and his advocacy of justice for those under the yoke of unscrupulous procurators. At the time of the Secular Games in 88, popular opinion was probably riding high for Domitian who had proven himself an effective leader in his efforts to repair the quality of life in the rubble-strewn city at the beginning of the decade.

The theme of *pietas* to the gods or to the deified imperial family appears frequently in the Flavian coinage and poetry. Denarii of 81–84 commemorating Pietas Augusti represent Domitia with her son, the imperial heir, who died in infancy (fig. 28).[114] An *aureus* makes the prince's apotheosis more explicit by showing him standing on the globe of the earth reaching out to the stars above (fig. 29).[115] The expression of *pietas* between the members of the imperial family as an imperial virtue supports the dynastic claim to rule: as mortals revere the gods, the Flavians express affection and loyalty to one another.[116] The Templum Gentis Flaviae may also be seen as a monument of Pietas Augusti.

Although nothing remains of the temple itself besides a concrete podium, a group of well-known architectural and relief fragments have been assigned to it or to an arch associated with it (figs. 30 and 31). Gerhard Koeppel has found that fragments in the Kelsey Museum in Ann Arbor and those acquired by Hartwig for the Terme Museum in Rome belonged to the same structure.[117] Through a stylistic comparison of the fragments' architectural decoration and relief sculpture with dated monuments, Koeppel attributes them to the late first century A.C. The subject matter of the two panels assembled from the fragments is the *adventus* of Vespasian to Rome and a sacrifice before the Temple of Quirinus on the Quirinal hill. Torelli, however, interprets the latter as a scene of the foundation of the temple of the Gens Flavia showing the Temple of Quirinus in the background.[118] Both of these interpretations suggest not only that the site of the Flavian shrine on the Quirinal was significant but also that its iconography depicted the Quirinal temple with pedimental sculpture

[113] Levick (supra n. 60), 50–73.

[114] Suet. *Dom.* 3. Mart. *Epigr.* 6.3.5–6, on the birth of a son to Domitia and Domitian who died young. A. La Penna, "Tipi e modelli femminili nella poesia dell'epoca dei Flavi," *Atti del congresso int'l. di studi vespasianei*, 1:223–51.

[115] *BMCRE* 2, lxxlx, pl. 61.6 and 7.

[116] Quintilian *Inst.* 3.7.9, praises the *pietas* of Domitian in deifying the deceased members of his family.

[117] Koeppel (1980), 14–29.

[118] Torelli (supra n. 104), 569.

showing Romulus taking the *auspices*.[119] The mythical founder of the city is evoked as the predecessor of the Flavian dynasty, and it is his apotheosis that provides a model for the deified Flavians.

The siting of the house and the dynastic shrine on the Quirinal follows the example of Augustus on the Palatine. Adjacent to his Temple of Apollo and to its Greek and Latin libraries, his house incorporated several Republican houses.[120] One of these was that of Q. Lutatius Catulus, consul of 102 B.C. with Marius and author of learned treatises on early Rome. In Catulus's political struggles with Marius, the former assumed the title of the "new Romulus," because his house was supposedly built on the site of Romulus's hut. The hut had been destroyed by fire during the Gallic sack of 390 B.C., leaving only the *lituus*, Romulus's augur's wand, intact as a relic.

Furthermore, Verrius Flaccus, the tutor of Gaius and Lucius Caesar, wrote about the site of the domus Catalina and the legendary hut of Romulus in a commentary on the *Fasti Praenestini*. Augustus then exploited the connection by erecting a platform as an *auguratorium* behind the adjacent Temple of Apollo.[121] Romulus had performed his first act of augury, the sighting of the twelve vultures, on this type of platform. In 27 B.C., however, Augustus could not complete his identification wth Rome's founder by adopting the honorific name of Romulus because of its connotations of kingship and fraticide.[122] It was only through his recreation of evocative monuments that the claim could be made.

Perhaps a similar intention on the part of Domitian can be seen in his building on the Quirinal. The Augustan complex on the Palatine consisted of a house and temple on the site of Romulus's dwelling. Domitian erected a temple on the site of his father's house located near the Temple of the divine Romulus or Quirinus. Domitian is also credited with restoring Romulus's hut on the Palatine, but it was on the Quirinal that the relationships of the dynastic shrine and the founder's temple, and of their common Sabine heritage, were displayed.[123] By imitating the Augustan program on the Quirinal rather than on the Palatine, Domitian asserts

[119] P. Hartwig, "Ein römisches Monument der Kaiserzeit mit einer darstellung des Temples des Quirinus," *RM* 19 (1904): 23–37.

[120] Suet. *Aug.* 72. Coarelli (supra n. 102), 140.

[121] Tacitus *Ann.* 12.24, on the proximity of the house in which Augustus was born and the Curiae Veteres, an organization founded by Romulus.

[122] K. Scott, "The Identification of Augustus with Romulus-Quirinus," *TAPA* 56 (1925): 82–105.

[123] Mart. *Epigr.* 8.80.5–6, on the restoration of Romulus's hut by Domitian. On the Sabine origins of the Quirinal and of Quirinus, see Varro *Ling.* 5.52.66; Pliny *HN* 25.119–26; Festus *Gloss.lat.* 255; and Wissowa, 153–55 on Quirinius's Sabine father, Reatinus. He came from Reate as did the Flavians (Suet. *Vesp.* 12).

himself as heir to both the founder of Rome and the founder of the Empire.

The most important temple on the Quirinal was the Temple of Quirinus, but very little is known about it, including its precise location, because there are no archaeological remains.[124] According to the legend, Romulus commanded the founding of the temple, and it was dedicated to him as the god Quirinus after his apotheosis. According to the historical tradition, it was vowed by L. Papirius Cursor in 325 B.C. and dedicated in 293 by his son.[125] Vitruvius describes it as a large octastyle and dipteral temple.[126]

As the temple of Rome's founder and first king, it played a major role in the formation of the imperial cult. Julius Caesar had adopted the dress of Romulus and had erected a statue of himself with the inscription "Deo Invicto" in the temple.[127] Augustus restored and rededicated the temple in 16 B.C. on a grand scale with a total of seventy-six columns, and a later oracle linked the temple with the fate of the emperor.[128] There is no mention of a Domitianic renovation in any of the sources, although the Hartwig relief discussed above as part of the Templum Gentis Flaviae depicts its pedimental sculpture.

The fragment of the Hartwig relief may represent a sacrifice occurring before the Temple of Quirinus, and the temple's pediment is depicted within the scene to identify the setting (figs. 30 and 31). The pedimental group depicts the twins Romulus and Remus and an assembly of deities present at the first augury.[129] *Pietas* toward Romulus is represented in one of the reliefs that decorated a part of the Templum Gentis Flaviae, itself an expression of *pietas* towards Vespasian and Titus among others in the imperial family.

Close to the Temple of Quirinus and the Templum Gentis Flaviae was the Ara Incendii Neronis, one of a series of altars erected by Domitian, probably in each region damaged by the fire of 64.[130] Both the Neronian fire and the conflagration of 80 destroyed sections of Rome, and this gave Domitian the opportunity to transform the city. The altar is one of three that bears the same inscription in commemoration of the limits of the

[124] Ovid *Fasti* 2. 511. Pliny *HN* 25.120. Platner-Ashby, 438–39. Santangelo (supra n. 85) 129–36.

[125] Platner-Ashby, 439.

[126] Vitruvius *De Arch.* 3.2.7.

[127] Scott (supra n. 122), 82–105.

[128] Platner-Ashby, 439.

[129] Koeppel (1980), 16 n. 7, for the bibliography of the Hartwig relief.

[130] Platner-Ashby, 30. Nash (supra n. 61), vol. 1, 60. *CIL* VI.826, 30837*abc*. Santangelo (supra n. 85), 150–51. Palmer (infra n. 134), 43–56.

Neronian fire and Domitian's rebuilding.[131] One was erected on the Alta Semita near the Flavian temple, another was on the Aventine slope near the Circus Maximus, while a third, the location of which is unknown, was said to have been used subsequently as building material for the main altar of St. Peter's in the early sixteenth century.[132]

The altars and their inscriptions served to distinguish Domitian from Neronian policies of excess following the example of Vespasian's construction of the Amphitheater on what had been Nero's lake.[133] The city, no longer the Emperor's private domain, was returned to the public through its civic institutions. Besides marking the extent of damage and the reconstruction, the altars propitiated the god Vulcan and forestalled a recurrence of fire on this scale.[134] In one sense, Domitian's enthusiasm for archaic cults resulted from the exigencies of the contemporary situation. By charting the city's condition before and after his public works, Domitian declared his role as restorer of the city, the *renovator urbis*, which was tied to his program of moral reform and religious revival.

Palmer found evidence for another Domitianic temple, a temple of the Gods of the Hills, located on a street linking the Quirinal to the Viminal.[135] At the same time Domitian celebrated the *sacrum Septimontiale*, the festival of the seven hills, with a splendid public banquet and a distribution of gifts in the amphitheater.[136] Again the rebuilding and planning of the city is tied to the practice of archaic cult and the glorification of early Rome.

The determination to build on strategic routes is also witnessed in the siting of the Forum Transitorium on the Argiletum. Perhaps the Domitianic plan entailed the revitalization of streets that had fallen into disrepair or had been left to haphazard development. The imperial building program revitalized these zones, giving greater prominence to archaic shrines like that of Pudicitia Plebeia and accentuating their proximity to the new imperial monuments such as the Forum Transitorium and the Templum Gentis Flaviae. The creation of monumental zones on the Palatine and on the Quirinal certifies Flavian history as the fulfillment of Rome's destiny and graces Domitian with the role of restorer. Not only were Domitian and his planners interested in the axial alignment of his monuments, such as that formed by the Temple of Minerva and the

[131] R.E.A. Palmer, *The Archaic Community of the Romans*, 52.

[132] Platner-Ashby, 30.

[133] Suet. *Vesp.* 9.

[134] R.E.A. Palmer, "Jupiter Blaze, Gods of the Hills, and the Roman Topography of *CIL* VI.377," *AJA* 80 (1976): 52.

[135] Palmer (supra n. 134), 43–56.

[136] Suet. *Dom.* 4.

equestrian statue in the Forum Romanum and another linking the Temple of the Deified Vespasian and Titus and the Arch of Titus, but they wanted to assert the Flavian ascendancy by possession of the most venerated or, at least, the most ancient sites in the city.[137] The center of old Rome, the Forum Romanum, was hemmed in by Domitianic monuments on the Capitol, the Palatine, and the Velia, and at the bases of the Esquiline and Quirinal hills.

[137] Torelli (supra n. 104), fig. 4, on the axial alignment of the Domitianic plan.

CHAPTER TWO

The Frieze

O NLY eight sections of the frieze, approximately one and a half bays, are extant *in situ* on Le Colonnacce (fig. 45). Most of the figures have suffered damage, especially abrasion, and are without heads, limbs, or parts of the upper torso. The situation has improved for the viewer because the surfaces of the frieze have been cleaned over the course of many years ending in 1989. A description of each section, along with a discussion of the style and technique, is found in the appendix.

The organization of motifs follows that of the articulation of the entablature into bays with the mythological scene in the central position of the first bay directly under the attic relief depicting Minerva (fig. 45, section 4, and fig. 82).[1] The attic relief of the armed and triumphant Minerva (with what was once her lance in her right hand and her shield in the left), which crowns the frieze, establishes that the scenes below take place in her domain, especially the mythological subject of Minerva punishing Arachne (figs. 82 and 83). Without a continuous narrative or a pattern of clearly repeated decoration, the frieze instead depends on the arrangement of figures along the vertical axis to emphasize the theme of Minerva's ascendancy. The double depiction of Minerva along the vertical axis provides the core of meaning around which other contrasting or complementary motifs are clustered. The scenes arranged horizontally around the vertical axis, that is, on either side of the mythological scene in the center, serve as glosses on the theme of divine punishment. In fact, the scene of the punishment of Arachne forms a central *emblema* surrounded by other contrasting motifs, moralizing exempla of virtue.

The mythological centerpiece portrays the goddess avenging her honor.[2] In an act that conveys her authority, the aegis-clad and helmeted

[1] As far as I know, no one has yet discussed the importance of the mythological scene's position in the center of the bay directly below the attic relief. See the Appendix for the attic relief.

[2] Ovid *Met.* 6.132–33.

Minerva, taller than the other figures, stands poised to the left, raising her right arm to strike Arachne (figs. 57 and 58).[3] Arachne kneels before her and extends her left arm in a gesture of supplication to Minerva. The figure of Arachne in tunic and mantle is undistinguished from many of the frieze's other now headless figures; nonetheless, the pair is linked through the diagonal formed by their raised arms and the frame of a loom behind them.

There are no other extant representations of the punishment of Arachne in ancient art. Although a Corinthian *aryballos* dated to about 600 B.C. was thought to have depicted this myth, it may very well show a domestic weaving scene (fig. 32).[4] Among contemporary works, Domitianic coin types usually depict Minerva armed in the Promachos type, if shown in an active pose. Neither a loom nor a spider is represented on any of the coins to indicate the mythological narrative. One type, however, is similar to the frieze's Minerva in its depiction of the goddess turned towards the left with the right arm held aloft (fig. 33). The *denarius* represents a statue of Minerva in a shrine, possibly that of Minerva Chalcidica adjacent to the Porticus Divorum in the Campus Martius.[5] The images of the goddess on the coin and in the frieze are not identical, and it is likely that a generic image of the armed Minerva served as the cult image of many of the Domitianic temples.

The frieze's representation of the goddess punishing a defiant mortal may serve Domitian in another way: as a warning about the dire necessity of expressing *pietas* to the gods and the consequences of failing to do so. Domitian was scrupulously correct in his attentions to the gods and in the filial piety that he demonstrated for his deified father and brother and that culminated in his dedication of the Templum Gentis Flaviae on the Quirinal.[6] The piety of the members of the imperial house, depicted as an

[3] Although Ovid describes Minerva as striking Arachne with a shuttle, here she appears to grasp the handle of a sword beater. Perhaps the carvers substituted a tool that could be seen by the viewers stationed below. H. Blümner, "Il fregio del portico del Foro di Nerva," *AnnInst* (1877): 26, observed this variation on the myth yet dismissed it as an example of artistic license. A sword beater or beater-in would have been more visible than a shuttle. The weaving sword or beater-in was used by weavers to push up the weft on the loom. Von Blanckenhagen, 124, identifies it as a spindle.

[4] G. D. and S. S. Weinberg, "Arachne of Lydia at Corinth," in S. S. Weinberg, ed., *The Aegean and the Near East, Studies Presented to H. Goldman*, 262–67, and pl. 35 for a Renaissance illuminated manuscript that depicts the myth of Arachnè. Picard-Schmitter, *Sur le châtiment d'Arachnè* (1965), 47–63, against the identification of the aryballos scene as the Arachne myth. *LIMC* 2.1, 470–71 (J. G. Szilagy) on the literary tradition of the Arachne myth.

[5] *BMCRE* 2, 346, no. 241, pl. 67.7, for a similar type; 305–06, nos. 42 and 44, pls. 60. 10–11, for denarii of 83. For the Porticus Divorum, see chapter 1.

[6] On the Templum Gentis Flaviae, see chapter 1.

imperial virtue in the contemporary coinage, no doubt developed from and was identified with piety towards their preferred divinities such as Minerva.[7]

The Arachne myth recounts the conflict of the divine order and mortal ambition.[8] Ovid portrays Arachne as a prodigious talent at the loom; the delicacy of her weaving is such a marvel that nymphs leave the hills and rivers to watch her perform. The young woman's pride is considerable, especially since she was born poor, the daughter of a Lydian wool-dyer, and raised without a mother's guidance. To Minerva she is an insolent climber, who refuses to humble herself before the goddess who taught her to weave (even after being given the opportunity when Minerva comes disguised as an old woman). The rivalry between Minerva and Arachne culminates in a weaving contest in which the figured designs of the fabrics woven by each describe their positions. Minerva's cloth depicts absolute authority in stately splendor: the twelve gods enthroned and the outcome of the contest between Minerva and Neptune for control of Athens (these scenes are also depicted on the sculpture of the Parthenon, the east frieze and the west pediment).[9] In the corners of the cloth are ominous scenes of the divine punishment of mortals who have been transformed for daring to challenge the gods.

In Arachne's fabric, on the other hand, the gods undergo transformation as a means to deceive the lovers that they pursue, as, for example, in the story of Jupiter and Europa. The figured cloth seems to pulsate with life, its scenes of the protean deities, their fiery loves, and slippery appearances are mesmerizing. Minerva is enraged by both the skill demonstrated by Arachne, which ironically demonstrates her success, and by the impropriety of the subject matter. She tears up Arachne's cloth and strikes her repeatedly. Unable to endure anymore, Arachne fastens a noose around her neck in an attempt to hang herself. Minerva transforms her into a spider out of pity. Suspended in the air, her body shrunken to a belly with a miniscule head, the spider Arachne weaves only to see her flimsy webs continually swept away.

Besides its demonstration of Minerva's ascendancy, the Arachne myth may also have been a vehicle for Domitian's attempts to re-invigorate

[7] Quint. *Inst.* 3.7.9: *pietas principis nostri.* Scott, 48 and 72. Mattingly, *BMCRE* 2, 312, nos. 65 and 66, pl. 61.9.

[8] Ovid *Met.* 6.1–145. E. W. Leach, "Ekphrasis and the Theme of Artistic Failure in Ovid's Metamorphoses," *Ramus* 3 (1974): 102–3, 115–18; *idem, The Rhetoric of Space*, 442–44, on Ovid's narration that privileges the goddess's point of view. B. Harries, "The Spinner and the Poet: Arachne in Ovid's *Metamorphoses*," *PCPS* 216:36 (1990): 64–82.

[9] F. Brommer, *Die Giebel des Parthenon*, 13–16; *idem, Der Parthenonfries*, 106–24.

public morals and to instill respect for the *mos maiorum*.[10] From Livy's account of Lucretia to countless epitaphs, a matron's skill at the loom connotes that she upholds the sanctioned ideals of womanhood: a selfless dedication to the demands of her household, sobriety, modesty, and chastity above all. Domitian's policies affecting private life and religion, particularly his reinforcement of the Julian laws on marriage and adultery and his prosecution of the Vestal Virgins for violation of their vows, drew attention to the feminine virtue of chastity and its alleged decline. Through the weaving motif, the frieze illustrates the imperial virtue of *pudicitia* as well as *pietas*, and the former is also more explicitly represented in an adjacent section as well.

The myth combines two motifs, weaving and hanging, emblematic of women's lives in antiquity. Although the meaning of the loom as a sign of the matron is clear, the significance of the noose in the myth has not been discussed. Hanging was a traditionally feminine means of suicide in Greek mythology, and the taint of death by hanging was also present for the Romans.[11] To be suspended in the air over the ground was devastating for women, who were traditionally associated with the earth and its powers of fertility. When Minerva tells Arachne that she must hang suspended forever, she is implying that her life as a woman is over even without the added horror of her transformation. Although Arachne has not been allowed to kill herself by the noose, she dangles in mid-air, cut off from the earth, in a state of ceaseless activity or, some may say, living death.

In Greek society, girls would rock on swings as part of a rite of passage that ensured their transition from adolescence to womanhood.[12] Long known as a fertility rite, swinging with its repetitive, rhythmic, and soaring motion served to initiate girls into sexual intercourse through symbolic means. The act of swinging, like all rites of passage, also sufficed as a symbolic death and a rebirth into the new state (the death of the virgin and the emergence of the marriageable woman) because it raised the girl above the earth and it took place in isolation from the community. For Arachne, the opposite seems to have taken effect with her suspended state: she remains in permanent exile from her peers and her prospects are frightfully diminished because of her demotion to spiderhood.

The Arachne myth has several meanings for Domitian: the young woman is a rebel against authority, an artisan whose level of skill threat-

[10] Mart. *Epigr.* 6.2; 6.22; 6.45; 6.91. Stat. *Silv.* 4.3.13–15; 5.2.101–2. Suet. *Dom.* 7–8. Dio Cass. 67.2–3. Grelle, 340–65. Livy 1.157. *CIL* VI.10230, Laudatio Murdiae, and *CIL* VI.1527, Laudatio Turiae, for the topos of the good matron. See chapter 1.

[11] E. Cantarella, "The Dangling Virgins: Myth, Ritual, and the Place of Women in Ancient Greece," in S. Suleiman, ed., *The Female Body in Western Culture*, 57–67.

[12] Hyg. *Fab.* 130. Apollod. *Bibl.* 3.14. C. Picard, "Phèdre à la balançoire et le symbolisme des pendaisons." *RA* 5 (1928): 47–64.

ens Minerva's supremacy in the field, and also an artist whose vision of the gods' sexual escapades is an affront to the campaign against *libido*. For Arachne weaving becomes a means of subversion because she has brought a feminine accomplishment and wifely duty into the arena of divine competition and mortal fame. Rather than instilling the matronly virtues of modesty and humility in Arachne, weaving has made her bold and reckless. Strictly speaking, she wins the contest because of the lifelike quality of her woven figures but it is the outspoken confidence in herself and her brazen repudiation of Minerva that does her in. As an artist she suffers the same fate as her woven characters (being tricked by Minerva in disguise), and her transformation follows the scenario depicted in the corners of the cloth made by Minerva.[13] As Eleanor Winsor Leach has observed, the fate of Arachne is identified with that of her work, and it is not only the upstart who is destroyed but also her vision, a mortal's perspective of the gods and their justice.

The scenes represented in the frieze make a cautionary example of Arachne while the women shown weaving and spinning under Minerva's tutelage are models of virtue. The groups immediately flanking the central scene provide responses to it. On the right and framed by another loom, three figures of varying ages rush towards Minerva: an old woman is prodded along by a matron who, in turn, draws along a girl (figs. 57 and 58).[14] The figure of the weary old woman is derived from the type of the market woman, usually thought of as a Hellenistic work but more recently identified as a Roman creation of the first century B.C. or the Augustan period, while the matron and girl recall the classical Niobid group with their running poses.[15] In the type of the stooped and haggard market woman, it is both the iconography and the realistic style, particularly the attention to the anatomical effects of aging, that suggest a context in conflict with the once heady aspirations of the young Arachne. The running poses and activated drapery of the matron and her charge are a restrained version of those of the fleeing Niobids, and it is the urgency evoked by the type that is fitting.[16]

[13] Leach (1974), 118.

[14] Von Blanckenhagen, 124, viewed the group including a child as begging for mercy on Arachne's behalf.

[15] G.M.A. Richter, *Catalogue of Greek Sculptures in the Metropolitan Museum of Art*, 111, no. 221, pl. 154. J. J. Pollitt, *Art in the Hellenistic Age*, 142–43 and 146, pls. 151 and 152, for the view that these were originally Hellenistic creations. B. S. Ridgway, *Hellenistic Sculpture*, I, *The Styles of ca. 331–200 B.C.*, 333 and 338, for the Roman attribution. H. P. Laubscher, *Fischer und Landleute: Studien zur hellenistischen Genreplastik*, 32–35, 116–17, cat. no. 38, suggests a date in the first century B.C. N. Himmelmann, *Über Hirten-Genre in der antiken Kunst*, 90, proposes an Augustan date.

[16] M. Bieber, *The Sculpture of the Hellenistic Age*, figs. 264 and 265, for the Uffizi and

This triad is probably intended as bystanders, the local inhabitants, but their composition and types suggest another explanation for their inclusion in the frieze. As an allegorical figure, the old woman, the matron, and the girl portray stages of life or the course of a lifetime. For anyone familiar with the myth, the significance of this group is clear. First, the triad's evocation of the passage of time emphasizes by contrast Arachne's brief career. Secondly, the juxtaposition of Minerva and the elderly woman may allude to the earlier episode when the goddess, appearing incognito as an old crone, warns Arachne.[17] Both Minerva and the stooped old woman represent the authorities whom Arachne has scorned.

In fact, the composition of the group with the oldest member closest to Minerva and the youngest last may also bear meaning. It suggests the dutiful conduct and devotion of the young to their superiors, in other words, *pietas*. In the contemporary coinage, children are depicted in allegorical contexts with personifications such as Pietas (fig. 28).[18] The juxtaposition of this triad with the child and Arachne may serve to emphasize Arachne's lack of pietas. Arachne's punishment illustrates the consequences of her reckless behavior, her disregard of the natural law between man and god. The triad, ostensibly serving as spectators to the scene, instead provides an edifying example.

To the left of Arachne and Minerva, a group of three figures is shown inspecting a piece of cloth, very likely the fabric woven in the contest between the goddess and the mortal, and perhaps originally painted to show a design (fig. 56).[19] Distinguished by her position on a pedestal and the drapery swag above, Minerva is probably depicted displaying her craftsmanship. Below her are two kneeling figures, one who smooths the fabric's nap with an oblong, cylindrical tool, perhaps a pin beater or a beater-in, while the other secures the fabric's edge. Similar poses are seen in the figures of the astragal players known from Hellenistic terracotta figurines in southern Italy (fig. 34).[20] Genre subjects of Hellenistic or Ro-

Vatican type of the fleeing Niobid. The pose but not the drapery is similar to the frieze's figure.

[17] Ovid *Met.* 6.26–43.

[18] A Pietas aureus struck for Domitia represents a personification of Pietas with a male child standing before her. *BMCRE* 2, 312, no. 65, pl. 61.9, probably dating from 81–84). In ritual contexts: *BMCRE* 2, 394, no. 426, pl. 78.8 for a sestertius commemorating the Ludi Saeculares of 88 depicting Domitian with a procession of three children who carry branches.

[19] Ovid *Met.* 6.129–31.

[20] Von Blanckenhagen, 129. R. A. Higgins, *Greek Terracottas*, pl.61A, for Capua, late fourth century B.C. British Museum Catalogue no. D161. The crouching Aphrodite, dated to the late third or early second centuries B.C., also shows this pose. D. M. Brinkerhoff, "Hypotheses on the History of the Crouching Aphrodite Type in Antiq-

man statuary are appropriate models for the frieze's figures because of their informal activities and postures.

Within the narrative framework, this scene precedes the myth's climax in the punishment scene. The frieze, however, does not represent the intervening episode of Minerva destroying Arachne's fabric. Ovid states that Pallas and Livor (Envy) inspected Arachne's work in hopes of finding a flaw.[21] Unsuccessful in this task, the furious goddess ripped Arachne's fabric. Given its juxtaposition with the punishment scene, this group probably represents Minerva brandishing her own work rather than inspecting Arachne's. The former would testify to her mastery of the craft and, therefore, support her summary treatment of Arachne.

The scenes flanking the central episode develop the mythological narrative. The pair of figures further to the left of this same section depicts the theme of Minerva's authority but in a different aspect (fig. 55). The seated figure is distinguished by the drapery swag above and a raised platform, devices that suggest the identity of a deity or a personification. Votive reliefs from the Acropolis in Athens from the late sixth and early fifth centuries B.C. frequently depict female figures seated in profile who are spinning thread (fig. 35), and a Sicilian terracotta relief depicts the goddess holding a distaff.[22] The figures have been identified as Athena Ergane, the goddess of work, but those without the obvious attributes of Athena, the helmet and aegis, should probably be interpreted as depictions of individual or exemplary women, which honor the goddess who watches over their domestic tasks. It is more likely, however, that the frieze's spinner, seated in an attitude of authority, represents Minerva Ergane, Minerva in her role as a worker or, more specifically, as a weaver.

The damaged and badly abraded figure standing before Minerva Ergane extends a smaller distaff towards the goddess, as if to imitate her actions or to receive instruction. As a teacher of domestic skills to the young, the goddess is shown in a benevolent aspect as opposed to her role in the punishment scene in the center of the section. Unlike that illustration of divine wrath, she is shown here in her most rational and responsible role.

uity," *GettyMusJ* 6–7 (1978–1979): 83–96, with bibliography. A. Giuliano, ed. *Museo Nazionale Romano, Le sculture*, 1.1, no. 100, 141–45, and no. 102, 145–46 (O. Vasari), for a statue of the crouching Aphrodite that may date to the Flavian period.

[21] Ovid *Met.* 6.129–130.

[22] Paus. 1,24,3; 1,25–26; 7,5,9. C. A. Hutton, "Votive Reliefs in the Acropolis Museum," *JHS* 17 (1897): 306–18. N. Di Vita, "Atena Ergane in una terracotta dalla Sicilia ed il culto della dea in Atene," *ASAtene* 30–32 (1952–1954): 146–54. S. Stucchi, "Una recente terracotta siciliana di Atena Ergane ed una proposta intorno all'Atena detto di Endoios," *RM* 63 (1956): 122–28. N. Kaltsas in J. Sweeney, T. Curry, and Y. Tzedakis, eds., *The Human Figure in Early Greek Art*, 171, no. 61.

Not only does the depiction of Minerva Ergane counter the image of vengeful Minerva in the center, but the attitude of the woman accompanying her is also distinguished from that of Arachne. Her attitude of an apprentice or a subordinate eager to learn provides a model of exemplary conduct in opposition to Arachne's defiance. This woman acknowledges what Arachne would not: that Minerva possesses mastery in the art of weaving, and that all those who practice the craft are indebted to her.

A passage from Statius, *Silvae* 4.1.22, a panegyric to Domitian, has Janus extolling Domitian, who will always be cloaked in a *toga praetexta* woven for him by Minerva.[23] As suggested in the introduction, it may be that the poet's enthusiasm for the new forum inspired this passage. Yet there is no strict correspondence between the poem and the frieze: Minerva is portrayed as the guardian of women and their work in the imperial forum while the poetic image, implying a more intimate bond between the goddess and emperor, does not figure here.

It is likely that the frieze's depiction of Minerva Ergane with her distaff and spindle implies that Domitian, like his patroness, is also a guardian of the traditional virtues summoned by the task of weaving. The Arachne myth is an effective vehicle for the concerns of the *princeps pudicus*. Devotion to Minerva and, by extension, to Domitian is rewarded, and transgressions are summarily punished.

Furthermore, the pair of weavers at a loom on the right side of the section as well as those carrying a basket of wool continue this representation of obedient and industrious women going about their daily tasks under Minerva's guidance (figs. 57, 59 and 60).[24] The loom, one of three depicted in this section, is a vertical loom with upper and lower beams. This type of loom replaced the warp-weighted loom, perhaps as early as the Augustan period, its chief advantage being that it allowed the weaver to sit because she wove from the bottom of the frame upwards. At the older loom one wove from the top downwards while standing, a method that was still used to make ceremonial garments worn by those undergoing rites of passage, such as the dresses and veils of brides and the tunics of boys assuming the *toga virilis*.[25]

[23] Stat. *Silv.* 4.1.13–15, and 21–22. Picard-Schmitter (1961), 433–450, particularly 450. See introduction.

[24] Von Blanckenhagen, 124 and 127, identified these figures as weavers preparing for Minerva's festival, the Quinquatrus. This cannot be supported by the idealized setting and figural types. For the status and living conditions of woolworkers, see N. B. Kampen, *Image and Status: Roman Working Women in Ostia*, 121–23. Much of it done outside the home was drudgery delegated to slaves. See chapter 3.

[25] J. P. Wild, *Textile Manufacture in the Northern Roman Provinces*, 69. L. M. Wilson, *The Clothing of the Ancient Romans*, 16–23. G. Crowfoot, "Of the Warp-Weighted

The standing figure appears to grasp several of the warp threads (a line incised over the loom's top beam and reaching the figure's hand may represent a part of the bundle of threads) while the figure seated cross-legged on a cushion below points an oblong tool, a spool or a shuttle, upward. They are probably threading the loom, one securing the top, the other the bottom. The poses of the weavers indicate that they are preparing to weave; therefore, they do not participate in the mythological narrative, which is concluded to the left. The slipping drapery of the standing weaver may indicate her nubile state and alludes to the ideological nature of the subject: its representation of the ideal feminine behavior in contrast to that of Arachne.[26]

Not all the stylistic quotations involve the idealization of the subject. The pose of the seated weaver was, no doubt, derived from that of the type of the drunken woman, the original of which may have been in Rome at this time, although the type was well known from copies throughout the Hellenistic and Roman periods (fig. 36). The weaver, however, is without the signs of advanced age and an altered state of consciousness that characterize the representation of the drunken woman, who was probably a *hetaira*.[27] It is interesting that the frieze's sculptors sought models in eclectic works of sculpture, even those that were contrary to the moralizing theme. Perhaps the rarity of the frieze's subject matter required its sculptors to seek models in genre statuary or works of a private character, regardless of the original meaning and context. It should be recalled that one could also view famous Greek masterworks, originally from Nero's collection, on display in the museum setting of the Templum Pacis next door.

The last three figures of this section are arranged in graceful studio poses that are also repeated throughout the frieze (fig. 60). The pose, drapery, and gesture establish stock figural types employed for muses, nymphs, and goddesses, which are also suitable for depictions of idealized matrons. Yet they are often indistinguishable from one another without the refinement of the generic type through the addition of the attribute. In fact, it is the attribute that conveys meaning rather than the

Loom," *BSA* 37 (1936–1937), 36–47. H. Blümner, *Technologie und Terminologie der Gewerbe und Künste bei Griechen und Römern*, 162.

[26] For the slipping drapery motif in representations of Aphrodite and Venus, see M. Bieber, *Ancient Copies*, 46–47, 55–56, on the bibliography of Venus Genetrix. In Greek art this motif appears twice on the Parthenon. Brommer, *Die Skulpturen der Parthenon-Giebel*, pl. 49. Idem, *Der Parthenonfries*, 2, pl. 179.

[27] Pliny *HN* 36.32. Stuart Jones, *Cap.*, 89–90, no. 8, pl. 18. A. Furtwängler, *Beschreibung der Glyptothek Konig Ludwigs I zu München*, 362–64, no. 437, pl. 89. P. Zanker, *Die trunkene Alte, Das Lachen der Verhöhnten*, 32–42. Ridgway (supra n. 15), 337–38, pl. 174, thinks that the type is Roman.

figures' action because the figures are usually shown in attitudes of repose in a scene without an explicit narrative context. In this example, the attributes, the balls of wool and the basket, define the figures' activity in a way that is undermined by their poised and delicate attitudes. They are linked to the mythological scene because they transpose the action into a higher key: the grim punishment is redeemed by the rarefied world of domestic tranquility and cooperation.

Although they are ostensibly bringing a basket of wool to the weavers, the three figures form a self-contained unit. The distinct grouping of figures in pairs or triads in a loose row on the same relief plane with little or no overlapping is typical of the composition. The simple arrangement of the groups and the repetition of poses and gestures enhance the iconic character of the scenes and its mythological subject matter. The background was probably originally painted to depict a landscape setting in the appropriate sections (no doubt, paint was applied to the figures as well).

In summary, the section consists of a central mythological emblem surrounded by contrasting scenes of feminine virtue and its cultivation by the goddess. On the left, Minerva Ergane presides over the education of young women while on the right, the triad of varying ages and the pair of weavers follow the examples provided by the goddess. The groups that do not directly refer to the mythological emblem illustrate its antithesis: they depict young women fulfilling their household duties under the tutelage of Minerva Ergane. On the vertical axis, Minerva dominates as she demonstrates her powers, while the expository scenes and didactic exempla are arranged along the horizontal axis.

My proposal that the frieze represents a central *emblema* surrounded by related scenes can be tested in the sections that flank the center of the bay. In the third section to the left, which forms part of the entablature broken out from the wall, a headless and damaged female figure, seated in three-quarter view on a chair with a footstool, is shown drawing her veil (fig. 45, section 3; figs. 50 and 51). Von Blanckenhagen identifies the figure as Vesta but this cannot be supported without the presence of the Vestal Virgins, the altar and sacrificial instruments or the *palladium*, which accompany depictions of Vesta in official art and coinage.[28]

Although poorly preserved, the frieze's figure, on the contrary, is distinguished by gesture rather than attribute. Instead the figure is a personification of the imperial virtue of Pudicitia. She draws her veil (to cover her face) as do other figures of Pudicitia represented on second-century

[28] Von Blanckenhagen, 122. *BMCRE* 2, 353, no. 258, pl. 68.6, for a *tetradrachm.* G. E. Rizzo, "La Base di Augusto," *BullComm* 60 (1932): 1–109, pl. 2 and pl. C.

coins, often sestertii, of imperial women (figs. 37 and 38).[29] Gesture links Pudicitia with the figure facing her, who responds to the presence of the personification with a raised hand. The woman paying homage to Pudicitia through the iconic gesture of the raised right hand directly counters Minerva's confrontation with Arachne in the center of the bay (fig. 58). This gesture, emphasized by the enlarged hand, and its variants recur throughout the frieze as a leitmotif.[30] It is an act of obeisance that shows a mortal's reverence for a goddess (or personification).

Pudicitia, as a symbol of feminine chastity, was enlisted as a deity of the imperial house by Livia.[31] She was worshipped in at least two shrines in Rome. As discussed in the first chapter, one of these, the shrine of Pudicitia Plebeia, was located on the vicus Longus not far from the Forum Transitorium.[32] Although the cult had been reestablished under Augustus, Domitian also advocated the cult and probably rebuilt the shrine as part of his wider program to reinstitute traditional religion and the Julian laws.

If this is correct, then the personification of Pudicitia in the frieze may represent a local shrine frequented by devout matrons, the type idealized as the figures spinning and weaving in the frieze's adjacent section. The section is composed of two groups: Pudicitia and her worshipper, and three female figures, loosely arranged as a unit although the latter two are turned towards each other as if in conversation (figs. 52 and 53). They are wearing the same garments, a peplos fastened under the breasts, as opposed to the tunic and mantle of Pudicitia and her worshipper. Their position next to a river god nestled in a rocky niche with reeds suggests that they are to be identified as nymphs (fig. 53).[33] This tranquil scene of Pu-

[29] BMCRE, 3, cxxxi, cxxxv, cxxxvi, cl, 355, no. 913, pl. 65.1, gold quinarius for Sabina; 537, no. 1878, pl. 98.18, sestertius for Sabina, from 117–128. BMCRE, 4, cxxxiv, 373, no. 2142, pl. 52.2, sestertius for the younger Faustina; 432, no. 347, pl. 59.8, for an aureus of Lucilla Augusta, from 164–69. As depicted in Attic vase-painting, the gesture of lifting the veil (to reveal the face) may indicate sexual availability. R. F. Sutton, The Interaction Between Men and Women Portrayed on Attic Red-Figure Pottery (Ph.D. diss. Chapel Hill, 1981), 165–66. G. Neumann, Gesten und Gebärden in der griechischen Kunst, 41 n. 134. In Roman art, however, the gesture of drawing the veil (to cover the face) usually expresses modesty or chastity. The first reference to Pudicitia appears on a Trajanic denarius of Plotina from 112–115 that represents an ARA PUDIC(ITIAE): BMCRE 3, 107, no. 15, pl. 18. Hadrian introduced the personification in coinage but, perhaps, the frieze's figure was among those that established the numismatic type. E. D'Ambra, "Pudicitia in the Frieze of the Forum Transitorium," RM 98 (1991): 243–48.

[30] R. Brilliant, Gesture and Rank in Roman Art, 102.

[31] Val. Max. 7.1. Livy 10.23.1–10.

[32] Palmer (1974), 114 and 142. See chapter 1.

[33] Von Blanckenhagen, 123–24.

dicitia, her worshipper, the nymphs and river god illustrates the devotion to the gods and observance of their rites, the world from which Arachne has been excluded. The nymphs as ideal feminine types recall the figures of women weaving under the auspices of Minerva Ergane, the models of time-honored tradition, in the central section.[34]

Domitian's cultivation of these old-fashioned attitudes is well-documented. Even his monetary policy of 82, which increased the standards of precious metal coinage to the level set by Augustus, was part of his campaign to recover the past by restoring the old criterion of value.[35] Domitian's vision of the future depended on his interpretation of the past.

In the opposite section that forms the right side of the bay, other imperial virtues may be represented as well (fig. 45, section 5; figs. 61–64). The first three figures have been entirely removed from the section yet one can reconstruct the figure types from the remaining contours of the frieze. Again, a reclining river god located the scene in an idyllic, bucolic world. The two other non-extant figures, one seated and the other standing under drapery swags, may have represented a personification of Pietas accompanied by a child as depicted on contemporary *denarii* (fig. 28).[36] As stated above, Pietas is important for Domitian's dynastic aspirations and also appropriate to the theme of the Arachne myth.

The extant headless figure on the right holds a set of scales over a tall wool basket (similar in shape to the one shown on the fourth section between Minerva and the old woman). Flanking her, another female figure displays a piece of fabric or a few balls of wool caught up in a section of her mantle (fig. 64).[37] According to von Blanckenhagen, the scene is continued from the central section, which represents the weavers preparing for Minerva's festival, the Quinquatrus.[38] Yet the presence of the river god and the drapery swags suggests a different meaning.

The figure with the balance is similar to that of another imperial virtue depicted on the coins of Titus and Domitian (fig. 39 depicts an *as* of 86).[39]

[34] E. Paribeni, "Ninfe, charites e muse su rilievi neoattici," *BdA* 36 (1951): 105–11. D. K. Hill, "Nymphs and Fountains," *Antike Kunst* 17, pt. 2 (1974): 107–08. C. M. Edwards, *Greek Votive Reliefs to Pan and the Nymphs* (Ph.D. diss., New York University, 1985).

[35] I. Carradice, *Coinage and Finances in the Reign of Domitian, A.D. 81–96, B.A.R. Int'l. Series* 178, 163.

[36] For the Pietas denarius, see *BMCRE* 2, 312, nos. 65 and 66, pl. 61.9, dated to 81–84; 347, no. 247, pl. 67.14, for a denarius of 94–96. Scott, 73.

[37] G. Zimmer, *Römische Berufsdarstellungen, AF* 12, 82, on the source for this figure in one of the depictions of clothmakers on the shop sign of Verecundus in Pompeii.

[38] Von Blanckenhagen, 125–26.

[39] *BMCRE* 2, xlviii, xc, 384, no. 389, pl. 76.3 for an *as* of 86. J. R. Fears, "The Cult

She often represents Moneta or Aequitas, personifications of the imperial mint and its policies. The message conveyed by the personifications signals equitable and sound government, a theme relevant to the punishment scene of the central section in its affirmation of justice. Picard-Schmitter considered the frieze's figures to be Fates, Lachesis and Atropos, who honor Minerva in her rendering of divine justice. The Fates are from the vocabulary of private funerary art rather than that of the official iconography, and the attribution of an imperial virtue is more likely to be correct because of the depiction of Pudicitia in the opposite section (fig. 45, section 3).[40] Minerva rightfully avenged her honor, and Arachne deserved her penalty. The attributes of woolwork, the basket and the fabric or balls of wool, attest to the moralizing context of the Arachne myth.

The related themes of transgression, punishment, and justice may be determined partly by the Forum Transitorium's function as a site of law courts.[41] Several references in the poetry of Martial and Statius indicate that trials took place here as they commonly did in the other fora. Given the poets' consensus on the Forum Transitorium as a seat of law courts, the representation of a figure holding a balance must have been significant for the site. Another layer of meaning is apparent: the emblem of divine punishment, along with the personification of justice, give visual expression to Domitian's reputation as a staunch supporter of law and order, to his policies to eradicate corruption in the courts.

Several general principles are apparent from this analysis of the frieze so far. The organization is hierarchical, with the representations of the goddess in the attic relief and in the mythological scene below forming the vertical axis, the dead center of the bay, around which the other figures are grouped. The mythological narrative is abbreviated into an emblematic device, the climactic scene of the punishment of Arachne, and the narrative is extended by expository scenes that either refer to the plot or provide glosses on it. The group of three women rushing to Arachne is an example of the former while the depiction of Minerva Ergane is the latter. Models of socially sanctioned behavior are shown in action at the loom or depicted as personifications of imperial virtues such as Pudicitia or Moneta (Aequitas). The narrative is allusive, glimpsed through discrete references, and elaborated by a conflation of different motifs, per-

of Virtues and Roman Imperial Ideology," *ANRW* 2.17.2, 901–02, on Domitian's Moneta types and their demonstrations of the regime's "fair dealing."

[40] Picard-Schmitter (1966), 607–16. Picard-Schmitter (1961), 435–40. For examples of depictions of the Parcae or the Fates in funerary art, see Stuart Jones, 1: 314, no. 3, pls. 78 and 82. G. Calza, *La necropoli del Porto di Roma nell'Isola Sacra*, 123–25, figs. 53–55. A. Wallace-Hadrill, "The Emperor and his Virtues," *Historia* 30 (1981): 298–323.

[41] See chapter 1.

sonifications, genre subjects, and allegorical figures.[42] The mythological emblem would have been immediately recognizable, as would the secondary figures that are, after all, based on stock types.

Virtually all the figures in this bay of the frieze represent the antithesis of Arachne, who is shown already defeated, kneeling before Minerva. The principle of antithesis works on more than one level: Minerva punishes Arachne, and the flanking scenes demonstrate the rewards of living within the *mores maiorum*; the impious Arachne is surrounded with exempla of *pietas* and *castitas*. In the former, Minerva's authority is reasserted and, in the latter, feminine virtue is defended. Minerva and Domitian, by implication, are strict guardians of ancestral customs who preserve the balance between the human and divine orders.

The remaining sections are located on either side of the extant bay (fig. 45). These tend to represent deities in landscapes characterized by personifications and, in contrast to the sections of the extant bay, the settings seem to be specifically sited in Rome.[43] In some sections, they are shown accompanied by worshippers who express their reverence through gesture or who prepare for rites. The scenes correspond in theme: fertility is evoked through the motifs of flowing water and milk, and imperial or domestic virtue is suggested by the loom and wool that are shown in another section without the trappings of the Arachne myth. If the center of the bay depicts Arachne as an artisan who challenges Minerva, then the theme of cultural conflict is contrasted with that of the natural world yoked to the imperial system in the following panels.

The sixth section, placed over the column on the southern side of the bay, depicts a cultic scene (see figs. 45, section 6; figs. 65–67). The first figure, which is almost completely defaced along with the broken corner of the relief, is shown moving to the right; above her a large-lobed leaf, most likely a fig leaf, is carved at the edge of the broken block. To the right, the upper torso of an exceptionally well preserved female figure is seen from behind a rocky ledge (fig. 67). The figure looks down at her chest where her right hand cups the milk trickling from her left breast in a pattern of wavy lines. Propped on the rocky ledge, the figure should be identified as a fertility goddess with a shrine on or near a hill. Juno Lucina and her shrine on the Esquiline received the offerings of women who wanted to bear children, yet the scene lacks a representation of an infant

[42] T. Hölscher, *Staatsdenkmal und Publikum*, 17, on the device of allegorical conflation used in the monument erected on the Capitol for Sulla in 91 B.C.

[43] Similar motifs of figures perched on hilltops are shown in the so-called Neo-Attic reliefs. T. Schrieber, *Hellenistische Reliefbilder*, pls. 90 and 44. J. Sampson, "Notes on Theodore Schreiber's *Hellenistische Reliefbilder*," *PBSR* 62 (1974): 27–45, and particularly 43, n. 80, for a supplementary list of reliefs and bibliography.

or torch, the characteristic attributes of this goddess.[44] Through the motif of the fig tree above the rocky height, one may identify the figure as Rumina, the deity of nursing mothers.[45]

There is a venerable tradition of the *kourotrophos* in Etruscan art that influenced depictions of Roman goddesses. An anecdote recounts that Caligula's baby daughter Drusilla suckled a statue of Minerva, perhaps a representation of Minerva Mater, who was to oversee her education and development.[46] Usually characterized as a virgin warrior, Minerva in her role as mother, an Etruscan adaptation, is also appropriate to the Arachne myth, the tale of the downfall of the motherless weaver, even if not represented in the extant frieze. Rumina may be seen to complement this lesser-known aspect of Minerva.

Rumina's shrine, which was believed to have been restored under Augustus, was located by a fig tree at the base of the Palatine near the spot where Romulus and Remus were supposedly suckled by the she-wolf (here the figure is placed atop the hill probably for greater visibility). A fig tree marked the site because its fruit gives a white, milky juice. The two women working over a table or plank below are probably preparing for the rites of Rumina, perhaps cutting a rod that they have taken from the tree (fig. 66). The garment of the one figure, which leaves her breast exposed, may indicate her participation in the cult or may simply emphasize the cult symbolism characterized by the bare-breasted Rumina.[47]

If the position of a section is significant for its subject matter, then the other section marking the architectural division of the extant bay should also portray a relevant deity and, indeed, Venus dominates the second section (fig. 45, section 2; fig. 49). Venus is a composite of various types including, among others, the Venus Victrix and the so-called Venus of Capua.[48] She stands in the center of a group with two other female fig-

[44] W. Amelung and G. Lippold, *Die Skulpturen des Vatikanischen Museums*, 1:809–10, no. 731A, pl. 86. H. Brunn, "Giunone Lucina, bassorilievo del Museo Vaticano," *AnnInst* (1948): 430–38, pl. N. Ovid *Fasti*, 2.435ff. and 3.248–58. Von Blanckenhagen, 125, tentatively identifies the lactating figure as a nymph of a fountain because of water's utility to textile workers. Yet he also recognized the significance of water for cult practices. Von Blanckenhagen, 123, identifies another figure in the second section as Juno Lucina but this is unfounded.

[45] Varro *Rust.* 2.11.5. Festus *Gloss. Lat.* 270M. Pliny *HN* 15.77. Plutarch *Quaest. Rom.* 57. Ovid *Fasti* 2.380. W. Warde Fowler, *The Roman Festivals of the Period of the Republic*, 310–11. A. M. Franklin, *The Lupercalia*, 18–19, and 62. Platner-Ashby, 321.

[46] Suet. *Calig.* 25.7. R. Enking, "Minerva Mater," *JdI* 59–60 (1944–1945): 111–24. L. Bonfante, "Caligula the Etruscophile," *Liverpool Classical Monthly* 15 (1990): 98–100. Idem, "Iconografia delle madri: Etruria e Italia antica," in A. Rallo, ed., *Le donne in Etruria*, 85–106. I thank Larissa Bonfante for sharing these with me.

[47] For the motif of the slipping drapery, see supra n. 26.

[48] In the coinage, Julia Titi also assumed the identity of Venus. Mattingly, *BMCRE* 2, 247, no. 141, pl. 47.15, for a denarius dated to 80–81.

ures, now headless like Venus, and gestures to a hill personification whose badly damaged figure can be seen on the left edge of the relief above a rocky outcropping. The gesture of the hill personification appears to be one of reverence, and that of Venus, an acknowledgment of it.

Von Blanckenhagen identifies Venus as the Venus of the Cloaca Maxima but, although this shrine is close to the Forum Transitorium, it bears no relationship to any hill and, clearly, the reciprocal gesture between the elevated figure and the goddess is central to the scene.[49] The female figure atop the hill may be a personification of the Aventine because of its proximity to several Venus shrines located below in the Circus Maximus. The Aventine is also significant as the site of the first Temple of Minerva.

One of these Venus cults is of particular significance. The Temple of Venus Obsequens was located near the Forum Boarium at the Tiber end of the Circus Maximus.[50] The temple was founded by money from fines extracted from women charged with crimes of adultery in 295 B.C. This cult of Venus the "obedient" is relevant for the frieze because of its relationship to the cults of Pudicitia, one of which is referred to in the adjacent section. Fabius Maximus built the temple of Venus Obsequens, probably in imitation of his father's dedication of the shrine of Patrician Chastity in the Forum Boarium in 331 B.C. Both the cults of Pudicitia, Patricia or Plebeia, and Venus Obsequens reflect the state's promotion of moral standards in response to a crisis or decline.

The frieze's Venus may represent Venus Obsequens or even a conflation of several Venus shrines. The historical connection between cults enshrining feminine virtue, Venus Obsequens and Pudicitia, is asserted through their representation in adjacent sections in the frieze (fig. 45, sections 2 and 3). Located on the same side of the bay, the depictions of related cults reinforce the hortatory messages against adultery or other forms of illicit and seditious behavior as illustrated in the central mythological scene.

The two draped female figures who flank Venus are probably not Juno Lucina and Diana, as von Blanckenhagen has proposed, because they lack the typical attributes but, rather, a priestess or attendant and perhaps a minor mythological figure such as a muse.[51] The cross-legged pose and

[49] Von Blanckenhagen, 121. See R.R.R. Smith, "The Imperial Reliefs from the Sebasteion at Aphrodisias," *JRS* 77 (1987): 88–138, on hill personifications.

[50] Platner-Ashby, 552. Palmer (1974), 134–35. The other temple in the Circus Maximus was that of Venus Verticordia. It was erected in 114 B.C. to atone for the crime of incest among the Vestal Virgins after a *prodigium* followed the acquittal of two Vestals at their first trial. Pliny *HN* 15.119. Platner-Ashby, 554–55.

[51] Von Blanckenhagen, 121–23. Rizzo (supra n. 28), pl. 3, side B. The cross-legged pose by itself is not sufficient to characterize the figure as Diana. O. Bie, *Die Musen in*

leaning posture of the figure on the right is characteristic of depictions of the muse Polyhymnia or of nymphs. The heavily draped figure to the left recalls commemorative portraits of matrons or priestesses, the types that would attend the goddess in this shrine.[52]

On this side of the bay, Venus complements the personification of Pudicitia and the nymphs as feminine ideals of grace and beauty. Pudicitia sternly safeguards the institutions of marriage and the family, while female sexuality and fertility are represented by Venus and Rumina, placed in corresponding positions at either end of the bay. The splitting of the female deity is characteristic of Greco-Roman mythology, and the alluring Venus and the motherly Rumina represent two aspects of femininity, securely differentiated and sanctioned by their service to the state and by the cult rituals that set standards. Rumina is also adjacent to Moneta (Aequitas), implying that just imperial policy brings prosperity and ensures the well-being of the succeeding generations. The sections located on the ends of the broken entablature share a similar compositional format with a personification or goddess in an elevated position and three female figures below. The frieze's division into bays provides a setting for this diffuse arrangement of central and flanking scenes.

Venus, Pudicitia, Rumina, and Moneta (Aequitas) all share broad historical allusions to the first dynasty, the Julio-Claudians, and to the legendary founders of Rome, Aeneas, and Romulus and Remus.[53] Coins were the popular medium used to convey these themes: Pudicitia, Venus Augusti, and Moneta (Aequitas) are represented by coin types while Rumina is reflected in those that show the she-wolf suckling Romulus and Remus. Venus Augusti and Pudicitia were elevated by Augustus and Livia to become deities of the imperial house. The religious foundations of the state are symbolized by these figures, who refer to Rome's heroic beginnings, its tutelary divinities, and ancestral values. Not only is the piety of the Flavian house acclaimed by the depiction of these figures but its return to the principles of the Augustan regime is also evoked.

The first section facing the Forum's entrance to the Subura also represents the propitiation of the gods (fig. 45, section 1; figs. 46–48). The

der antiken Kunst. D. Pinkwart, *Das Relief des Archelaos von Priene und die 'Musen des Philiskos'.* Bieber (supra n. 26), pls. 126–27. The cross-legged pose is also seen on Greek funerary reliefs, most notably the Ilissos Relief, as well as on the Parthenon frieze. See N. Himmelmann-Wildschutz, *Studien zum Ilissos-Relief.*

[52] Bieber (supra n. 26), pl. 97, figs. 586, 588; pl. 102, figs. 612, 613, 615, 616; pl. 103, on the types used for the portraiture of matrons (the so-called Pudicitia type). Also, Zanker (1988), 162, on the moral significance of matrons' garments.

[53] K. Galinsky, *Aeneas, Sicily and Rome,* 203–41, on the relationship of Venus to the Julio-Claudian house. *BMCRE* 2, 43, no. 241, pl. 7.9. This denarius was struck for Domitian in 77–78. Supra n. 29.

scene takes place in Rome. Whereas most of the figures in the other sections are female, the three figures here are male. Two of these are personifications or deities: the one emerging from the rocky cliff near the spring or brook is a deity while the one reclining below is the personified Tiber river.[54] Although the river god lacks specific attributes, his identity as the Tiber can be determined through a comparison with the Antonine Palazzo Rondanini relief (fig. 40).[55] The Antonine relief depicts water flowing down a steep, rocky background to the river god below. The snake of Asklepios identifies the Tiber island above and, therefore, the river god represents the Tiber.

In the Palazzo Rondanini relief, the Tiber personification holds out a *patera* to collect the stream of water pouring down on him. Von Blanckenhagen observed a similar spatial relationship between the cascading stream and the river deity in the frieze, and identified the figure above as Fons, the deity of fountains and springs, and the figure below as his grandfather, Volturnus, who is synonymous with the Tiber in Rome.[56] Yet the figure emerging from the rocks is distinguished by his position and resembles a hill personification or a deity with a hilltop cult as depicted in the second and sixth sections of the frieze (although these personifications are female).

A likely candidate for the frieze's figure is a deity associated with both a hill and water. Furthermore, the steep rocky background with a torrent of water rushing down to the Tiber approximates the later Palazzo Rondanini relief. Semo Sancus Dius Fidius is appropriate as an old Roman god worshipped in temples on the Tiber Island as well as on the Quirinal. (As discussed in the first chapter, the Quirinal temple contained a bronze statue of Tanaquil, who is represented with her spindle and distaff displayed as relics of the chaste matron.)

Not only is the cult of Semo Sancus appropriate to the subject matter of the frieze's other sections but its Quirinal temple is located near the Flavian dynastic temple, as well as near the shrine of Pudicitia Plebeia.[57] Von Blanckenhagen interpreted many of the figures as deities worshipped at local shrines.[58] Yet, as shown above, some of his attributions are unconvincing and the frieze cannot be read as a symbolic map of craftsmen's

[54] For the Tiber personification on a Domitianic coin, see J.M.C. Toynbee, *The Hadrianic School*, 115, pl. 16, fig. 9.

[55] Ibid., 114, pl. 27, fig. 2. L. Salerno and E. Paribeni, *Palazzo Rondanini*, 211, no. 25, fig. 120.

[56] Von Blanckenhagen, 120–21. On hill personifications, see A. Alföldi, *Aion in Merida und Aphrodisias*, fig. 4.

[57] See chapter 1.

[58] Von Blanckenhagen, 118–27.

shrines in the Forum area. Perhaps the deities represented designate various sites of particular significance to Domitian without conforming to any coherent topographic scheme. In fact, Domitian's esteem for historically evocative sites is witnessed by his revival of the archaic festival of the Septimontium and his rebuilding of quarters of the city as commemorated by the Arae Incendii Neronis.[59]

Furthermore, Semo Sancus Dius Fidius was thought to be a progenitor of the Sabine race and served as a god of alliances and treaties as his epithet Fidius indicates.[60] As mentioned in the introduction, the Flavians came from the Sabine town of Reate, modern Rieti, and their choice of a seat in Rome on the Quirinal, the old Sabine settlement, probably reflected this heritage. If the frieze's figure depicted Semo Sancus in his shrine on the Tiber Island, then it would evoke the Sabine contribution to Rome as well as the trust that is the prerequisite of good government. This deity and the Tiber god receive the worship of the figure in exomis who approaches them with outstretched hand, an act of obeisance.

The exomis of the third figure, a laborer, is a short, sleeveless tunic rolled at the waist and exposing most of his chest (fig. 48). Similar abbreviated dress is seen in other sculptures portraying peasants, such as the type of the old fisherman.[61] Another parallel for the garment is found in a fragmentary contemporary relief from the vicinity of the Theater of Marcellus that represents Minerva Ergane visiting a carpenter's workshop (fig. 41).[62] Two figures in this relief, the one standing at the sawhorse and the other lifting an object onto a table, wear the exomis but they are shown absorbed in the work at hand, seemingly oblivious to the goddess on the left. The frieze's figure, however, is displaying reverence to the deity before him.

The laborer approaches the others on the left with his right arm raised, his hand outstretched in the gesture of adoration. Nothing remains of his left arm beyond a short stump draped with a part of the exomis, but the edge of an object attached to the figure's left thigh may indicate a pail or pitcher carried to fetch water. Von Blanckenhagen considered the figure

[59] R.E.A. Palmer, "Jupiter Blaze, Gods of the Hills, and the Roman Topography of CIL VI, 397," AJA 80 (1976): 43–56, especially 51–52, on Domitian's celebration of the old Septimontium and his rebuilding of the city after the fires of 64 and 80 and the fighting of 69. See chapter 1.

[60] RE 1.2, "Sancus," 2252–2256 (Link). Roscher, vol. 4, "Sancus," 316–19 (Wissowa). Scott, 78 and 185–86.

[61] Bieber (supra n. 16), fig. 592. Stuart Jones, 2:144, no. 27, pl. 50. Laubscher (supra n. 15), 49–58. Pollitt (supra n. 15), 143–46.

[62] A. M. Colini, "Officina di fabri tignarii nei frammenti di un'ara monumentale rinvenuti fra il Campidoglio e il Tevere," Capitolium 22 (1974): 21–28. Schürmann, 58–62.

to be a fuller who is propitiating Fons for the water necessary to his craft.[63] The scene thus serves as an introduction to the theme of Minerva's tutelage of craftsmen in the textile industry.

On the contrary, fullers usually commemorated themselves as craftsmen in their funerary reliefs by emphasizing the equipment of the trade: huge vats, ovens for drying the wool, and frames for sulphuring or bleaching the cloth (fig. 42).[64] Even if an idealized depiction of the craft, the frieze should indicate the fuller's profession through a tool or prop. A pail or pitcher in the figure's left hand would not be specific enough because these utensils were also used in rituals. Rather than representing water only as a resource of certain artisans like fullers, it is more likely that its widest possible meaning is evoked: the substance that is necessary for life becomes the symbol of life itself, of fertility, abundance, and prosperity. The presence of the laborer suggests that the fruit of Domitian's policies benefited the lower social strata as well.

The seventh section of the frieze, which forms part of the other bay, also depicts a ritual event (figs. 45 and 68–72). The repeated poses and actions within the scene, the symmetrical composition on the left, and the group of observers lend the scene an iconic air. On the left side, there are two pairs of seated and standing figures interrupted by a figure between them who is either winding wool or decorating a shrine (figs. 69 and 71). The first seated figure also is handling wool, with a gesture similar to one depicted in a Roman tomb painting known from a drawing published by Ashby in 1914, which has a youth seated in profile and holding or wringing one fillet band from a row suspended from a frame (fig. 43).[65] Like the youth in the painting, the first figure sits in profile and holds an object hanging from above, a ball of wool probably attached to the frame behind (fig. 69). Thus the seated figure is pulling the bundle of threads or taking them to show the figure standing before her.

The cult of Diana at Aricia, modern Ariccia, like that of Juno Lucina on the Esquiline, governed aspects of women's lives.[66] Women worshippers formed torchlit processions to the temple and left votive plaques and offerings, especially threads hung over a fence, to ensure the goddess's

[63] Von Blanckenhagen, 120.

[64] Zimmer (supra n. 37), 27–28, with bibliography. Kampen (supra n. 24), fig. 79.

[65] T. Ashby, "Drawings of Ancient Paintings in English Collections," *PBSR* 8 (1914): 1–62, pl. 3. The tomb was located near S. Maria della Navicella.

[66] A. E. Gordon, "The Cults of Aricia," *CPCA* 2 (1953): 1–20. F. Coarelli, *I santuari del Lazio in età repubblicana*, 165–85. E. Gullberg and P. Astrom, *The Thread of Ariadne, Studies in Mediterranean Archaeology*, 21, 44–47, on the hanging or wrapping of wool or thread on columns or on buildings. The wool may have served as a protective barrier to ensure the purity of these structures.

favor. As the virgin goddess who protected both wild animals and young unmarried women, Diana presided over initiation rituals for untamed nubile girls. In Greece the shrine of Artemis at Brauron was decorated with spindles and loom weights, and temple inventories indicate that woven textiles and garments were also dedicated to the goddess, who guided young girls through adolescence towards the socially sanctioned roles of marriage and motherhood.[67] The weaving motif figures prominently in the training and indoctrination of young women (a child-sized weaving implement has been found at Brauron).

Among the garments dedicated to Artemis or to the Roman Diana were girdles. The girdle was taken off at strategic moments for the bride and matron, the defloration of the wedding night and childbirth. For the virgin the loosening of the girdle was preparation for the acts that defined her as a woman, that marked her maturity. According to the ancient medical authorities, the removal of the girdle for sexual intercourse allowed the flow of blood that might otherwise be blocked and cause the young woman to strangle herself. If she resisted marriage, the virgin could also use the girdle as a noose in a bloodless death that exempted her from the sexual initiation that lay ahead.[68] The hanging motif is a significant aspect of Arachne's punishment because she, like the suicidal virgins of the medical texts, is an *unnatural* woman who is trapped in maidenhood, a woman's first stage of development; but Arachne, unlike the others, is returned to nature as the spider spinning her web—it is not enough that she should exemplify a state of arrested development.

Although her standard attributes are not shown, it may be that the first seated figure is Diana but not the goddess of Aricia; rather, the Diana worshipped in Rome. Diana of the Aventine also protected women and her temple was so closely identified with its site that the hill was called *collis Dianae*.[69] Diana's cult on the Aventine was important because of its antiquity and its Augustan restoration, and its depiction here would have complemented the scene of Minerva's temple on the Aventine in the eighth section.

The focus is on the piety of the anonymous female figures, with Diana preparing for the weaving depicted in the following section. The third

[67] S. G. Cole, "The Social Function of Rituals of Maturation: The Koureion and the Arkteia," *ZPE* 55 (1984): 233–44.

[68] H. King, "Bound to Bleed: Artemis and Greek Women," in A. Cameron and A. Kuhrt, eds., *Images of Women in Antiquity*, 121. Also, Cantarella (supra n. 11), 57–67. Apul. *Apol.* 68–69.

[69] Mart. *Epigr.* 7.73.1; 12.18.3. E. Simon, *Augustus. Kunst und Leben in Rom um die Zeitenwende*, 103–4, on the Augustan restoration of the Temple of Diana on the Aventine, which was undertaken by L. Cornificius.

figure is draping threads or roves of wool on an enclosure or frame (figs. 69 and 71).[70] Her outfit, the mantle rolled as a thick sash at her waist, is one that was worn by cult acolytes.[71] She may be unwinding or stretching the yarn from the ball of wool that the first seated figure, Diana, is holding. The other pair appears to be mimicking the actions of goddess and worshipper.

The motif of a triad appears again in this scene with the group under drapery swags on the right. The reactions of the figures, who stare and point at the others making ritual preparations, suggest that the activity of the scene is exceptional (fig. 72). Enhancing the solemnity of the occasion is the gesture of the seated figure who clasps her right hand to her chest in the gesture of oath-taking.[72]

Perhaps the gesture indicates that she is making a personal vow. In the sphere of private worship, the gods are propitiated by vows and simple gifts. The activity depicted on the left may be seen as a prelude to an offering, while the seated figure to the right makes a vow to the presiding deity. On the other hand, it may be that this scene is a pendant to the adjacent eighth section that depicts Minerva at her Aventine temple.

The eighth section, which is in a position similar to the long fourth section placed above the Forum's perimeter wall, contains elements from the wool-working theme of the fourth section and from the idyllic tableau of the third section (figs. 45 and 73–81). Minerva is depicted enthroned in a landscape identified by a reclining personification and populated by her devotees, including two women at a loom (figs. 80 and 81). Clearly the representation of the loom has nothing to do with a workshop setting or even a craft festival as von Blanckenhagen had proposed but, rather, forms part of this ideal, sylvan world with young women or nymphs learning the craft under the tutelage of their patron, Minerva.[73]

[70] Prop. 4.6.6: "three times around the hearth wind the fillet of wool." This is intended as decoration for a celebration in 28 B.C. at the Temple of Apollo on the Palatine. Tac. *Hist.* 4.53, on the Capitol decorated with fillets and garlands as part of the opening ceremony of its restoration. *Taeniai,* flat ribbons and round tubular fillets, occur in other religious contexts as a means of protection or purification, also appropriate for tombs and stelai.

[71] O. Brendel, "The Great Frieze in the Villa of the Mysteries," in O. Brendel, ed., *The Visible Idea, Interpretations of Classical Art,* 93, observed that the mantle worn on the hips characterized acolytes in Dionysiac scenes.

[72] *RE* vol. 6, "Fides," 2281–86 (Otto). Roscher vol. 1, "Fides," 1481–83 (Wissowa). *BMCRE* 2, xci and xcii, 373, no. 348, pl. 73.7; 377, no. 363, pl. 74.7, for *dupondii* of 85 representing Fides. G. Piccaluga, "Fides nella religione romana di età imperiale," *ANRW* 2.17.2 (1981): 703–35. M. Torelli, *Typology and Structure of Roman Historical Reliefs,* 10.

[73] Colini (supra n. 62), 21–28, for a contemporary relief depicting Minerva visiting a workshop. B. M. Felletti Maj, *La tradizione italica nell'arte romana,* 334, pl. 69, figs.

The repetition of the loom in the sections along the perimeter wall raises the possibility that, again, the Arachne myth is portrayed in this section of the frieze. The figures moving down from the rocks on the left could be the nymphs that Ovid describes as being lured from the hills and woods to watch Arachne weave (figs. 74, 75 and 76).[74] Yet the procession of nymphs aproaching the loom is interrupted by the depiction of the goddess enthroned in the center near the olive tree that marks her sanctuary (figs. 77 and 78). This type of the enthroned Minerva, also represented in the minor arts such as the first-century silver plate from Hildesheim (fig. 44), indicates that the goddess is in her domain.[75]

The pair of figures casually standing before Minerva seem to offer her something, and this exchange mirrors that of the second pair of figures in the adjacent seventh section. Perhaps they are showing the goddess the wool that is spun and wound in the flanking scene (the object in the figure's hand appears to be the oblong end of a fillet or rove of wool but the marks on the panel above seem to trace the outline of a tool or a branch). The wool then is used to thread the loom depicted on the right side of the eighth section (figs. 80 and 81). The pair of standing and seated weavers are in analogous poses to those of the central section but here the standing weaver appears to be pulling a bundle of threads over the loom's upper beam, perhaps in order to begin threading the loom. The wool, either a bundle of threads or even a fillet, may also have been hung on the loom as an offering to the goddess, an appropriate act given the cult setting and the activities represented at the Temple of Diana in the adjacent section.

Yet the subject matter of this section has much in common with the others of the frieze. A goddess, seated in profile, is approached by a suppliant. Again, the landscape elements indicate a specific site through the reclining personification, perhaps of a road on the Aventine, and the olive tree sacred to Minerva (figs. 75, 77 and 78).[76] The figures, particularly

169 a, b, for a painting of a procession in honor of Minerva's Quinquatrus held in a carpenter's workshop. Naples, Museo Nazionale. Pompeii, R 4, 33, via di Mercurio.

[74] Ovid *Met.* 6.15–16.

[75] E. Pernice and F. Winter, *Der Hildesheimer Silberfund*, 21–24, pls. 1–2. U. Gehrig, *Hildesheimer Silberfund*. Von Blanckenhagen, 126–27, observed that the women gathered around Minerva were not in the proper attitudes of mortals before deities and, therefore, were meant to represent not Roman women but nymphs. He interpreted the scene as showing the celebration of the first Quinquatrus at Minerva's temple on the Aventine.

[76] *BMCRE* 2, 407, no. 478, pl. 81.2, for a *dupondius* of 95–96, the reverse of which depicts Minerva's helmet and shield before an olive tree. The reclining personification may represent a street, rather than the Aventine. Suggestions for its identification are the Clivius Publicius connecting the Forum Boarium to the Aventine or the vicus Portae Raudusculanae that continues the vicus Piscinae Publicae on the eastern part of the

those climbing down the rocks and leaning on pillars, resemble the types of nymphs or muses discussed above (fig. 76). Rather than a specific mythic event, this scene probably represents Minerva in her cult center on the Aventine.

The only departure from the other sections is the depiction of an architectural element, the arched entrance to the right of the loom (figs. 80 and 81). Without the rest of the broken section, it is difficult to tell whether this represents a gate to the precinct or to another part of the city.[77] The arch may also have served as a scenic divider in the section, and the lost section could have shown a scene occurring on its other side. In this way, representations of activity inside and outside of Minerva's domain would have been contrasted.

In conclusion, the subject matter of the extant bay of the frieze is organized around a central mythological scene, the punishment of Arachne. Presented as a cautionary tale, the narrative is abbreviated into its climactic event, the punishment scene, which is fashioned into a bold emblem signaling the goddess's wrath. The other figures, women weaving, goddesses, and personified virtues, idealize the traditional domestic role of the matron as the domain of Minerva and, more importantly, as the cornerstone of society. The drama of the central mythological emblem is diffused by the quiet and picturesque scenes of women weaving or spinning under Minerva's guidance and the flanking sections that depict imperial virtues in idyllic settings.

The contrast was intended to exhort the viewer to follow the *mores maiorum*; however, it more likely served to rekindle nostalgia for the remote past even in the late first century. The frieze gave visual expression to Domitian's advocacy of moral reform, particularly in regard to the *lex Julia* and the cult of Pudicitia; but these policies, like those of Augustus, failed and did not check illicit behavior or restore civic values. Nor could the program be expected to work, because it attempted to retrieve what never existed in the first place: the pristine virtues of traditional society always resided in a Rome that was long gone.

The other bay, only partially extant, focuses on the pacific Minerva receiving her devotees and their gifts of wool in stately splendor. The

Aventine. Platner-Ashby, 124 and 65. For other personifications of streets in Roman art, see Stuart Jones, *Cap.* 51, no. 8, pl. 10; I. S. Ryberg, *The Panel Reliefs of Marcus Aurelius*, 32, pl. 22, fig. 18; E. Angelicoussis, "The Panel Reliefs of Marcus Aurelius," *RM* 91 (1984): 141–205.

[77] If the reclining personification represents a street leading up the Aventine, then the arch could be a nearby gate such as the Porta Trigemina or the Porta Raudusculana. Platner-Ashby, 418 and 414. It is interesting that the loom is set up against an exterior wall because weaving was often done outdoors in antiquity. Wild (supra n. 25), 62, 69.

events are charged with a significance befitting the rarefied atmosphere of the Aventine with its sacred olive tree. Although the moralizing exempla of the first bay are not in great evidence here, two devotees are shown in the admirable activity of threading a loom and the one extant flanking section depicts the preparation of the wool presented to the goddess. If the first bay indicates the triumph of the goddess over a rebellious mortal, then the second bay depicts the rituals of power in the goddess's sanctuary, the presentation of votive gifts, the gathering of onlookers, and the goddess's possession of her domain. The divine realm is also characterized by the elegance and grace of the figures descending the rocks on the left, as well as by the static quality of the procession, which proceeds with pauses and half-halts, leading up to Minerva.

Again, the center of the section forms a self-sufficient unit that recalls the imagery of coins, medallions, or emblema inserted in mosaics. The group of Minerva, the two adherents, and the olive tree, could abbreviate the subject of the entire section. The organization of the narrative condensed into discrete, focal units, which summon mottos or legends expressing an abstract principle or a moral truth, is well known in the Republican coinage and Augustan art.[78] One may consider this tendency to emblematize a narrative partly a result of the Roman preference for the edifying exemplum. A scene is stripped down to its essentials in order that one concise image may suffice to evoke the entire narrative.

In this reduction of the narrative into its most characteristic image, gesture is important to delineate hierarchical relationships between figures. Throughout the frieze, pairs of figures are linked by a similar gesture, but it is most telling in the confrontation between Minerva and Arachne (fig. 58). The bold diagonal axis created by Arachne's pleading gesture below and the goddess's recoiled arm about to strike from above signifies the absolute power of divine punishment. The viewer realizes that Arachne's pleas are in vain, that the kneeling, gesticulating figure is in an irreversible crisis unlike the figures of the other sections who display reverence to the gods with the same gesture. (It is telling that similar gestures immediately convey the meaning of the mythological conflict in Velázquez's representation of the punishment of Arachne in his *Las Hilanderas* of 1656–1657 in the Prado.)

The emblematic narrative is developed by the representation of personifications, deities, and genre figures that contrast or complement it. Analogies are formed by the complementary motifs, such as Venus and Rumina, which forge links among the diverse subjects and allow the viewer

[78] P. G. Hamberg, *Studies in Roman Imperial Art, with Special Reference to the State Reliefs of the Second Century*, 15–45. Zanker (1988), 157–66.

to interpret one in terms of the other.[79] The principle of antithesis, or definition by opposition, is useful because of the moralizing message that operates on the level of cultural clichés and stereotypes: the defiant Arachne as opposed to the dutiful matron.

The other sections represent the propitiation of old Roman or Sabine deities. The cults of Rumina and Venus Obsequens strengthened the institution of marriage and encouraged procreation. Semo Sancus Dius Fidius represents the Flavian's Sabine origins, and its Quirinal cult also instilled respect for ancestral virtues with its statue of Tanaquil and her spinning relics. Representation of these deities would have linked Domitian's revival of archaic cults to venerable antiquity and to previous periods when moral vigilance was required of Romans. The common denominator of these sections, as well as those of the bay, is found in illustrations of *pietas*, simply expressed in the gesture of the extended hand, enlarged for emphasis, palm open.

The discussion of a decorative program is limited because only a fraction of the frieze is extant. The surviving sections, approximately one and a half bays out of about thirty-eight bays, are all that is left of the relief sculpture, which originally extended the entire length of the Forum's long perimeter walls. The problem of lost monuments has long attracted the interest of scholars, who have developed methods of reconstructing them.[80] Historical or literary sources, as well as the images represented on coins or on works of minor arts, provide evidence because they frequently indicate the arches and honorary statues or, at least, the leading motifs of the monuments that are no longer extant. Speculation on the subjects of the frieze's lost sections is simplified by Domitian's appropriation of Augustan models and the rather limited repertory of myths, symbols, and figures that form the vocabulary of the Flavian iconography. Stock images, such as the Minerva Promachos, are repeated often in various contexts, and symbols, the river god for example, are allusive enough to participate in a broad range of meanings.

It is likely that the frieze comprised a decorative program: some of the motifs depicted on the extant sections may very well have been repeated on the lost sections or modified to represent variations on a common theme. A brief discussion of the possible themes of the lost sections may suggest the relationship among the sections of the frieze and the character of its program.

The organization of the subject matter of the non-extant sections prob-

[79] R. Brilliant, *Visual Narratives: Storytelling in Etruscan and Roman Art*, 78.

[80] For example, F. S. Kleiner, *The Arch of Nero in Rome*. G. Koeppel, "The Role of Pictorial Models in the Creation of the Historical Relief during the Age of Augustus," in R. Winkes, ed., *The Age of Augustus*, 89–106.

ably followed that which is outlined above. The center of each bay may have been decorated with a mythological episode abbreviated into an emblematic representation and surrounded by related allegorical figures, probably personifications of imperial virtues. Above the emblem, an attic relief would depict Minerva or other deities who are the protagonists of the central mythological scene in the frieze. It is unlikely that there was more than one attic relief over the fourth section because of the frame provided by the projecting cornice.

Without a doubt, Jupiter and Juno would have been depicted because the Capitoline triad was also honored by Domitian's rebuilding of the temple and his institution of the Capitoline Games in 86 with competitions in athletics, music, and rhetoric.[81] Besides these gods, Hercules may have been portrayed in the attic reliefs since he was represented by a statue in the Aula Regia of Domitian's palace on the Palatine and honored with a temple on the via Appia.[82] A pendant for the the seventh section representing the Temple of Diana on the Aventine could have depicted the Temple of Apollo on the Palatine. The temples of Diana and Apollo were paired both by the poets and in Augustan iconography.[83] In this way an assembly of gods could have been depicted in the Forum.

Schürmann has proposed that the attic relief of each bay may have depicted Minerva in a different aspect such as Minerva Hygieia or Minerva Promachos.[84] The entire scope of Minerva's worship would have been gathered under the auspices of the Temple of Minerva in Domitian's Forum. It is striking that the one extant bay happens to represent Domitian's patron deity, and this leads one to suspect, along with Schürmann, that here Minerva was ubiquitous. The healing goddess, Minerva Hygieia, could have been represented in a bay next to that of Minerva Mater, shown as a *kourotrophos* to express her motherly devotion to Domitian and the city.[85] However, as mentioned above, it is more likely that other divinities such as Jupiter and Juno were represented in the attic reliefs as well (although there are just about enough mythological aspects of Minerva to fill all thirty-eight bays in an encyclopedic program).

Furthermore, personifications such as an enthroned Roma, Victory, or

[81] At the games in honor of the Capitoline Jupiter, Domitian wore a golden crown with images of Jupiter, Juno and Minerva. Suet. *Dom.* 4–5. Tac. *Hist.* 3.74. Dio Cass. 66.24. On the pediment of the Capitoline Temple that depicted Minerva seated at the left of Jupiter, see *BMCRE* 2, 351, no. 251, pl. 68.3, for a *tetradrachm* of 82.

[82] J. Sieveking, "Zwei Kolosse von Palatin in Parma," *JdI* 56 (1941): 72–90. Scott, 133–57. Mart. *Epigr.* 9.64.1–2; 9.65.5–6; 9.101.1–2.

[83] Simon (supra n. 69), 103, for the imagery of Sol and Luna in Horace's *Carmen Seculares* as well as on the breastplate of the Augustus of Primaporta.

[84] Schürmann, 13. See introduction.

[85] Supra n. 46. See introduction.

Pax in the attic reliefs would complement the depictions of Domitian's tutelary divinities, and are particularly appropriate to Minerva. Roma and Minerva are, respectively, the personification and goddess of the city under Domitian. Given that Minerva has two distinct aspects as the warrior goddess and as the guardian of domestic institutions and industries, both Victory and Pax would be relevant. A winged Victory is depicted in both of the contemporary Cancelleria Reliefs; a conflation of the goddess and her achievement, Minerva Victrix, is represented in the coinage and statues.[86]

Closely associated to Minerva-Athena is the divine craftsman Hephaestus. A depiction of Hephaestus making the armor of Achilles would complement that of Arachne and the matrons weaving cloth. Even his creation of the first woman, Pandora, would have been a suitable subject for the frieze with its mythological subject of female transgression. Minerva-Athena also supervises craftsmen such as Prometheus, and Argos building the ship Argo. Daedalus, as another mythological craftsman, is relevant, but two scenes represented in Pompeian painting, Pasiphae and Icarus, are difficult to imagine in this context.[87]

A representation of a male craftsman could have been intended to contrast the mythological exemplum of Arachne. The subject of the relief depicting Minerva's visit to a carpenter's shop discussed above (fig. 41) is also known through a late antique gold glass bowl that depicts various carpenters building a ship, one of whom has Minerva at his side.[88] A minor work of art, such as the bowl, may reflect a monumental version of the same subject that is no longer extant but, perhaps, was known to the designers of the frieze. Lacking a narrative, the scenes show Minerva's support of the anonymous workers who regularly worship her and recognize her as their superior in all skills.

If the decoration of the extant bay is not an anomaly, then gender roles seem to have been important in the program of the frieze. A mythological tale that demonstrates an inversion of such roles is the story of Hercules and Omphale. After committing a murder, Hercules sought purification, which he could only obtain by being sold into slavery. The Lydian queen

[86] For example, see *BMCRE* 2, 301, no. 12, pl. 59.10, aureus of 81; 310, no. 83, pl. 62.3, denarius of 85; 344, no. 237, pl. 67.1, denarius of 95–96. H. Cohen, *Description historique des medailles frappées sous l'Empire romain*, vol. 1, no. 516. C. W. Keyes, "Minerva Victrix? A Note on the Winged Goddess of Ostia," *AJA* 16 (1912): 490–94. See infra n. 95.

[87] See W. J. T. Peters, *Landscape in Romano-Campanian Mural Painting*, 109. P. H. von Blanckenhagen, "Daedalus and Icarus on Pompeian Walls," *RM* 75 (1968): 106–43.

[88] Colini (supra n. 62), 23, fig. 4. I thank Barbara Kellum for pointing this out to me.

Omphale bought him and set him to work; the most notorious of his tasks were women's work and he is often depicted spinning wool.[89] An element of parody surfaces in this myth through the mocking of the strapping, muscle-bound hero, but it may also serve as another lesson of what happens when mortals approach the gods.

Representation of cults or sacred sites in Rome may have been interspersed in the small reliefs placed on the ends over the columns as well. A relief depicting the Lupercalia could have formed a pendant to the representation of Rumina in section six. In fact, a relief fragment that probably depicts Mars was found near the Forum Transitorium in the late nineteenth century.[90] According to the reports, the scale of the relief's figure and its style correspond to those of the Forum's frieze. Unfortunately, the fragment has been lost.

An Aeneas scene similar to that of the mythological panel of the Ara Pacis Augustae may also have belonged to this group.[91] Deities from the founding myths, such as Mars and Rhea Silvia, who are portrayed in bucolic landscapes, would have provided accompaniment. The Hartwig Relief's depiction of the pediment of the Temple of Quirinus suggests that Romulus may also have been represented in the frieze.[92] The second king of Rome, Numa Pompilius, was significant for Domitian because of his role in re-organizing Roman religion and also because of his Sabine origins.[93] A relief that depicts Numa founding the cult of Vesta would have been in character.

An episode showing the Palladium myth would have been appropriate because the ancient image symbolized the transmission of power to the Flavians and their role in safeguarding the eternity of Rome. In the contemporary coinage, both Vesta and Domitian are portrayed holding the palladium, and Vesta may have been depicted in an attic relief above a palladium scene in the frieze.[94] The Vestal Virgins also figure prominently in Relief B of the Cancelleria Reliefs.[95]

[89] Ovid *Heroides* 9.73.

[90] C. L. Visconti, "Trovamenti di oggetti d'arte e di antichità figurata," *BullComm* 18 (1890): 226. P. Orsi, "Latium et Campania, nuove scoperte nella città e nel Suburbio," *NS* (1890): 239.

[91] E. Simon, *Ara Pacis Augustae*, 22–23, and bibliography. Zanker (1988), 201–10.

[92] P. Hartwig, "Ein römisches Monument der Kaiserzeit mit einer Darstellung des Temples des Quirinus," *RM* 19 (1904): 23–37. Koeppel (1980), 14–29, and 16 n. 7, for bibliography.

[93] E. Simon, "Virtus und Pietas. Zu den Friesen A und B von der Cancelleria," *JdI* (1985): 543–55.

[94] Scott, 186. BMCRE 2, 237, no. 83, pl. 46.5, denarius of 80; lxxxix, 355, no. 265, pl. 68.9, for a sestertius of 81.

[95] F. Magi, *I rilievi flavi del Palazzo della Cancelleria*, pls. 1 a and b. J.M.C. Toynbee,

The theme of divine punishment is significant for the message of the frieze. A mythological emblem of divine punishment is Marsyas, the musician who is flayed alive by Apollo for the hubris of challenging the god to a contest on the flute. Although the narrative corresponds to that of Arachne with the protagonist challenging a deity for mastery of an art (and, again, Athena/Minerva is the inventor of the musical instrument), Marsyas was represented in other contexts: the statue of Marsyas erected in the Forum Romanum also signifies the *libertas* of the plebeians and a heroic Trojan heritage.[96] The political and mythological associations of Marsyas may have appealed to Domitian's social initiatives. Among the many myths that refer to divine punishment, those involving a competition between a mortal and divinity would have enhanced the program.

As a legendary episode from Rome's early history, the punishment of Tarpeia would have been appropriate because of its theme of a woman punished for betraying the city during an enemy attack. Furthermore, there was a tradition of representing Tarpeia as an *exemplum impietatis* on coins and in public art.[97]

Not all the cult scenes had to occur in Rome. As von Blanckenhagen has proposed, the depiction of a festival in honor of Minerva, which includes textiles as props or cult offerings, recalls the east frieze of the Parthenon in Athens.[98] Yet, according to von Blanckenhagen, the Forum's frieze does not represent the festival itself with processions of the participants as shown in the Parthenon frieze, but rather indicates the preparations for it with the scenes of women weighing, dyeing, and stretching the wool in the fifth through seventh sections. As discussed above, sections five through seven probably portray personifications, deities, and the rites of women under Minerva's (and Diana's) tutelage rather than craft scenes. If the Parthenon frieze provided the inspiration for the Fo-

The Flavian Reliefs from the Palazzo della Cancelleria in Rome. E. Simon, "Zu den flavischen Reliefs von der Cancelleria," *JdI* 75 (1960): 135–56. Simon (supra n. 93). F. Ghedini, "Riflessi della politica domizianea nei rilievi flavi di Palazzo della Cancelleria," *BullComm* 91 (1986): 291–309.

[96] Serv. *ad Aen.* 3.20. Torelli (supra n. 72), 99–105. P. H. von Blanckenhagen, "Narration in Hellenistic and Roman Art," *AJA* 61 (1957): 78–83, for images of Marsyas in Pompeian painting. P. B. Rawson, *The Myth of Marsyas in the Roman Visual Arts, An Iconographic Study, B.A.R. Int'l. Series* 347, 11–12; Appendix B, 224–31.

[97] See chapter 3.

[98] Von Blanckenhagen, 126, 131. O. Premerstein, "Der Parthenonfries und die Werkstatt des panathenaischen Peplos," *OJh* 15 (1912): 1–35. W. Gauer, "Was geschicht mit dem Peplos?" E. Berger, ed., *Parthenon-Kongress Basel*, 220–29. M. Robertson, "Two Question-Marks on the Parthenon," *Studies in Classical Art and Archaeology. A Tribute to P.H. von Blanckenhagen*, 78–87. He interprets metope 20 as depicting the invention of spinning or weaving.

rum's frieze, it is limited to the idea of Minerva's patronage of the domestic arts.

Nonetheless, a non-extant section may have represented the Panathenaia on the Athenian Acropolis crowned by an attic relief showing Athena Parthenos. This subject would be appropriate for the longer section above the enclosure wall and would complement the eighth section with its scene of the enthroned Minerva receiving worshippers at her Aventine temple.

It is also likely that Minerva's festival, the Quinquatrus, celebrated at Domitian's Alban villa (rather than in the Forum and the Subura) was depicted in another long section.[99] In particular, this subject would require the sylvan setting that recurs in the frieze's extant sections. Its corresponding attic relief may have resembled coin types that show the emperor's private shrine of Minerva or even Apollo because the celebrations included poetic competitions.[100]

It is less likely that the non-extant reliefs portrayed Vespasian, Titus, or Domitian. As mentioned in the first chapter, the program of the Porticus Divorum and the Temple of Minerva Chalcidica in the Campus Martius attribute the Flavian military success to Minerva's patronage. A battle scene or, rather, a representation of a mythological battle (beneath an attic relief depicting Minerva Victrix) could have served as an analogue of the Flavian victories and as an example of Minerva's martial aspect to counter that of her domestic and civic role in the extant bay. There is no evidence to indicate whether the *damnatio memoriae* of 96 affected the frieze.

[99] Suet. *Dom.* 4. Dio Cass., 67.1.2.

[100] Mattingly, *BMCRE* 2, 401, no. 455, pl. 80.2, for a *semis*; 401, no. 456, pl. 80.1, for a *quadrans*. Both semis and quadrans date to 90–91. Also, 363, no. 296, pl. 71.1, for a sestertius of 85.

Virgins and Adulterers

MYTHOLOGICAL subjects appear to have been a significant part of the frieze with its focus on the Arachne scene in the extant bay. The meaning of the mythological centerpiece is apparent when seen in the context of the flanking sections depicting obedient weavers or personifications that offer uplifting and edifying models of behavior. Personifications of imperial virtues, the equivalents of moralizing themes in Roman literature and historical writing, are commonplace in state art. The frieze's representation of the Arachne myth, however, is exceptional and unparalleled in the public monuments of the empire.[1]

The subject of mythological exempla in Roman art is vast and goes beyond the scope of this chapter. Yet a context can be supplied for the frieze through a discussion limited to a few works of sculpture, in relief and in the round, that represent specific mythological themes with didactic content. Given the narrative of Arachne's meteoric rise and downfall, appropriate mythological themes include those of punishment, particularly divine punishment, and those that illustrate the teaching of the young and their initiation into the social order or, of course, the failure of such attempts and the fate of those who challenge their elders. The conflicts described in the myth can be delineated as mortal against immortal, youth against age and experience, low birth against divine standing and clout, self-taught skill against effortless gifts, and independence against steely authority. Many myths include one or several of these conflicts but another category has to be considered, that of gender.

It is unusual in Roman state art with its political and military themes that all but six of the figures of the frieze are female, although the other non-extant bays may have had a proportionately higher number of male figures (e.g., female figures appear as winged Victories slaying bulls in

[1] For the tradition, see H. W. Litchfield, "National *Exempla Virtutis* in Roman Literature," *HSCP* 25 (1914): 1–71. K. Galinksy, "Augustus' Legislation on Morals and Marriage," *Philologus* 125 (1981): 124–44. See introduction.

the repetitive scenes of the friezes of the Basilica Ulpia in the Forum of Trajan, but in the Forum Transitorium the mythological sequence is more complex and still, remarkably, dominated by female figures). It is the depiction of the goddesses and the personifications that give meaning to the mythological emblem and the surrounding scenes in terms of gender. Both the social role of women and their sexuality, that is, the imperial construction of femininity, are narrowly defined. On the one hand, Arachne represents women as transgressors, tempestuous and uncontrollable without divine intervention, and, on the other, the personification of Pudicitia stands for prohibition, the vigilance needed to guard against acts of passion that betray fathers, husbands, and the state (figs. 45, 50, 51). Yet, in the myth Arachne's crime of *impietas* is not sexual, although Pudicitia is a figure of chastity for virgins and of purity, or productive sexuality, for matrons. Arachne, therefore, does not stand in opposition to Pudicitia so much as she does in relation to Moneta (Aequitas), the figure holding the scales placed across the bay from Pudicitia (figs. 45, 64). As discussed in chapter 2, the figure representing justice glosses the punishment scene. Pudicitia, identified with the moral matron and her demure weaving, serves as another exemplum, yet her relationship to the mythological emblem needs to be explored against a broader context of meaning.

The centerpiece of the suppliant Arachne framed by the depictions of Pudicitia and Moneta (Aequitas) (with Venus and Rumina on the sections above the columns dividing the bays) extends the weaving motif in another direction. For Arachne the domestic chore of weaving became a means of subversion, an allegedly feminine way of challenging the goddess's dominion: Arachne's quest for mortal glory led her to weave a web of deceit and seduction, her cloth was a primer on illusion and appearances. That this myth is not represented on any extant state monument should give one pause and also direct attention to the accompanying motifs, the personifications known from coinage. In the light of imperial allegory, the depictions of weavers may also represent women who weave the bonds between men by evoking the trope of the state as a fabric, a cloth made of a myriad of threads spun from diverse materials and woven tightly together (recall Minerva's fabric that charted the divine order). Woman as a sign of mediation, as an object of exchange among men, figures prominently in the founding myths of Rome. The myths revolve around the themes of initiation or assimilation, prohibition, transgression, and punishment; the founding myth typically begins or ends with violence committed against a woman (or women) as a result of a social threat, an internal division, that is then redirected against the outside as, for example, in war.

[79]

The frieze of the Basilica Aemilia, located in the Forum Romanum close to the Argiletum and next to the Forum Transitorium, represents female protagonists in its depiction of episodes from the legendary founding of Rome (figs. 84 and 85).[2] The Basilica Aemilia was originally constructed by the gens Aemilia in 179 B.C. for whom it served as a monument of considerable splendor and renown.[3] The frieze, which was arranged around the interior of the building, narrates legends of early Rome and, among such subjects as the Aeneas and Romulus cycles, two scenes are relevant to this discussion: the rape of the Sabine Women and the punishment of Tarpeia.

Scholarly opinion on the date of the frieze has been divided, and dates ranging from about 79 B.C. to A.D. 60 have been offered.[4] More recently, the proposal that the frieze dates to or after an Augustan restoration of 14 B.C. has been gaining ground although it is still not generally accepted (Gianfilippo Carettoni made a case for a date of about 34 B.C.).[5] Arguments for the Augustan date rest, in part, on the recognition of Augustus's marked enthusiasm for antiquarian subjects such as the frieze's encyclopedic treatment of the founding of Rome and its relevance for his program of moral reform.[6]

The rape of the Sabine Women occurs because Romulus sought wives for his band of rough-and-ready settlers, many of them outlaws requesting asylum in the newly founded city.[7] With the male population growing, there were not enough women in the city, and nearby towns had no interest in forming alliances with Rome through intermarriage. Romulus invited the neighboring peoples, the Sabines among them, to a festival that was interrupted by the kidnapping of the Sabine women by the Romans, initiated by a prearranged signal from Romulus to his men. The Romans stole the women who would not be given over to them in marriage, and the foreign women, under force, submitted to marriage and motherhood in the homes of their enemies. The marriages were honored by the law so that the Romans would have legitimate children.

Some time later, the Sabines decided to attack the Romans to avenge

[2] G. Carettoni, "Il fregio figurati della Basilica Emilia," *RivIstArch* 10 (1961): 5–78. H. Furuhagen, "Some Remarks on the Sculpted Frieze of the Basilica Aemilia in Rome," *OpRom* 3 (1961): 139–55.

[3] H. Bauer, "Basilica Aemilia," in M. Hofter et al., eds., *Kaiser Augustus und die verlorene Republik*, 200–12.

[4] Carettoni (supra n. 2), 5–78.

[5] Dio Cass. 54.24.2–3. D., Strong *Roman Art*, 78–79, suggested that both the style and the subject matter indicate a date about 14. N. B. Kampen, "The Muted Other," *ArtJ* 47 (1988): 15–19. Most recently, Bauer (supra n. 3), 200.

[6] N. Kampen, "Reliefs of the Basilica Aemilia: A Redating," *Klio* 73 (1991): 448–58.

[7] Livy 1.9–13. Also, Ovid, *Ars. Am.* 1.99–134; *Fasti* 3.187–228.

the abduction of their women. They gained entry to the Capitol through the aid of a Roman woman, Tarpeia, who betrayed her city to the enemy. The fighting raged and, at a crucial point, the Sabine women inserted themselves in the battle lines between their Roman husbands and their Sabine fathers and brothers. The women exclaimed in horror and confusion at their situation: they felt that they were to blame for the crisis, and they appealed to their fathers' and husbands' affection for their sons and grandsons. At this moment a truce was declared that annexed the Sabines to Rome.

This myth, like all founding myths, serves to legitimize social practices and the organization of power. The rape is clearly a political act, planned and carried out like a military action, and it is successful beyond its immediate consequences: the Sabine women become Roman matrons, their sons are Roman citizens, and, after the war, the Sabine people and land are under Roman authority, too. As Norman Bryson, among others, has observed, the story is about boundaries between the Roman and non-Roman, outsider and insider, captive and matron, enemy and neighbor, but the lines of demarcation shift and all is subsumed under the name of Rome.[8] In the beginning of the legend, Rome is an underpopulated city of fugitives and thugs ostracized by hostile neighbors, yet by the end it has become a proud capital that rules over its neighbors as client states. Even the assimilation of foreigners does not disturb the status quo: the Sabine women are introduced as foreign booty conquered and plundered, and are absorbed as model wives and mothers. Even before the Sabine attack, Romulus's wife Hersilia had urged that the brides' parents be allowed to live in Rome, thus initiating the process of accommodation.

The Sabine women play a pivotal role in the story. Starting out as victims of Roman aggression, the ultimate outsiders become insiders and, inexplicably, identify themselves as the cause of the bloodshed. When they speak out in the midst of the fighting, their appeal stops the men in their tracks and a peace is made, but it is a peace under Roman rule. Livy's story places the women on the front lines in between the Romans and the Sabines, and as they form a boundary between their husbands and fathers, they uphold their Roman marriages and their new allegiance. That they blame themselves for the fighting suggests how far they are willing to serve as mediators—not only have they already sacrificed their identities as Sabines and assimilated Roman ways but they are also ready to sacrifice themselves by flinging their bodies amidst the drawn swords.

Patricia Klindienst Joplin has noted the contradictions in the story that

[8] Norman Bryson, "Two Narratives of Rape in the Visual Arts: Lucretia and the Sabine Women," in S. Tomaselli and R. Porter, eds., *Rape*, 159.

are barely suppressed by Livy in his History.[9] The Sabine women, abducted, raped, and married by force, consider themselves, *not* the Romans, to be the source of strife and the cause of warfare. Their logic is all the more perverse because a woman's role is implicitly powerful in her critical responsibility of maintaining the line of descent, of bearing and raising sons as her husband's heirs. Yet in the founding myth she is the foreigner, the woman taken from her people against her will to live with a Roman husband. As a stranger, her position is paradoxical because the captive bride, brought in from the outside and distinguished by her difference, has a central role as wife and mother. Her resentment gradually gives way to an acceptance of her lot; she must transfer her *fides*, her affections and loyalty, to the new state and her new house.[10]

The story casts brides and mothers as newly inducted Romans whose loyalty to the city is proven in a test that conflates personal and political bonds, domestic and civic responsibilities, and reaffirms Roman supremacy. Furthermore, the compliance of the Sabine women offers a model for the victims of imperial expansion through the relative ease in which they take up the Roman cause as their own: demonstrating obedience and submission to their conquerors, the women only challenge their husbands by intervening in the battle that results in the truce and Sabine capitulation to Rome. The seizure of Sabine women, the motif of marriage by capture, precipitates a war that eventually unites the two states, although under Roman sovereignty.

Marriage, even in less extraordinary circumstances considered a duty to society, serves the needs of the state to ensure its survival and increase its manpower. It also provides the proper vehicle to control women and to harness their sexuality in their roles as mothers. The correct behavior of wives, their loyalty to their husbands, is made explicit by the transformation of young girls, outsiders from neighboring settlements, to outstanding Roman matrons who play a decisive part in resolving the conflict to Rome's advantage (their action in the midst of the battle also underscores the often questionable loyalty of women who must shift their allegiances from their fathers to husbands although the Sabine women entertain no such treacherous impulses). In theory the bride could resist social expectations in a number of ways, such as refusing motherhood, but this rarely happened in the founding myths or in early Roman society. Instead, as Eva Stehle has pointed out, the model bride and ma-

[9] P. Klindienst Joplin, "Ritual Work on Human Flesh: Livy's Lucretia and the Rape of the Body Politic," *Helios* 17 (1990): 56–59. J. Hemker, "Rape and the Founding of Rome," *Helios* 12 (1985): 41–48.

[10] E. Stehle, "Venus, Cybele, and the Sabine Women: The Roman Construction of Female Sexuality," *Helios* 16 (1989): 145–51. In the following I rely on Stehle.

tron possess the ideal qualities of new citizens: they internalize the interests of their masters and they are subjected to their control. This is precisely how the predicament of the Sabine women is resolved; yet both legendary Sabine and actual Roman women frequently maintained close contact with their fathers or male relatives (recall that the Sabine parents moved to Rome) even though they may have been under their husbands' authority.[11]

The frieze of the Basilica Aemilia also depicts other subjects that develop the themes of the rape of the Sabine Women. Stehle finds meaning in the relationship between the scene of the rape and another panel in the frieze that may depict Ops, the goddess whose festival was associated with the Consualia, the occasion for the abduction of the Sabine women. Consus is the god of the storehouse, and the women are metaphors for the harvest in the context of the agricultural festival. As the fruits of the field, the brides bring in wealth into the community with the prospect of sons or, in other cases, dowries. Furthermore, in their role as matrons they serve to protect the resources of the family and the community, just as the Sabine women did when they intervened in the battle.

The fragmentary frieze from the Basilica Aemilia represents two Romans carrying off two Sabine women in their zeal to acquire the wives that they lacked (fig. 84). Natalie Kampen has analyzed the meaning of the classicizing style of the frieze, the clarity of its composition without any overlapping of figures, and the idealization of its sturdy figures with their open arms and flowing drapery, as contributing to the authority of the work and its message.[12] The style summons the past and a golden age that demonstrated moral superiority over the lax and lapsed climate of social upheaval in the late Republic and early empire. Kampen proposes that the frieze of the Basilica Aemilia served as an exemplum for the Augustan program of moral reform and religious revival. Like its Domitianic revival, the Augustan laws on marriage and adultery (and chastity) of 18 B.C. and A.D. 9 attempted to bolster the institution of the family by punishing illicit acts and rewarding socially sanctioned ones such as marriage and childrearing. In this program the role of female sexuality was closely circumscribed.

Kampen also perceives a relationship between the two scenes of the frieze, the rape of the Sabine Women and the punishment of Tarpeia, that

[11] Marriage with *manus* indicates that the wife is under the authority of her husband, while *sine manu* means that she remains under that of her father (if still alive). Marriage without *manus* was more common by the late Republic. J. F. Gardner, *Women in Roman Law and Society*, 31–65. S. B. Pomeroy, "The Relationship of the Married Woman to her Blood Relatives in Rome," *Ancient Society* 7 (1976): 215–27.

[12] Kampen (supra n. 5), 15–16.

stand in contrast to one another.[13] The latter depicts an episode from the Sabine attack on Rome (fig. 85). The Sabines steal into the city unnoticed at night with the assistance of a Roman woman, Tarpeia, the daughter of the commander of the Capitol. She is shown at the moment when she is being crushed by the shields of the Sabines, the enemies for whom she has opened the gates. Motivated to betray her city either by greed (she was bribed with gold) or by her attraction to the Sabine commander, Tarpeia is despised as a traitor even by those whom she has helped. She is proof that the desires of women can place the city in imminent danger; she is the means by which the boundaries of the city are ruptured.

The story of the punishment of Tarpeia is an inversion of that of the rape of the Sabine women. Whereas the Sabine women are foreigners who come to protect Roman interests as their own, Tarpeia is the native daughter who forsakes her own people for false promises of gold or love. During the battle, the Sabine women wedge themselves between the opposing forces and speak out as a group to identify themselves as mothers of Roman sons. Tarpeia, the weak link in the line of defense, is silenced and entombed by the enemy shields thrust upon her.

The myth of Tarpeia was well known in Augustan Rome through her depiction on coins and in poetry: she was shown buried alive with shields on denarii of 18–16 B.C., and she was the subject of an elegy of Propertius (4.4) that portrayed her as an indisputable example, immoral and impious.[14] Tarpeia proved to be a useful anti-heroine in the wake of the Augustan social legislation and the revival launched by the Secular Games of 17 B.C.

The two panels of the frieze of the Basilica Aemilia convey a moral lesson by contrasting of two models of feminine behavior, one instructive and the other cautionary. A similar relationship is found in the frieze of the Forum Transitorium with its central mythological emblem representing punishment and the flanking sections depicting personifications of virtue or goddesses. In both friezes feminine virtue is upheld through the violence done to Arachne, Tarpeia, and the Sabine women, although the latter are ennobled as exemplars of *pudicitia*, matrons who are pure in their devotion to their husbands. In contrast, Tarpeia represents female sexuality out of control that threatens the security of the city: Tarpeia's defenseless body and her compromised position are the result of her transgression. Both the loss of Tarpeia's chastity and the breach in the fortifications suggest that the city is envisioned as a female body: its pas-

[13] Kampen (supra n. 5), 15–16.

[14] Denarius of P. Petronius Turpilianus, Rome, 18–16 B.C. Zanker (1988), 161–62. Kampen (supra n. 6), 452, fig. 5. *BMCRR* 1, 2326 and 2328. *BMCRE*, 1.6.29–31, pl. 1.16. For the Sabine Women depicted on a coin: Kampen, supra n. 6, 451, fig. 4.

sages guarded, its traffic regulated, and its honor defended. The virgin's hymen has long been a metaphor for the city walls.[15] Both boundaries are the object of prohibition and precaution, and the focus of religious and political rituals. Access can be won through violence or through the permission of the father or king, and in the founding myths the exchange of women is usually intended to keep political violence at bay. When this goes awry as in the story of Tarpeia, the woman's body becomes the target of aggression.[16] The daughter's or matron's chastity may serve as a sign of the political stability of the city or state.

As exemplified in the story of the Sabine women, the bride crosses boundaries, exchanges loyalties, and becomes committed to preserving the sanctity of her new home. She not only maintains the integrity of her home through her chastity but also by supervising its economy, by minimizing waste and safeguarding the goods and provisions that her husband brings home. The matron's domain is the hearth, the symbol of the interior life of the domus. Her role in protecting domestic life, its self-sufficiency and inner privacy, is reflected in the public sphere by the cult of the Vestal Virgins, the priestesses, matronly in aspect yet celibate by vow, who kept the state hearth fire burning in the temple in the Forum Romanum.[17]

In critical periods, in times of military defeat or social upheaval, the Romans accused the Vestal Virgins of violating their vows of chastity. If convicted, the Vestals were executed, usually buried alive. The grim punishment is appropriate given the Vestals' activities in an enclosed and interior setting, their guarding of the hearth fire and the grain used in sacrifices, both substances associated with fertility and increase, which were generated from within the undefiled boundaries of the sanctuary. Besides their role as matrons, the Vestals were also the perpetual daughters of the archaic king who had to remain intact, chaste, and uncontaminated. If their virginity was violated, they were condemned to sterility and death, swallowed up by the earth, and sealed in it as if in a tomb.[18] Unlike the Sabine women who were seen as the bounty of an abundant harvest, the executed Vestals were imprisoned in the cold and stony earth, a barren and impenetrable home. The female body, whether of a Vestal, the traitor Tarpeia, or a martyr such as Lucretia, was sacrificed for the good of the

[15] P. Klindienst Joplin, "The Voice of the Shuttle is Ours," *Stanford Literature Review* 1 (1984): 25–53.

[16] Klindienst Joplin (supra n. 9), 54.

[17] M. Beard, "The Sexual Status of the Vestal Virgins," *JRS* 70 (1980): 12–27. On the Roman wife as housekeeper, Cicero *Phil.* 2.69; Plut. *Rom.* 22.3. T. Pearce, "The Role of the Wife as *Custos* in Ancient Rome," *Eranos* 12 (1974): 16–23.

[18] See introduction for the Domitianic trials and executions of the Vestal Virgins.

body politic so that the city walls and the letter of the law would remain inviolable.

Livy tells the story of Lucretia.[19] Lucretia's husband, Collatinus, made a bet with his companions, among them Sextus Tarquinius, during a lull in the Roman siege of Ardea. The men, Etruscans of the ruling elite and commanders of the Roman army, bet on their wives' virtue, and rode back to Rome to settle the matter. The wives were found to be revelling late at night, with the exception of Lucretia who was spinning with her servants. Yet Lucretia was not allowed to win the test of virtue and, later, Sextus Tarquinius made another visit to Lucretia while she was alone in order to seduce her. She would not surrender to his advances. He threatened that he would ruin her by killing her and placing her naked body in bed next to that of a male slave, and informing Collatinus that he caught them *in flagrante* and dispatched the pair of adulterers in outrage. Faced with this prospect, she gave in to him and then killed herself after sending for her father and husband, and declaring her innocence in the presence of two witnesses.

Patricia Klindienst Joplin points out that one must read Livy carefully to catch an important fact: that Collatinus and Sextus Tarquinius are blood relations who competed for power and prestige.[20] The rivalry between the Tarquins was transferred to their wives, and Lucretia, the paragon of domesticity working tirelessly at her spinning, was not so much an irresistible object of desire as an instrument to dishonor her husband. Sextus Tarquinius wanted revenge for losing the bet, and Lucretia, unwittingly, played the victim to full effect: she did not know the role her husband had played in her predicament (he had brought her rapist to her), she feared Sextus Tarquinius's lies and his ability to destroy her husband's reputation, and she took her own life. The rivalry between the men was resolved through a substitution of a false conflict, the test of their wives' virtue, for the actual conflict, the competition for power. The violence was self-inflicted: Lucretia, the victim of the struggle, killed herself and, with the demise of the once chaste woman, the men were on an equal footing. Furthermore, the matron sacrificed herself out of shame for her rape (the Sabine women also blamed themselves for the war), and her corpse, carried through the city streets, aroused revolutionary sentiment. In the legendary history of early Rome, the violation of Lucretia results

[19] Livy, 1.57–59. Ovid *Fasti* 2.723–852. A small group of Etruscan funerary urns may have depicted the death of Lucretia. J. P. Small, "The Death of Lucretia," *AJA* 80 (1976): 349–60.

[20] Klindienst Joplin (supra n. 9), 59. I. Donaldson, *The Rapes of Lucretia: A Myth and Its Transformations*, 3–12. The story of Verginia and Appius Claudius is probably a revision of the Lucretia story.

in the overthrow of the despised Etruscan monarchy. Lucretia served to inspire Brutus to take action with the support of a united citizenry. The assault on the city of Ardea is transformed into a civic conflict, with a woman's wounded body as the reason to rally. The woman, and here it was a matron of record, was used not only to maintain the balance of power between political rivals (her husband and his cronies), but also to redress the relationship between ruler and ruled in the creation of the new government, the Republic under Brutus. Chastity and its loss is a sign of fluctuating political fortunes, of the fragile security of the city and its institutions.

One must turn to securely dated Augustan public monuments for the narration of founding myths and their utility in aspects of social control. The Augustan program, the shaping of a personal and national mythology from the tales of revered antiquity, had at least one crucial function: to establish the Augustan age as the culmination of Roman history.[21] History was revised to present Augustus as the heir of Aeneas and Romulus, and of Venus and Mars. The mythological themes popularized under Augustus in his official programs provided models that informed and inspired the Flavians, especially Domitian.

Of particular interest is the role of the female protagonist in Augustan art. Female subjects, besides deities and personifications, are rarely depicted on state monuments of the early empire, with the exception of the Ara Pacis, a few reliefs depicting the Vestal Virgins, and the Ravenna relief.[22] For example, the arrangement of the statuary in the Forum of Augustus, which was vowed in 42 but dedicated in 2 B.C., represents the male lineage with Romulus, Aeneas, and Mars as forebears of the first emperor along with the *summi viri*. In the central statuary niches, Aeneas is honored as the *exemplum pietatis* who rescued his father, son, and the household gods from Troy (only Venus is honored as mother of the clan) while Romulus serves as the *exemplum virtutis* in his role of triumphator.[23] Aeneas, Romulus, and Mars are also represented on the reliefs on the front side of the Ara Pacis of 13–9 B.C.

In the Forum of Augustus, the focal point of military ceremonies and

[21] Zanker (1988), 167–238.

[22] I. S. Ryberg, *Rites of the State Religion in Roman Art*, MAAR 16 (1955): 49–54, J. Pollini, "Gnaeus Domitius Ahenobarbus and the Ravenna Relief," *RM* 88 (1981): 117–40. N. B. Kampen, "Between Public and Private: Women as Historical Subjects in Roman Art," in S. B. Pomeroy, ed., *Women's History and Ancient History*, 218–48. G. Koeppel, "Die historischen Reliefs der römischen Kaiserzeit, 1: stadrömische Denkmaler unbekannter Bauzugehörigkeit aus augusteischer und julisch-claudischer Zeit," BJb 183 (1983): 61–144. See chapter 2 for the Flavian period.

[23] Zanker (1988), 201–06.

those concerning foreign policies, Romulus and Aeneas are honored as founders of Rome but elements of their history are simplified. Romulus and Remus, after all, are born from the rape of the first Vestal Virgin, Rhea Silvia.[24] The story begins with the virgin's uncle, who has removed her father as king of Rome and has murdered her brothers. In order that Rhea Silvia would have no sons who could threaten his claim to the throne, the uncle appointed her as a Vestal Virgin. Rhea Silvia was then raped by Mars and gave birth to twins, who were disposed of (cast into the Tiber) by the uncle. The raped virgin became a pawn in the struggle between the two rival brothers, the two kings. Her body was contested: first she was punished by prohibition through her vows of chastity, and then by the transgression of the divine rape, and finally by her incarceration by her uncle. Both her enforced chastity and her violation indicate the male control of female sexuality and reproduction and, furthermore, they were sacred acts, sanctioned by the gods.[25] As far as we know, Rhea Silvia was not depicted in the Forum of Augustus, but female figures, caryatids in the colonnade and attic, personify subjugated peoples and, in this sense, may be considered as violated women, enslaved foreigners signifying Rome's mastery (Vitr. *De Arch.* 1.1.5). Captive women are servants of the empire but the mother of Romulus is conspicuous by her absence. Chastity and transgression figure prominently in the founding myths, in the story of Rome's quest for empire, divinely inspired.

Aeneas claims descent from Venus. Augustus and the Julio-Claudian line, therefore, have divine parents, Venus and Mars, on both lines of descent. In Greek and Roman mythology, it is typical for a hero to be descended from the gods. Yet the creation of divine genealogies unleashed further complications. According to Ovid, Venus and Mars are also adulterous lovers in myth, and the depiction of this couple may have elicited comment in light of the Augustan social program and the Julian laws against adultery.[26]

The female subjects represented in the Augustan program were usually deities or personifications governing fertility and regeneration. The motif of the nurturing female is prominent in the mythological and allegorical panels of the Ara Pacis, e.g., the personification of "Tellus" and the female animals, the sow of Aeneas and the she-wolf of Romulus and Re-

[24] Livy 1.3. Ovid *Fasti* 3.11–52. In Augustan versions of the myth, Rhea Silvia was also a member of the Trojan family of Aeneas.

[25] Klindienst Joplin (supra n. 9), 58–9. Also represented on fragments of a painted frieze from the Columbarium Statiliorum. See R. Brilliant, *Visual Narratives: Storytelling in Etruscan and Roman Art*, 30–31.

[26] Zanker (1988), 193–215. The issue of the adulterous affair of Venus and Mars was glossed over by all except Ovid Tr. 2.295–96.

mus.[27] Nature supplants culture: the she-wolf serves as the mother worthy of heroes, and Rhea Silvia is omitted (in the reconstruction of the fragmentary panel). The virgin is replaced by the animal who cared for Romulus and Remus after her uncle cast them out of the city.

Matters of procreation were under the scrutiny of the state due to the Augustan marital legislation, and it is no coincidence that the maternal figure of the so-called "Tellus" panel of the Ara Pacis, with its tableaux of the natural world under cultivation represented by fruit, grain, and domestic livestock, evokes the blessings of offspring and motherhood under the protection of Augustus (fig. 86). Variously interpreted as Tellus, Venus, Italia, and Pax, the figure is a personification created in the Augustan period that seems to have multiple associations.[28]

The relief, which accompanies the "Tellus" scene on the same side of the Ara Pacis, represents the personification Roma (fig. 87). Although very little of the relief is extant, it has been reconstructed by Giuseppe Moretti to show Roma in the guise of an Amazon armed with helmet, shield, spear, and sword, and one exposed breast. Probably originally flanked by personifications of the Roman people and senate (or by Honos and Virtus), Roma is seated on a pile of enemy weapons to indicate that peace is the result of military preparedness and vigilance. No doubt, she serves as an appropriate defender of the honor of the city and empire because she is chaste and pure. The body of Roma, replete with bronze armor, repels advances, both sexual and military (she is like Minerva in these respects). Her attitude is very different from that of "Tellus," who is clad in clinging, transparent drapery amidst a symbolic landscape that declares its fertility—it is practically dripping with dew.

As Diana Kleiner has demonstrated, the Ara Pacis Augustae can also be interpreted as a monument to the imperial family in its portrayal of the children, the dynasty's second generation, in family groups in the long friezes (fig. 88).[29] Idealized figures represent the imperial women: Livia, Julia, the elder Antonia, and the younger Antonia, among others. The identities of figures who may depict Augustus's adopted sons, Gaius and Lucius Caesar, are still disputed, although it is clear that they were present along with other imperial children and their mothers.[30] The court is shown to be a model of the traditional family encouraged by the marital laws. The broader theme of the Ara Pacis Augustae affirms the achieve-

[27] Kampen (supra n. 5), 16.

[28] Zanker (1988), 172–76.

[29] D.E.E. Kleiner, "The Great Friezes of the Ara Pacis Augustae. Greek Sources, Roman Derivatives and Augustan Social Policy," *MEFRA* 90 (1978): 753–85.

[30] J. Pollini, *The Portraiture of Gaius and Lucius Caesar*, 21–28. C. B. Rose, "Princes and Barbarians on the Ara Pacis," *AJA* 94 (1990): 453–67.

ments of the Augustan peace and its social stability, which are dependent on the proper conduct of women in domestic life and the encouragement of productive sexuality.

Female mythological subjects are significant in the sculptural program of another Augustan monument, the Temple of Apollo on the Palatine. Dedicated in 28 B.C., the temple honored the god to whom Augustus credited his victory over Antony at Actium in 31 B.C. The siting of the Temple next to the house of Augustus emphasizes the relationship; in fact, Apollo was said to have been the divine father of Augustus.[31] The marble temple itself was constructed in the ancient Tuscan style with traditional terracotta decoration.[32]

Several of the archaistic terracotta plaques from the Temple of Apollo recovered by Gianfilippo Carettoni in 1968 depict mythological scenes that lend themselves to an overt political interpretation.[33] The implicit comparison between contemporary events and mythology is seen in the terracotta sima decoration that depicts Isis shackled between a pair of sphinxes. As Barbara Kellum has proposed, Isis is to be identified as Cleopatra VII, the fierce Egyptian queen and ally of Marc Antony, against whom war had technically been declared; she is shown captured like a victory trophy.[34] In the propaganda of the 30s, Octavian (Augustus) and his enemies are represented as gods, and their deeds are reenacted in mythological guise (Octavian is identified with Apollo, while Antony favored Hercules and then Dionysus—for a plaque that represents the struggle of Apollo and Hercules over the Delphic tripod, see fig. 89). Antony seemed to live out a divine masquerade in regal splendor in the east, and his neglect of his wife, Octavian's sister, in favor of Cleopatra branded him as debauched and decadent in the minds of conservative Romans.[35]

More relevant than the terracotta plaques of the Temple of Apollo for

[31] F. S. Kleiner, "The Arch in Honor of C. Octavius and the Fathers of Augustus," *Historia* 37 (1988): 348–57. On the Augustan building program on the Palatine, see G. Carettoni, "I problemi della zona augustea del Palatino," *RendPontAcc* 39 (1966–1967): 55–75; 44 (1971–1972): 123–39.

[32] Vitr. *De Arch.* 3.3.4. P. Gros, *Aurea Templa, BEFAR* 231, 214.

[33] G. Carettoni, "La costruzioni di Augusto e il tempio di Apollo sul Palatino," *Quaderni del centro di studio per l'archeologia etrusco-italica* 1 (1978): 72–74.

[34] B. Kellum, "Sculptural Programs and Propaganda in Augustan Rome: The Temple of Apollo on the Palatine," in R. Winkes, ed., *The Age of Augustus*, 169–76. The discussion of the sculptural program essentially follows Kellum's interpretation of the political meaning of the Danaid group as an analogue for civil war. I thank her for allowing me to read a chapter of her forthcoming book on Augustan Rome. My interpretation of the Danaid group differs in emphasis on the bride motif.

[35] Zanker (1988), 44–53, 57–65.

this discussion are the ivory panels of the temple doors and the statuary group erected in the portico. Only a fragment of the door frame is extant, but both the doors and the sculpture of the portico are attested by Propertius.[36] The reliefs on one side of the doors showed the attempted Gallic sack of Delphi in 279 B.C. at which Apollo successfully defeated an attack on his shrine, and a victory was gained for Actian Apollo.

The scenes of the other side showed Apollo and Diana avenging an insult to their mother, Latona. Niobe, the fruitful mother of twelve children, boasted that she was equal to Latona, who had only two.[37] To uphold their mother's honor, Apollo and Diana hunted down all of Niobe's children and killed them. Zeus turned the dead children into stone, and Niobe herself was also transformed, literally petrified by her grief. The myth of Niobe illustrates the fall of a proud, boastful woman who dared to compete with a superior. Niobe challenged Latona in her abilities as a mother to bear and raise children, and divine punishment came with the slaughter of her family and the end of her life as a woman: she is returned to the earth as a stone, the antithesis of the fertile, moist earth as depicted in the "Tellus" relief on the Ara Pacis.

The theme of divine punishment invites comparison with the Arachne myth. Although they differ in status, Niobe and Arachne both threatened higher authorities. Arachne put herself in competition with a goddess in the arena of the domestic and artistic skill of weaving, that is, in the making of fabrics woven with marvelous images of the gods' deeds, their disguises and abductions. Like Niobe, Arachne is visited with destruction and returned to nature, although not as a stone but as a spider spinning sticky webs. Their punishments are fitting: the ambitious weaver is left in a state of frenzied animation, ceaselessly spinning away, and the boastful mother is rendered mute and barren, the stone in a field evoking the image of the infertile earth, closed and unyielding. Arachne and Niobe were initially brought down because of a few, reckless words: the irrepressible young woman was transformed into an animal who traps and, perhaps, devours her mates, while the matron became an inanimate object in the landscape.

Barbara Kellum has discussed the significant themes of the Niobe myth in the Augustan political context: vengeance and the duties of a loyal son.[38] The actions of Apollo resemble those of Octavian, who had avenged the murder of his divine adoptive father, Julius Caesar.

A sculptural group, which was placed in the intercolumniations of the

[36] Prop. 2.31.3; 2.31.12
[37] Hom. *Il.* 24.604. Ovid *Met.* 6.182–3.
[38] Kellum (supra n. 34), 172–73.

portico surrounding the temple, achieved a certain notoriety, no doubt because of its lurid subject matter, Danaus and his daughters, the Danaids.[39] Not only was the group distinguished by a Greek mythological subject rarely depicted in monumental sculpture (as is the frieze of the Forum Transitorium with the Arachne myth), but also by the quantity of the statuary. All but one of the fifty daughters of Danaus obeyed their father's command to murder their bridegrooms on their wedding night. Fifty statues represented the daughters, along with their father, Danaus, although the bridegrooms were probably not represented by fifty equestrian statues, as indicated by a late source.[40]

The massacre was precipitated by a quarrel between two brothers, Danaus, with his daughters, and Aegyptus, who had fifty sons.[41] Aegyptus, the stronger of the brothers, was eager that they settle the dispute by marrying his sons to their cousins, even after Danaus had fled their home in Egypt for Argos in Greece. Initially reluctant, Danaus consented to the marriages but secretly instructed his daughters to murder their husbands on their wedding night. The marriage beds became bloodbaths when the brides cut off their husbands' heads. A political conflict between two brothers, kings of neighboring lands in north Africa, is resolved in the exchange of women, the bride motif. Unlike the Sabine women, the Danaids, however, rejected the role of mediators, and executed their father's plan with a grisly efficiency. The myth of the Danaids illustrates the betrayal of the most intimate social bond in the name of revenge, and the story is also an inversion of the legend of Tarpeia, in which it is Tarpeia who betrays Rome and is punished for her act with death at enemy hands. In contrast to the Sabine women and Tarpeia, the Danaids are resistant to marriage or to any relationship with these men who are their cousins. The Danaids are punished for their crime against marriage and the family in Hades, where they are assigned the endless labor of filling a leaky jar with water (in other versions of the myth all the daughters are killed except for one who spares her husband or they are purified by Athena and Hermes and given in marriages to new suitors).[42]

It is significant that the family was Greek, although they lived in Egypt. Not only were they foreigners, but one of the Danaids is called Cleopatra in several sources.[43] Cleopatra, a descendant of the Greek Pto-

[39] Prop. 2.31. Ovid *Tr.* 3.1.61–62. A group of fifteen to twenty marble torsos of "Amazons" found on the Palatine in the sixteenth century may have been some of the Danaid figures. See C. Vermeule, *Greek Sculpture and Roman Taste*, 49–51.

[40] *Schol. Pers.* 2.56.

[41] C. Bonner, "A Study of the Danaid Myth," *HSCP* 13 (1902): 129–73.

[42] Schol. *Eur. Hec.* 886. Apollod. *Bibl.* 22. Pind. *Pyth.* 9.11.2.

[43] Apollod. *Bibl.* 2.1.5,4 and 7; Hyg. *Fab.* 1.70.

lemies who ruled Egypt, is clearly to be seen in the figures of the Danaids whose unbridled rage leads to fratricide and civil war. The myth provides an analogue to events of the years between 43 and 31 B.C., during which the disintegration of the Second Triumvirate propelled Octavian and Antony into rivalry for control of the Roman world. In this conflict, Roman fought against Roman, and the campaigns were accompanied by conscriptions and mass killings of citizens. After Octavian defeated Antony and Cleopatra at the battle of Actium in 31 B.C., it was necessary to expiate the bloodshed of the civil war through acts such as the dedication of this temple with its sculptural program alluding, through mythological models, to the breakdown of social bonds, the rupture of families.

Paul Zanker points out that the one Danaid, Hypermestra, who refused to obey her father and, instead, saved her husband, Lynceus, provides a heroic model.[44] There are two versions of the myth: in one, Lynceus promised to respect Hypermestra's virginity; in the other, Lynceus consummated his marriage to Hypermestra with her consent. In the latter version, Hypermestra spares Lynceus because, as a typical bride, she desires a child. In the former, she spares him—ironically—precisely because he agrees not to consummate the marriage. The other husbands consummated their marriages by taking the reluctant brides by force, then fell asleep, and later were roused by the pressure of daggers at their throats. The festivities of weddings are turned upside down, with tenderness replaced by brutality, consummation by rape, and the prospects of new life by death.

One bloody wound is answered by another: the act of defloration is the catalyst for the decapitation of the bridegrooms. Sexual initiation, the breaking of the hymen, holds a promise of violence that is fulfilled when the Danaids murder their husbands (the decapitation serves as a metaphor for castration). By absolutely rejecting marriage and their husbands, the Danaids attempted to keep their bodies intact, sealed, and unopened. As Page duBois comments, they represent an extreme form of the typical resentment of spirited young women, acolytes of Artemis-Diana, toward the yoke of marriage, and they stand by their father because they are still young girls living under his roof.[45] The Danaids are no longer virgins, and they cannot act as wives although they have submitted to the corruption of the marriage bed.

Blood is let in marriages that are synonomous with war, the wedding

[44] Ovid *Her.* 14. P. Zanker, "Der Apollontempel auf dem Palatin. Ausstattung und politische Sinnbezüge nach der Schlacht von Actium," in *Città e architettura nella Roma imperiale, AnalRom*, Suppl. 10 (1983): 21–40.

[45] P. duBois, *Sowing the Body, Psychoanalysis and Ancient Representations of Women*, 146–47.

night is a battlefield in which the violated brides are warriors who mutilate their rapist-husbands.[46] Not only is the institution of marriage under attack, but the sanctity of blood relations is contaminated by the murder of cousin by cousin. The family is destroyed by Danaus and his daughters, the brides who resolutely refuse to be possessed by their husbands.

The linking of marriage and violence is also suggested in the preparations for the Roman wedding. The bride's coiffure is created by parting her hair with a spear that had been bloodied, dipped in the wounds of a dead gladiator.[47]

In reality the spear may have been a shortened, blunted instrument similar to a knitting needle or crochet hook, but the gruesome origins of the ritual reflect a preoccupation with the blood shed during the first act of intercourse.[48] For men the rite of passage ended with their emergence as warriors, and the intrusion of a weapon in a bride's trousseau, particularly one that touched her head, indicated her submission to her husband. Marriage, not warfare, was the rite of passage for women; bloodletting initiated both institutions.

Furthermore, the bride, treated as a captive and war booty in the founding myths, was prepared for her wedding in a ritual manner. In Greek society parallels between the bride and a sacrificial animal have been noted: both were considered to be wild and untamed creatures who must suffer their fate, both were expected to meet ritual standards of purity, the heads of both were filleted and adorned (it is significant that the Roman Vestal Virgins wore their hair in the bride's coiffure), and they were brought forth in processions accompanied by flute-players, torch-carriers, and celebrants.[49]

During the Roman wedding the bride's procession to her new house was enlivened by guests singing obscene and humorous songs, and such songs were also part of the triumphator's procession to the Capitol.[50] Both processions and raucous singing mark the passage from the wider world to the confines of the house or the city in which the bride or general will reside. The powers of the bride and the triumphator, the threat of uncontrolled sexuality and aggression, are subdued through the crossing

[46] M. Detienne, "Les Danaides entre elles ou la violence fondatrice du mariage," *Arethusa* 21 (1988): 159–75.

[47] Festus 62–63 M; 55 L. Ovid *Fasti* 2.560. W. Burkert, *Homo Necans: The Anthropology of Ancient Greek Sacrificial Ritual and Myth*, 62.

[48] M. Torelli, *Lavinio e Roma*, 32–33.

[49] N. Loraux, *Tragic Ways of Killing a Woman*, 31–48. On the Vestals: Beard (supra n. 17), 15–16.

[50] Stehle (supra n. 10), 146–47. L. Bonfante Warren, "Roman Triumphs and Etruscan Kings," *JRS* 60 (1970): 65.

of sacrosanct boundaries, the threshold and the city gate, and restrained by the society within.

It is not known how the statue of Hypermestra was displayed in relation to the other figures of the portico, but, surely, a moral contrast is implied (as in the sections of the friezes of the Forum Transitorium and the Basilica Aemilia). Among the Danaids, Hypermestra upholds the bonds of family and marriage in a world mad for vengeance (although, in one version, she maintains her virginity). In contrast, the Danaids' rejection of marriage to their cousins, marriages that were legitimate, went against nature and society. They are girls, untamed and as wild as animals, who prefer to fight and kill rather than to be taken in marriage. To the ancient Greek and Roman, the vision of a band of young women wielding daggers, an image as threatening as the bloodthirsty sisterhood of the Amazons, represented the failure of social institutions, such as marriage, that were intended to civilize young women and to mold them into wives and mothers.

Furthermore, Zanker suggests that the Danaids were represented carrying vessels of water in the underworld, which was their means of atonement.[51] While the Danaids are almost always depicted in vase painting as water carriers, this is not the case for the sculpture in the portico of the Temple of Apollo. Barbara Kellum observes that the narrative moment of interest here was the bloody wedding night.[52] Ovid (*Tristia* 3.1. 60–62) describes the statue of Danaus holding his sword drawn, indicating that the bloody assault is depicted already in progress. The Danaids were probably arranged in suggestive poses of attack between the columns of *giallo antico*, yellowish marble interspersed with red blotches.[53]

Yet the water-carrying motif is significant for the Danaids' role. Vessels, hollow or full, have long been associated with the female body as a container for the male seed. The jar also evokes household goods under the care of the wife in her domestic duties and, thus, symbolizes the faithful and fertile wife. Giulia Sissa has pointed out that the Danaids, all husband-killers except for Hypermestra, were trapped in an intermediate

[51] Zanker (supra n. 44), 27–31, discusses archaistic statuary (including the bronze dancing figures in Naples from the Villa dei Papiri), some of which represent water carriers. Yet there is no compelling reason to link these works with the Palatine Danaid group. See *LIMC* 3.1, 337–46 (E. Keuls) on representations of Danaids, and *LIMC* 3.5, 402, kat. no. 2 (G. Berger-Doer) on Hypermestra. E. Keuls, *The Water Carriers in Hades: A Study of Catharsis Through Toil in Classical Antiquity*, 46–49, for a version of the myth that has Lynceus killing his sisters-in-law (Ovid *Her.* 14. 115–18). R. Ling, *Roman Painting*, fig. 111, for a representation of the Danaids in the underworld in the Odyssey Landscapes.

[52] Kellum (supra n. 34), 173.

[53] Prop. 2.31.3. Kellum (supra n. 34), 173–74.

state: they were no longer virgins yet they could never be mothers because of the taint of their crime.[54] Furthermore, Sissa observes that their bodies are analogous to the leaky vessels, pierced by the rape of their wedding night yet unable to conceive or to carry children. Their bodies are useless, empty, and sterile. They are doomed to repeat an act that reenacts their unfulfillment.

Zanker notes that the selection of a mythological subject for the statues of the portico was problematic because of the nature of Octavian's victory over Antony.[55] One could not portray Romans attacking their enemies because the enemies, with the exception of Cleopatra, were Romans. In a temple commemorating Apollo's role in the victory at Actium, as well as the beginning of a new age, the realities of the civil war were better represented, indirectly, with the myth of the Danaids' wedding night providing the key. The myth provided the vehicle to express the horror of fratricide, of a world torn apart by internecine conflict, yet it also may have served to displace responsibility for the civil war, substituting the preferred Augustan preoccupation with moral responsibility, particularly feminine morality. The statues of the Danaids recalled Cleopatra, an evil, unnatural, and foreign woman to the Romans, who evoked the menace of female depravity and corruption. In other words, the fighting was portrayed not only as the result of the political ambitions of Octavian and Antony but also as a symptom of more pervasive social ills.

After he won the war, Augustus set out to heal Roman society, and one of the key themes of his policy was *pietas*, which was demonstrated by rebuilding temples, reviving old cults, and calling for a return to ancestral values. The *lex Julia de maritandis ordinibus*, his legislation to enforce traditional morality and to encourage marriage and the birth of children, may have been proposed in 29–28 B.C. but was finally enacted in 18 B.C. in anticipation of the Secular Games.[56] Related to these laws, the *lex Julia de adulteriis coercendis* of 18 or 17 B.C. made adultery a crime that was prosecuted in the courts (the *lex Papia Poppaea* complemented it in A.D. 9).[57] Conventional attitudes placed the blame for the alleged moral collapse on aristocratic women, whom the poets described as making a mockery of their marriage vows.[58] Augustus seemed obsessed with his program of

[54] G. Sissa, *Greek Virginity*, 157–64, 147–56.

[55] Zanker (supra n. 44), 29.

[56] L. Raditsa, "Augustus' Legislation Concerning Marriage, Procreation, Love Affairs, and Adultery," *ANRW* 2.13 (1980): 278–339.

[57] Grelle, 346–350. E. Cantarella, "Adulterio, omicidio legittimo e causa d'onore in diritto romano," *Studi in onore di Gaetano Scherillo*, 243–74. A. Richlin, "Approaches to the Sources on Adultery in Rome," H. Foley, ed., *Reflections of Women in Antiquity*, 379–404.

[58] Horace *Carm.* 3.6; 3, 24.

moral reform, and perhaps it was the idea of decline, so deep-rooted in Roman thinking, that troubled him. The Julian laws, which were devices to maintain social control, failed.

It would have been impossible to redeem the institution of marriage to the extent that Augustus seems to have expected, because Roman attitudes towards marriage were so deeply ingrained and contradictory. Judith Hallett has argued that the Romans seemed not to value the bond between man and wife as highly as other relationships and did not expect as much from it (as, for example, from father-and-daughter or mother-and-son relationships) and, in fact, invective against marriage was commonplace.[59] When Augustus tried to persuade members of the senate to marry and have children as their civic duty, he read them a speech made by a censor in the late second century B.C. In the tract entitled "On Increasing the Birthrate," marriage is considered a necessary ordeal fraught with discomfort and aggravation.[60] Moralists such as the elder Cato had appreciative audiences for anecdotes about uppity, overbearing wives who refused to obey their husbands.[61]

The emotional distance between husband and wife is based, to some extent, on social practices: women wed while they were very young— frequently aristocratic girls were married by the age of fifteen, although others married in their late teens or early twenties; men became husbands in their twenties or thirties, and spouses were chosen by fathers who looked for advantages, especially political ones, from the marriages.[62] Furthermore, the legal terms of Roman marriages may also have contributed to the situation since the wife left the *potestas* of her father and came under her husband's authority in marriage *in manus*; in the marriage without *manus*, more popular since the late Republic, the wife remained in her father's power and, upon his death, became an independent property owner. In the latter arrangement, the wife was not a part of her husband's family (she would be legally independent from him) and, in the former, she counted as an adopted daughter (in relation to her husband or to the *pater* of the house) in terms of her legal rights and obligations.[63]

Marriages were all the more fragile because of the ease with which Romans could divorce and remarry. Often political motivations, specifically the need to create alliances among the senatorial families, forced couples to split up and regroup. Given that the elite matron was often legally and

[59] J. Hallett, *Fathers and Daughters in Roman Society*, 211–62.

[60] Aul. Gell. *NA* 1.6.2.

[61] Plut. *Cat. Mai.* 8.2–3, 9.6, 17.7, 20.2.

[62] K. Hopkins, "Age of Roman Girls at Marriage," *Population Studies* 18 (1965): 309–27. B. D. Shaw, "The Age of Roman Girls at Marriage: Some Reconsiderations," *JRS* 77 (1987): 30–46.

[63] Gardner (supra n. 11), 67–80.

financially independent and commonly outlived her older husband (to whom she had been given in an arranged marriage rather than a love match), she was portrayed by the satirists as immoral and wanton, eager for all sorts of lovers from the gutter.[64] Among the historians, Livy subordinates the violence done to heroines, such as Lucretia, to political ends, and Tacitus reports charges of adultery used to support accusations of treason among noble households teeming with informers.[65] Cases of adultery became staples in the schools of rhetoric, but these were sensationalized exercises that strained credibility.[66] It is rather difficult to assess how adultery actually affected the divorce rate and how the Lex Julia was administered.

The crime of adultery in the lex Julia de adulteriis coercendis was defined as sexual intercourse between a matron and any man besides her husband; a married man could indulge himself with male slaves or freedmen, or with unmarried women who were not respectable (he could also keep concubines of both sexes in his home). It is not clear exactly what the Domitianic revival of the law entailed because it is not discussed in legal texts of the late Empire.[67]

The law is primarily concerned with procedure: the husband was to divorce the wife as soon as he knew of her adultery (and if he didn't, he was liable for charges of complicity or pimping; husbands accused of profiting from their wives' infidelity incurred derision and contempt), the husband or father had sixty days to accuse her of adultery, and two months after the divorce any third party could make the charge within the next four months (although the statute of limitations was five years, perhaps in case evidence emerged much later).[68] The penalties, according to the Digest 48.5 and Codex 9.9, include the father's right to kill the lovers if he caught them in flagrante delicto at home, and the husband's right to kill the adulterer only if he was *infamis* (an actor, a freedman of a member of the immediate family, a pimp, or a criminal). If the adulterer escaped the murderous wrath of the husband or father, then he would be accused and tried first (and the woman's reputation depended on the outcome of his trial). If found guilty in their separate trials, the wife and her lover were exiled separately, and they could stand to lose property.

Adultery was a crime against the family and the state because the pa-

[64] Mart. *Epigr.* 1.62; 2.56; 10.69; 12.58; 6.31; 3.92; 6.67; 10.41. Juv. *Sat.* 6.115–35; 364–74; 642–50. J. P. Sullivan, "Martial's Sexual Attitudes," *Philologus* 123 (1979): 288–302. K. R. Bradley, "Remarriage and Structure of the Upper-Class Family at Rome," in K. R. Bradley, ed., *Discovering the Roman Family*, 156–76.

[65] Supra n. 19. Tac. *Ann.* 2.50.

[66] Richlin (supra n. 57), 390–91.

[67] See chapter 1, for Martial's allusions to the law.

[68] Richlin (supra n. 57), 380–83, for a summary of the evidence.

ternity of the child and the transmission of property would be in question if the mother were not chaste. The legislation applied mainly to the elite, for whom it was an unpopular measure. Augustus took the initiative of setting a harsh example by sending his adulterous daughter and grand-daughter into exile in 2 B.C. and A.D. 8. There were imperial divorces, Julia and Tiberius, Octavia and Nero, and Domitia and Domitian, the latter allegedly on the grounds of adultery although the absence of an heir probably motivated their temporary separation.[69] Other husbands may have simply looked the other way, as the poets suggest. Husbands or fathers could also have taken their own measures without recourse to the law.

The ideal marriage is less clearly defined in the sources. The *materfamilias* was expected to fulfill herself through her devotion to her family, to the raising of children and the management of the home. Despite the cynical view of wedlock held by the moralists, the ideal wife was the *univira*, the woman who had been married only once in her lifetime and, preferably, for a long time.[70] Her identity and status depended on motherhood, as exemplified in the female figures of the friezes of the Ara Pacis and in the "Tellus" panel (fig. 86). The Augustan legislation also attempted to encourage adults to become the parents of legitimate offspring.

The Augustan laws, the lex Julia de maritandis ordinibus and related measures, penalized unmarried men from the ages of twenty-five to sixty and unmarried women from twenty to fifty who did not have children and did not remarry if they were divorced or widowed.[71] These citizens did not have the right to inherit or to dispose of wealth freely. If, on the contrary, a married couple had children, and three children in particular, they gained the *ius trium liberorum* (the right of children), which gave them privileges such as advancement in the father's political career and financial autonomy for the mother.

The reasons why Augustus felt compelled to establish these laws are not known. Concern for manpower and the army may have been a factor behind this appeal to increase the birth rate.[72] He may have wanted to ensure that propery would not pass out of the possession of noble families due to childlessness and will-hunting.[73] There may also have been a shortage of available nubile women: although Augustus did not care for marriage between those of different status, he allowed the freeborn, except

[69] See introduction.

[70] S. Dixon, *The Roman Mother*, 22. Columella *Rust.* 12.4.

[71] Dixon, ibid., 71–73, 84–103.

[72] Horace *Carm.* 3.6.

[73] A. Wallace-Hadrill, "Family and Inheritance in the Augustan Marriage Laws," *PCPS* 27 (1981): 58–80.

senators and their descendants through males to the third degree, to marry freedwomen or freedmen.[74]

One of the prerequisites of empire is the moral superiority of its citizens, as Horace implies in his *Carmen Saeculare* of 17 B.C., written to be sung by a chorus of boys and girls in the sanctuary of Apollo on the Palatine on the last day of the festival. Karl Galinsky has suggested that the moral principles on which the Augustan legislation was grounded served to justify the expansion of the empire.[75] The sense of Rome's historic mission would be meaningless if the Romans were no better than those they defeated and governed, and the continuity of the empire depended on the cultivation of these values among the new men who were joining the senate.

The image of the dutiful matron at her loom was never far from these appeals to traditional morality. Suetonius claims that Augustus wore only clothing woven by the women of his family, implying that Livia was a model of probity and industry, a Lucretia who never had to be tested.[76] That woolworking was synonomous with the chaste matron is a refrain common to literature and the epitaphs of matrons, both freeborn and freed. Yet, the activity of weaving was also thought to bring certain powers to the weaver.

For Arachne weaving is synonomous with the young woman's assertion of her own power and vision, with the poet's capacity to tell a tale, as represented in her woven depictions of a mortal's view of divine justice and its deceptions. It is also a means of expression for the mythical Philomela, raped by her brother-in-law, rendered mute by a brutal act, and left to weave her story in a fabric to inform her sister of the crime.[77] Weaving serves as a form of communication for women who, in most cases, were not taught to read or write as were men.[78]

The activity of working a loom is one of binding and connecting the threads, and spinning is fashioning a continuous, sturdy thread from the loose, formless wool. The production of an elaborate woven fabric from dirty, unsorted wool becomes a metaphor for creating order out of disorder and also for growth and increase by the process that converts raw, animal by-products into refined, luxurious goods. In popular superstitions wool and weaving were thought to affect agricultural production and human reproduction.

For example, the elder Pliny reports that women were not supposed to spin while walking near a field under cultivation because the twirling ac-

[74] Dixon (supra n. 70), 93.

[75] Galinsky (supra n. 1).

[76] Suet. *Aug.* 73.

[77] Apollod. *Bibl.* 3.193. Ovid *Met.* 6.424–674.

[78] Klindienst Joplin (supra n. 15), 43–53.

tion of the spindle could blight the harvest (perhaps, by tangling the roots or stalks of the plants). Unborn babies could also be harmed by the proximity of spinners (the fertile female body is equated with a flowering field). Infections of the groin were treated by tying the area with threads from a loom: each thread must be knotted and the name of a widow must be called out as each knot is tied. One was, in effect, *remarrying* the widow by announcing her name at the same time as tying the knot and, therefore, making the knotted threads fertility amulets.[79] In other instances, such as before the onset of labor, clothing had to be untied or loosened and hair unbraided to signal the opening of the body and the passage of the infant.[80] The actions of binding and unbinding, whether threads, hair, or clothing, and of setting off the rotary motion of the spindle released forces that interfered with nature.

Wool also had powers of purification. Woolen fillets were hung in sacred sites, on temples and altars. During the festival of the Compitalia, woolen figures, substitutes for human sacrifice, were hung at vulnerable sites, at crossroads and on house doors.[81] In the marriage ceremony, the bride, never far from her distaff and spindle, decorated the doorposts of her new home with woolen fillets and then anointed them with animal fat before crossing the threshold.[82] This marked the bride as the *custos domi*, the keeper of the house, and suggested her role in protecting and conserving its resources. The wool smeared with fat absorbed impurities at the entrance, at the point of contact with the exterior. The wool, material for warm outer clothing, and the fat, an inner protective layer, *clothing for bones*, both evoke the riches of a prosperous and secure home. After her arrival in her new house, the bride was also expected to sit down on sheepskin, a rich furniture covering and material similar to the objects of her labor, the animal hair and hide to be refined as textiles.

The sight of a spinner, particularly upon awakening in the morning, leaving the house, or setting out on a journey, was a grim reminder of the inexorable Fates, Clotho, Lachesis, and Atropos, who spin a thread for each person at birth and cut it off at death.[83] If wool is the raw material of life, then the spun thread represents the extent and duration, the narra-

[79] Pliny *HN* 28.29; 28.48. X. Wolters, *Notes on Antique Folklore, on the Basis of Pliny's Natural History, Books 28.22–29*, 113–24, 132. The explanation of the knotting of the threads is my own. Also, J. Maurin, "Labor matronalis: aspects du travail féminin à Rome," in E. Lévy, ed., *La femme dans sociétés antiques*, 139–55.

[80] See chapter 2.

[81] Macrobius, *Sat.* 1, 7, 34. M. B. Ogle, "The House-Door in Greek and Roman Religion and Folklore," *AJPh* 32 (1911): 251–71. See chapter 2.

[82] Pliny *HN* 8.194. Plut. *Quaest. Rom.* 31.

[83] Mart. *Epigr.* 9.17 for Julia Titi as a Fate, spinning the destiny of Domitian's son. Wolters (supra n. 79), 123–24. See chapter 2 for Picard-Schmitter's identification of several of the frieze's figures as the Fates.

tive, of that life. Greek myth and tragedy abound in women who weave plots of intrigue, and woven garments serve as instruments of murder for Clytemnestra, Medea and, unwittingly, for Deianeira. The domestic task of woolwork kept women cloistered in the home, and the darkened confines of the women's quarters were allegedly seething with treachery and deceit. If spinning is seen to be a more mechanical activity, then weaving allows for the artifice of enraged wives who trap their men by suffocating or poisoning them in their webs. A vision of the Fates was a warning of one's impending death.

Weaving is also a metaphor for statesmanship. The state is a well-woven fabric, and weaving is the art of composition and division, skills recognized as those required of politicians, who bring unity and order.[84] The loom serves as a civilizing agent not only through its role in the household economy but also because of the regular arrangement of warp and weft threads intersecting at right angles in the form of a grid. The grid is the schema of the ideal city plan with its symmetrical blocks and intersecting streets as an emblem of civilization and of a rational distribution of space. With its back and forth motion, over and then under the warp threads, the spool or shuttle, like the senator followed by his entourage as he makes his way to the forum, follows a regular course, marked by the connections made along the way. The weaver as navigator is suggested by the Greek word, *histos*, that denotes the loom (or its upright beam), as well as the mast of a ship. The methodical and deliberate actions of the weaver at the loom are analogous to those of the men who chart the progress of civic life, and reflect the cunning of the politician, the orator, and the general. Artemidorus in his interpretation of dreams states that to dream of the upright warp-weighted loom predicts a journey because a woman working at this loom has to walk back and forth (and to dream of the loom with upper and lower beams suggests rest because a woman may sit as she works that loom).[85] The back-and-forth movements of the weaver can also be likened to the journey of the bride from her father's house to that of her husband and to her role in knitting the bonds between men, in creating harmony from discord.

Weaving instruments, such as the shuttle and pin beater, were said to *sing* as they ran among the threads. A weaver uses the pin beater (or beater-in), a tool to beat the weft into place with quick strokes, like a

[84] Plato *Leges* 311.

[85] Artemidorus *Oneirokritika* 3.6. The old-fashioned warp-weighted loom was still used to weave the bride's costume and the tunics worn by boys assuming the *toga virilis*. See chapter 2.

musician plucking the strings of a lyre with a plectrum.[86] The musical notes of the pin beater, the *nightingale* of woolworkers, had the power to enchant its listeners and to transport lovers of song. The sounds and rhythms of weaving are evidence of the divine order and the divine inspiration of artists and artisans.

Spinning and weaving served to initiate women into domestic life and fostered self-sufficiency and prosperity. Woolwork provided metaphors for civilization and progress and for the bonds formed by members of an organized community, as well as for the power of the spellbinding artist. As activities with the power to create gossamer from base materials, spinning and weaving assumed supernatural properties associated with the Fates and also with cunning women who used their craft to turn order into chaos, trust into treachery, and life into death. What is missing is any indication of the economic realities of woolwork: who actually spun the wool and wove the garments worn by elite matrons, virtuous or otherwise, and their spouses?

A staff in the imperial household produced fabric and garments. Many workers in the imperial and noble households, as well as those in urban workshops, were slaves, with male slaves working as supervisors in the top establishments while female slaves did the spinning (few epitaphs remain of professional female weavers).[87] The urban workshops making fabric and clothing on consignment provided employment for free men and women, as well as for slaves. Literary sources and funerary inscriptions suggest that women from the lower social orders earned little income from spinning or weaving, either by taking in work for others or by working outside the home. The ideal of the matron making her own cloth had little to do with the reality of fabric work as a low-paying job for free women and men and an occupation for slaves. The low status and meager financial rewards of the textile industry are probably confirmed by the few funerary reliefs that depict the craft with representations of sheep, shears, and displays of cloth (for a relief depicting a fuller, see fig. 42; a late second-century sarcophagus in the Getty Museum, Malibu, offers an unusual representation of men combing and winding wool).[88]

[86] Plato, *Cratyl.* 389. Verg. *Aen.* 7:18. S. B. Pomeroy, "Supplementary Notes on Erinna," *ZPE* 32 (1978): 17–22. G. Crowfoot, "Of the Warp-Weighted Loom," *BSA* 37 (1936–37): 45–46.

[87] Columella *Rust.* 12.9. N. B. Kampen, *Image and Status: Roman Working Women in Ostia*, 121–23. S. Treggiari, "Jobs in the Household of Livia," *PBSR* 43 (1975): 48–77; idem, "Jobs for Women," *AJAH* 1 (1976): 76–104.

[88] G. Zimmer, *Römische Berufsdarstellungen, AF* 12, 120–32, kat. nos. 33–46a. G. Koch, *Roman Funerary Sculpture: Catalogue of the Collections*, 86.AA.701, no. 9, 24–27. Another related relief was on the New York art market in 1986.

CONCLUSION

Women's Work

THIS STUDY of the Forum's frieze reveals that its anomalous imagery, in some ways more typical of a private than of a public context, is nonetheless determined by imperial ideology. Rather than depicting vine scrolls or Victories slaying bulls, the frieze's motifs are transposed to another key: worship at sacred places and the virtues evoked by the loom and spindle convey the dominant and authoritarian values of Roman society under Domitian.

The theme may be conventional in some ways yet the underlying organization of the motifs is not easily discernible. The mythological episode is the centerpiece of the frieze's depiction of moralizing exempla, both literally and figuratively: the punishment of Arachne serves as a grim reminder of the fate of those who defy the goddess, while the surrounding scenes of women spinning and weaving under the tutelage of Minerva represent models of virtue. Rather than depicting weaving as a craft or industry, the woolworking motif serves as a *topos* for the devout matron, the guardian of traditional society.

The ideological content of the frieze is emphasized by its composition and internal structure. A hierarchical composition is evident in the central position of the mythological scene directly below the attic relief of the militant Minerva. Placed on the dominant vertical axis, the mythological event, Minerva punishing Arachne, is abbreviated into an emblem that depicts the culminating scene. The scenes that interrupt the narrative with depictions of personifications or deities on either side serve as glosses, which extend the theme through the more mundane and official iconography. The reduction of a narrative into its most telling episode and the substitution of symbolic figures for a coherent narrative sequence constitutes an emblematic narrative, which alludes to abstract moral truths through the juxtaposition of the mythological scene with the personifications. By presenting models of exemplary behavior and deterrent cases of reckless conduct, the emblematic narrative operates on the principles of analogy and antithesis.

In the Augustan period, the emblematic or iconic subject was employed to convey the proclaimed return to the mores maiorum.[1] In particular, female protagonists or, rather, anti-heroines and mythological subjects reflect the Augustan preoccupation with the morality of domestic life, and also convey the need for reform, so urgently desired by Augustus and expressed, in part, through his social legislation. Domitian attempted to reinforce the Julian law on adultery in 89–90 in order to recast Roman society, to rehabilitate or, at least, inhibit the spoiled aristocracy and to impress the new elite from the provinces, who were entering the Senate in greater numbers. His Secular Games of 88, also established under Augustus, were intended to mobilize the entire populace in religious worship and celebrate his vision of a new society and a new age. Accordingly, Domitian sought out mythological exempla to give shape to his vision, and it is the cautionary message of the Arachne myth that was probably prominent among them.

Not only is the representation of the Arachne myth unusual in this context but its incorporation of non-narrative or symbolic elements is significant for the study of Roman relief sculpture. The often conflicting aims of narrative and symbolic representation in Trajanic relief sculpture, for example, need to be reconsidered in this light.[2] Moreover, there are broad implications for the question of what constitutes narrative in Roman art.[3]

The symbolic representation and emblematic narrative derive from the imagery of coins, medallions, and the emblema of mosaics, and both the minor arts and monumental sculpture convey the same themes of imperial propaganda. The frieze makes use of an eclectic yet stock iconography to familiarize its audience with a rare mythological subject that was not depicted on any other extant state monument, and the moral of the story is brought home by the non-narrative elements, such as the personifications that provide commentary on the theme. It seems as if the frieze was aimed at the widest possible audience from unlettered artisans of the Subura, for whom the repetition of a clichéd message made sense, to the recently inducted elite, who were perhaps more sensitive to the patriotic and commanding images of Minerva.

Domitian's social programs were only a part of his plan to restore Rome's sense of mission: the urban, as well as the moral, fabric needed

[1] Zanker (1988), 205, on the narrative technique that ignores temporal distinctions and conveys the presence of an "icon."

[2] See, for example, the standard account of P. G. Hamberg, *Studies in Roman Imperial Art with Special Reference to the State Reliefs of the Second Century*. More recently, on sign theory and Roman reliefs, see A. M. Leander Touati, *The Trajanic Frieze*.

[3] R. Brilliant, *Visual Narratives. Storytelling in Etruscan and Roman Art*.

repair. Not only did he complete the projects left unfinished by his father and brother, but he also had the opportunity to rebuild quarters of Rome that were destroyed or damaged by the fire of 80. Domitian intended to be remembered as the *renovator urbis* for restoring the city and, more importantly, its hallowed temples and revered shrines. The old state religion also served to bolster the Flavian dynasty: Domitian dedicated temples to Minerva, as well as to his father and brother, and erected a temple of the Flavian dynasty on the site of his birth on the Quirinal. Many of his buildings were located on strategic routes within the city or in historically significant sites so that the Flavian ascendancy was assured by its possession of the most venerated locations. The siting of the Forum Transitorium along a street amid the other imperial fora clearly illustrates this predilection.

Just as the more unusual aspects of the architectural design of the Forum resulted from the its restricted site, so the frieze's iconography was determined by its rare mythological subject, and its sources are found in Hellenistic or Roman genre statuary and votive reliefs, among other works. Even the categories of public and private art are less definitive in this context: the sources of the frieze's imagery imply that the boundaries between official and vernacular modes were less rigid than once was believed. In particular, sources for the weaving motif as a moralizing exemplum also derived from individual commemorations, such as the reliefs and inscriptions adorning tombs.

The counterpart to the mythological subjects and idealized imagery of the frieze is the commemoration of women, decent and faithful matrons, in funerary art and epitaphs. Of course, references to the matron's skill at the loom frequently appear in epitaphs to indicate the domestic virtue of the honored woman. Weaving implements, such as the spindle and distaff, are represented in funerary reliefs and on altars as the attributes of the exemplary matron.[4] Conjugal fidelity and devotion to the family and home were demonstrated by the matron's tireless preoccupation with her chores, and her selfless attention to weaving, once seen as the test of moral purity, became a standard refrain. Towards the end of the Flavian period (the late first century A.C.), the commemorations of the matrons of the lower social strata appear to be influenced by the mythological portraits of the imperial women. One relief in particular, that of Ulpia Epigone in the Museo Gregoriano Profano in the Vatican, depicts the partially nude and bejewelled deceased as Venus who displays a wool basket.[5]

[4] G. Zimmer, *Römische Berufsdarstellungen, AF* 12: 63, 193, kat. no. 133. Este, Museo Nazionale Atestino, Inv. 1347.

[5] E. D'Ambra, "The Cult of Virtues and the Funerary Relief of Ulpia Epigone," *Latomus* 48 (1989): 392–400. D.E.E. Kleiner, "Second-Century Mythological Portrai-

The equation of weaving and chastity probably had to do with the matron's role as the preserver of her husband's possessions, which he often acquired abroad and brought home for her to maintain or to convert into finished products (from wool to textiles). Women's work was usually a solitary affair, performed within the house, and the ideal wife, always busy with her tasks at home, had no time to waste, no opportunites for flirtations or indiscretions. As the custodian of her husband's keys, she was to guard the home against unwanted intrusions and to enhance its value through her industry and thrift. The matron, like the Vestal Virgins, renewed and increased the resources of the home from within. An act of adultery not only violated the marriage vow but constituted the pollution of the home and of her body, a wasting of the wealth that she created in the form of goods and heirs.

Chastity and its loss, which is typically portrayed as rape (whether the crime is the violation of a virgin or the adultery of a matron), figure prominently in the founding myths. In the legendary early history of Rome, women were taken as brides in conflicts between men (the Sabine women), and were sacrificed to protect the honor of their men or the city when violence prevailed (Tarpeia and Lucretia). A woman's chastity is a sign of her husband's authority and power, and of his ability to control her sexuality to ensure the legitimacy of his children. Rape indicates changing political fortunes, as in the story of Lucretia, or the divine mission of the founders, as for Rhea Silvia. In a rare Greek mythological subject depicted in a statuary group in the Augustan Temple of Apollo on the Palatine, the fury of the Danaids suggests women's rebellion against their lot as brides, as gifts given to balance power between men. The Arachne myth also tells the story of a defiant and unnatural young woman, isolated from the family and, ultimately, from her destiny as wife and mother.

The selection of the myth for the frieze of the Forum Transitorium is curious because Arachne is virginal—there is no question that she is chaste (it is significant that the frieze may also depict Diana, the virginal goddess who guides young women to marriage and motherhood). The myth, however, represents Arachne's weaving as a subversive activity. Instead of initiating the young woman into the domestic life that awaits her, weaving inflates her ego and gives her the foolish confidence to challenge Minerva. A feminine accomplishment, intended to subdue and discipline girls, is brought into the sphere of mortal ambition and divine competition to no avail. The artistry of Arachne, her skill, grace, and

ture: Mars and Venus," *Latomus* 40 (1981): 512–44; idem, *Roman Imperial Funerary Altars with Portraits, Archaeologica* 62.

vision, is destroyed, and she is returned to nature as a spider spinning dusty webs in dark corners. Nature triumphs over culture: her demotion to spiderhood indicates the futility of her labor, its endless repetition, and she hangs by her thread, alone. The vulnerability of her position, swinging suspended over the ground like the suicidal maidens who refused marriage, suggests what she has lost: she is trapped in her virginal state without ever being able to become a bride, to marry and have children. Her labor is sterile and fruitless.

In the competition between goddess and mortal in the myth, the fabric that Minerva weaves celebrates the divine order. Minerva's domain is both the martial, the heroic field of warfare, and the marital, the family and domestic institutions. Yet, her weaving not only civilizes wayward girls who resist marriage but it also has a darker side. Woolwork is the focus of a superstition that endows spinning and weaving with forces that interfere with agricultural production and human reproduction, with powers of life and death. The mystique of weaving is contradictory: it is the emblem of the virtuous and hardworking matron, and it is daily drudgery that is invested with covert powers in popular superstitions. In the former, weaving is elevated to the status of a high cultural achievement, while, in the latter, it is feared as an incomprehensible element of nature.

One last exemplum, the epitaph of Claudia from Rome in the second century B.C., is of the kind invoked by the arbiters of morality in the Augustan and Domitianic revivals:

> Friend, I have not much to say; stop and read it. This tomb, which is not fair, is for a fair woman. Her parents gave her the name Claudia. She loved her husband in her heart. She bore two sons, one of whom she left on earth, the other beneath it. She was pleasant to talk with, and she walked with grace. She kept the house and worked in wool. That is all. You may go.[6]

[6] *CIL* VI.15.346.

Style and Technique

THE NOTION of a Flavian official style is problematic. There is, on one hand the classicism of the Cancelleria Reliefs and, on the other, the greater naturalism of the reliefs on the Arch of Titus.[1] Although our knowledge of Flavian art is limited to the evidence of a small group of monuments, it seems that the emperor and the designers of state monuments eschewed a uniform style and, rather, selected from a range of styles. Perhaps the organization of the imperial workshops, the architectural context or the subject matter also affected the style of the monument.[2]

The frieze's style has been said to be similar to that of the frieze of the Arch of Titus (fig. 90).[3] The deep undercutting of the figures and the unarticulated background link the two works although the figural style and proportions differ. Compared to the stocky proportions of the figures of the frieze of the Arch of Titus, those of the frieze's figures reflect their sources in works of classical and Hellenistic sculpture. The drapery style, with its repertory of catenary folds, masses of vertical pleats, and smooth passages of fabric revealing the body beneath, also indicates its sources in monumental sculpture.

The frieze's figures are carved in high relief and, in some examples, are almost entirely carved away from the relief ground (fig. 91). Emphasis is on the figure, either isolated or in loosely knit groups of two or three, which stands out against the ground, unarticulated or occasionally depicted as a rocky slope. Even if the background was once painted, the

[1] F. Magi, *I rilievi flavi del Palazzo della Cancelleria*. J.M.C. Toynbee, *The Flavian Reliefs from the Palazzo della Cancelleria in Rome*. E. Simon, "Zu den flavischen Reliefs von der Cancelleria," *JdI* 75 (1960): 135–36. M. Pfanner, *Der Titusbogen*, for bibliography.

[2] P. H. von Blanckenhagen, "Elemente der römischen Kunst am Beispiel des flavischen Stils," in H. Berve, ed., *Das neue Bild der Antike*, 2:310–41, for his theory of generic styles. O. Brendel, *Prolegomena to the Study of Roman Art*, 133–37.

[3] Pfanner (supra n. 1), 85.

contrast between the figures and ground would still have been striking. The scenes are built up of a pair of figures united through the gesture of reverence (often there is a third figure in attendance), with a river god or loom in the background to provide the context. The scenes are formed, not by any integral relationship between figure and scenic space, but by the accumulation of tokens and props in a symbolic setting. The static and repetitive composition has an iconic quality.[4]

Although the figures are stock types, familiar from Hellenistic and Roman statuary and repeated throughout the frieze, varying levels of workmanship and degrees of finish are visible. A descriptive account of each section with its dimensions is found below but the characteristics of its style can be summarized with a few remarks. In the first section (figs. 47–48), the rendering of the striding laborer's musculature is rough and schematic, particularly in the forearm's division along a central ridge and in the upper arm's protruding sack of muscle defined by two deeply incised lines. The treatment of the hand follows this pattern of juxtaposing flat and raised areas: incised lines mark the contours of the fingers, as well as their division into joints to the extent that they appear to be in negative relief.

In contrast, the river god's arm differs in the more skillful modeling of a heavily-muscled limb in repose. Furthermore, the torsos of both the reclining figure and the tunicate figure are articulated with gradations of shallowly rippling muscles, which are relaxed in the former and held taut in the latter. In comparison, the laborer's chest is carved in a pattern of broad slashing marks for the collar bone and the pectorals. Traces of the flat chisel are visible.[5] It would appear as if two different sculptors were responsible for the divergent styles.

Von Blanckenhagen has observed that the style of the seventh section (figs. 68–72) differs from that of the others in the slender proportions, the more compact grouping of the figures, and the linear, hard-edged carving of the drapery.[6] He attributed this to the work of a different sculptor although, as stated above, the other panels seem to have been carved by more than one hand. The figures within this section are also not uniformly treated. The two standing figures on the right appear stockier than those on the left. They are carved in lower relief than the others and their drapery folds are indicated by a series of incised lines. Probably one sculptor carved one group only or several figures in a row in each section.

There is also evidence that the frieze blocks were carved on the ground

[4] Zanker (1988), 175, on a similar compositional scheme in the "Tellus" panel of the Ara Pacis.
[5] C. Blümel, *Greek Sculptors at Work*, 26–34, on the carving techniques.
[6] Von Blanckenhagen, 133.

and then assembled on the entablature, a practice that was unusual in this period.[7] Perhaps this can be attributed to the urgency of the construction schedule due to Domitian's extensive renovations. The carvers' haste is also noticeable in the rough bridges left for hands and feet, details which would not be easily visible from the ground. The loose grouping of the figures and the repetition of poses and of figural types may have permitted several sculptors to work on the same relief block with a minimum of planning.

A designer could merely order a standard nymph or muse type with different attributes, a woolbasket or set of scales, and the sculptor would immediately know what was called for. Originality or invention of motifs was not at issue here, but the arrangement and organization of these generic types or stock figures on the bays conveyed meaning to the viewer. On the Arch of Titus, there are similar discrepancies in workmanship and indications of a lack of planning overall.[8] One can speculate that the designer or even Domitian himself only blocked out rough ideas for the motifs, and the specifics were left to the sculptors in the particular imperial workshop.

[7] Peter Rockwell, conversation, November 1984.

[8] Pfanner (supra n. 1), 103. Also, see P. Rockwell, "Preliminary Study of the Carving Techniques on the Column of Trajan," in *Marmi antichi, problemi d'impiego, di restauro e d'identificazione, StMisc* 26 (1985): 101–105, on evidence of the lack of a carefully controlled design and of different carvers working on the same relief. A protective coating, *scialbatura*, was placed on the frieze as it was on other monuments; it is not known whether this was done in antiquity or later.

Sections of the Frieze

SECTION ONE

T<small>HIS</small> small panel, measuring 1.72 m in length and .775 m in height, projects outward from the Forum's precinct wall at the north-eastern end of Le Colonnacce (figs. 46–48).[1] The block from which it is carved joined the Arcus Aurae at this point, leaving much of the block hidden behind an attached support, no longer extant.[2] Facing the entrance from the Argiletum through the Porticus Absidata, this panel may have formed an introduction to the frieze for the passersby.

Three male figures, carved in high relief, are shown in a landscape consisting of steep rocky cliffs over which water cascades. The first figure on the left is raised above the others and also placed farther back in the relief. A nude male, shown from the waist up, emerges from a declivity between two rocky peaks, vertical precipices of large, polygonal stones. The height of his torso is approximately .18 m. He reaches towards the waterfall with his left raised arm while his right is bent at the elbow in a position suggesting lateral movement or an emphatic gesture. Without an extant head, neck, and forearms, and visible only from the waist, the figure can only be characterized by his location in the landscape on the slope and next to the stream of water.

The cascading stream, carved in meandering S-shaped ridges, disappears at the bottom of the relief block behind a semi-recumbent figure. The male bearded river god reclines on a rocky ledge at the base of a cliff. The length of the figure is .65 m and the height from hip to head is .39 m. Although the face and the crown of his head are not extant, the long locks reaching his shoulders and the outline of his beard are still visible. Both his hands rest on the mantle draped around his hips and legs.

The third figure to the right is carved in high relief against an unartic-

[1] I took the measurements in November 1984 and checked them the following year. The length of the individual panels varies, but the height of the frieze remains constant at .775 m. The marble is from Luni. See chapter 1.

[2] Von Blanckenhagen, pl. 43, section A1–B1.

ulated background. The height of the figure, from the foot to the top of the support that indicates the position of his head, is .69 m. The male figure is clad in a short, sleeveless laborer's tunic or exomis, rolled at the waist and exposing the right half of his chest. He approaches the others on the left. Although his right leg is missing below the exomis, the resting place for his right foot indicates that he is striding in that direction, propelled by his left leg. He is posed frontally yet his raised right arm and hand, extended with palm opened outwards, points to the stream and the figure flanking it. On the relief ground a support for the non-extant head suggests that the figure looked back to the left, perhaps at the next panel of the frieze located around the corner of the entablature. Nothing remains of his left arm beyond a short stump draped with a part of the exomis, but the edge of an object attached to the figure's left thigh may indicate a pail or pitcher carried to fetch water.

The rendering of the striding figure's musculature is rough and uneven in treatment. As mentioned above, the chest is carved in a pattern of broad slashing marks for the collar bone and the pectorals, which also reveal traces of the flat chisel.[3] The drapery is deeply undercut and fluid, while the articulation of the fingers is marked by incised lines, and the digits of the small fingers appear almost to be in negative relief.

Within the same relief varying levels of workmanship and degrees of finish are observed. For example, the firm handling of the tunicate figure's extant leg, almost fully in the round, with its delineation of the calf muscle and its appropriate tension differs markedly from the rendering of the same figure's arm. One may also compare the carving of the chests of the three figures: the chest of the figure raised next to the cascade is less schematic than that of the other two figures, particularly that of the striding figure.

SECTION TWO

This panel, measuring .95 m in length, forms the outer face of the first ressaut, placed parallel to the perimeter wall and above the column (fig. 49). Set at right angles to the first section, it also shares the compositional scheme with the first figure raised above the others in the landscape. A correspondence is formed between these first two sections through the gestures of the figures emerging from a rocky height on the left.

Although much of the upper left corner of the block is damaged along with the first figure's head, neck, and shoulders, a female figure is visible

[3] Blümel (supra n. 5), on carving techniques. Rockwell (supra n. 7). There is no evidence of the use of the drill here.

in the remains of the upper torso. Her extended left arm is unnaturally short, thick, and flat without any tapering towards the wrist; her large hand shows interior divisions by means of incised lines and of raised areas. As suggested above, the variation in the carving of the figures may be attributed to the work of different sculptors within the same panel.

The gesture with outstretched arm and oversized hand extended with palm open also resembles that of the figure in exomis in the former section, and again the gesture is answered by another figure. This repeated gesture indicates the focus of attention and the relationship between figures.

Three female figures stand in a row at the base of the hill. The first one turns slightly to the right in three-quarter view. Although her head is no longer extant, it appears as if she looked to the figure on the right. She stands .55 m tall (without compensation for the head). She is heavily draped in a peplos and mantle falling from her left shoulder to her right hip around her back and over her left arm. She holds some of the drapery in her left hand; her right arm below the peplos sleeve is broken off. Over both legs the drapery is pulled taut and folds are designated by incised lines, mostly consisting of diagonals or arcs pulling from the knee towards the inner thigh and calf. In contrast, a panel of free-falling drapery between her legs amasses solid, deeply undercut tubular folds that are also seen in the mantle.

The next figure on the right, draped only from the hips down, can be identified as Venus, although she does not conform entirely to one particular statuary type. Again lacking a head as well as parts of her left arm and of both breasts, she stands supported by her weight-bearing leg on her right while her left leg is flexed. With the support for her head, she stands .64 m tall. Her left hand rests on a short pillar and her right is raised in response to the figure above. The open palm shows traces of an object, perhaps a flower stem or a fillet that she held. As the center of the triad, Venus is also the focus of attention through the exchange of gestures.

The last figure in this panel also leans on a pillar, in fact, on the upper molding of the same pillar that supports the figure of Venus. Portions of the upper right corner of the panel have broken off along with most of the figure's upper torso and arms. The figure wears the peplos and stands with one leg crossed in front of the other. She is roughly .59 m in height.

SECTION THREE

The next section, measuring 2.40 m in length, forms the section of the entablature returning to the precinct wall (figs. 50–54). The section de-

picts six figures aligned in a loosely grouped row in the same relief plane. The arrangement of figures in a loose row, side by side, without any overlapping or stacking of figures one behind the other, is the standard composition used throughout the frieze.

The panel differs from the others because it is without a figure raised above the others in the first position on the left side. Instead, a female figure of a personified virtue, Pudicitia, seated in three-quarter view on a chair with a footstool, faces right and draws her veil with her left hand. The head and right arm are missing, and the right side of the figure is badly defaced. Despite this damage, one can see her thick set left arm with slightly swelling muscles and a series of thick tension folds in the fabric of the veil. The figure wears a long tunic, fastened beneath the breasts and caught up in in V-shaped folds there. Across her lap, a web of flattened catenaries indicates the mantle draped over her knees. The unarticulated background may originally have been painted.

The second figure gestures with her raised right hand, palm opened and held outwards with the thumb up. As stated above, this gesture and its variants recur throughout the frieze. The raised hand, enlarged for emphasis and carved in low relief, is starkly outlined against the background by means of incised lines. The carving of the hand contrasts with the fullness of the figure rendered in relatively high relief.

The figure stands with her weight resting on her right leg. Her head, neck, left shoulder, and arm are not extant. She is dressed like the figure before her with the exception of a mantle carried across her right hip and over her left arm in catenary folds.

The following three figures, all female, are loosely arranged in a row as a unit, although the latter two are turned towards each other in conversation. Perhaps the frontal pose of the first figure of the triad serves as a bridge between the two pairs of figures on either side. This figure, lacking head and left arm, may have carried something in her clenched right hand. Like the others in this group, she wears the peplos but covers it with a mantle fastened on her right shoulder and swept back over her left. The drapery folds fall in heavy, thick ridges, often undercut.

On all three figures, a column of vertical folds in the skirt separates and frames the legs, which are sheathed in tight drapery indicated by diagonal slashes and a stirrup of fabric looped under the knee. The figures' stocky proportions are similar to those of the figures in the second panel.

Cradling her chin with her hand, the second figure of this group leans on a short pillar and appears to be in conversation with the figure to the right. The figure's head is partially extant. Her hair was probably swept up in a knot at the back of her head in the coiffure typical for the portrayal

of goddesses or mythological figures. Her height is approximately .64 m while the figure to the right is about .59 m.

She faces the last member of the group, who is addressing her with her raised right hand in the same gesture expressed by the second figure in this panel. This gesturing figure may have held an oval object in her lowered left hand. All that remains of the head is part of her jaw line and probably a knot at the nape of the neck.

The figure that closes the scene is a reclining river god. He is nestled in a rocky niche surrounded by reeds, which he also holds in his right hand. In contrast to the bearded river god of the first section, this one appears youthful, with a smooth face and a fringe of curls around his head. One of the few figures with an extant head, he looks in the direction of the row of female figures to the left. He wears a mantle that covers his hips and legs and is also draped over his left arm.

SECTION FOUR

The section is placed parallel to the precinct wall and forms the center of the bay (figs. 54–60). Extending 5.86 m, it is the longest section of the extant frieze. Above it, the extant attic relief of Minerva (figs. 82 and 83) is vertically aligned with the panel's center section that depicts the punishment of Arachne. This suggests that each of the Forum's bays was surmounted by a central attic relief representing another aspect of Minerva or other deities pertinent to the mythological episode depicted in the frieze below. Around the central mythological scene of the punishment of Arachne are several groups of figures involved in the making of cloth.

The section begins with a low rocky mound that actually belongs to the river god's niche from the previous panel (fig. 55). A pair of seated and standing figures are shown spinning. The first figure, shown in profile view, is seated on a chair, which is raised on a platform like the chair of the figure depicted in the previous section and is framed by a drapery swag. The figure holds out a distaff and spindle in her left hand. Without a head and badly damaged, the figure's torso is visible only on its left side.

A standing female figure faces her and stands about .69 m tall. In her extended right hand, she holds out a smaller distaff to her colleague. Severely abraded like the accompanying figure, this spinner's figure is extant only in her right arm and below, as seen in the edge of her peplos in the front and below.

A standing female figure, wearing a high-belted tunic with mantle, is represented next. The traces of an object that she may have carried are

visible on the right. Her head is indicated by a support on the relief ground. Pivoting towards the right, she bridges the two groups of figures on either side of her.

The following group consists of three figures unrolling a piece of fabric. They are framed by another drapery swag. Two of the figures are shown kneeling on one knee, facing one another. The second one seens to be smoothing the fabric's nap with an oblong, cylindrical tool, perhaps a pin beater or a beater-in, while the other headless figure secures the fabric's edge.[4] The fabric may once have been decorated with a painted design.

Although the kneeling figure working the fabric is damaged, it is possible to see her face twisted around toward the right, away from the object of her work and in the direction of the mythological event. Her hair was worn in a braid wound around her head, probably ending in a knot at the nape of her neck. Her mantle is wrapped around her waist.

The third tunicate figure of this triad holds the roll of fabric in both hands and stands on a low platform. The height of the this figure is .57 m. Distinguished by her elevated position on the platform and the drapery swag behind her, the figure must be a goddess, and Minerva is the obvious choice.[5] Striding forward on one leg, the figure's pose implies more movement than is necessary for her task. Yet she forms part of the triad displaying the fabric.

The following pair of figures forms the centerpiece of the extant frieze; the pair is located in the middle of the bay directly beneath the attic relief of the armed Minerva (figs. 57 and 58). Although her head is defaced, the frieze's figure of Minerva can be recognized by the outline of her Corinthian helmet and her aegis on her chest over her peplos. With the plume of her helmet touching the frieze's upper border, she stands taller (.79 m) than any other figures in the section.

Minerva turns slightly to her right, and her raised right arm is poised over her shoulder, ready to strike Arachne kneeling below. She grasps a tool, possibly a sword beater, the edge of which can be seen continuing behind her head to the frame of the adjacent loom.

Arachne kneels on her right leg and extends her left arm, with her hand out and palm open, towards Minerva. This gesture of supplication is a variation on the repeated gesture of the extended and disproportionately large hand seen in the previous sections. The figure of Arachne is not distinguished from the other weavers. She lacks a head, and wears a tunic

[4] J. P. Wild, "Two Technical Terms used by Roman Tapestry Weavers," *Philologus* 3 (1967): 151–55, particularly 154–55, on the *radius* or pin-beater. H. Ling Roth, *Studies in Primitive Looms*, 125, fig. 193b.

[5] See chapter 2.

fastened beneath the breasts and a mantle around her hips. Only her situation characterizes her as the tragic heroine of the myth.

The pair is dramatically composed with a diagonal accent formed by their raised arms. They are framed by a loom behind them, which may have been painted with a figured tapesty woven in the contest.[6] The heightened atmosphere is enhanced by the three figures moving towards them from the right.

This group, posed before a loom, consists of another triad varying in height and carriage. The figure next to Minerva represents an elderly woman. Her stooped posture, sagging breasts, and the gesture of the woman behind her, prodding her on, suggest her advanced age. She wears a long tunic with a mantle tied around her waist. The old woman, now without a head, a left arm, and lower left leg, may have clutched her left arm to her side, and she seems to be holding several balls of wool in her raised right hand. A tall container, probably a wool basket, stands on the ground between Minerva and the figure of the old woman.

The second figure is the catalyst of this group. She prods the old woman on her right and leads the child on her left. Although it is difficult to tell because her head is missing, the slope of her shoulder suggests that she glances back at the girl whose hand she grips. She wears a belted peplos and her feet are clad in sandals.

The third figure, also the smallest of the triad, is being drawn forward by the central figure. Her diminutive size and her subordinate position as the last in the group indicate that she is a child. Although triads are repeated throughout the frieze, this group is unique in its portrayal of figures of different ages, an old woman and a child.

The next pair of figures work at a vertical loom consisting of a rectangular frame made from two vertical posts joined by two cross-beams. Like the other two looms to the left, this one may have leaned against an exterior wall although there is little to indicate a setting.[7] One figure sits cross-legged on a cushion while the other stands at the loom. The standing weaver appears to grip several warp threads (a line incised over the loom's top beam and reaching the figure's hand may represent a part of the bundle of threads) while the seated one proffers an oblong, hooked instrument, perhaps a spool, or a shuttle. They are both shown threading the loom, an operation that requires two weavers.[8]

[6] Sen. *Ep.* 90.20. G. Crowfoot, "Of the Warp-Weighted Loom," *BSA* 37 (1936–1937): 36–47. J. P. Wild, *Textile Manufacture in the Northern Roman Provinces*, 69, figs. 59 and 60, pl. 11a. Ling Roth (supra n. 12), 120, fig. 191, and 124, fig. 193a, for the type of vertical loom seen in the frieze.

[7] Wild (supra n. 6), 69

[8] Ibid.

Both weavers wear the same kind of garment, a peplos belted beneath the breasts. The peplos of the standing figure, however, slips from the right shoulder. This differs significantly from the dress of the other figures.

The last three figures of the fourth section are engaged in related tasks. The first two are turned towards each other and carry a basket, which probably contained balls of wool, while the third stands frontally and cradles three balls of wool in a pouch made by drawing up her mantle in front of her with her left hand. All three headless figures are of slightly heavier proportions than the figures to the left. They wear the sleeveless, belted peplos and the last figure covers herself with a mantle.

SECTION FIVE

This panel forms the other bracket enclosing the bay and measures 2.43 m in length (figs. 61–64). Like the third panel opposite, it begins at the inner corner with a depiction of a reclining river god in a rocky niche planted with reeds. Unfortunately, the figure of the river god has been completely removed from the frieze, and only its outline is visible as well as a rough cross-hatch pattern probably resulting from the cutting away of the figure.

The despoliation of this panel continues with two following figures that were also chiseled off. It is not known when this destruction occurred.[9] Both of the non-extant figures were framed by drapery swags. From the wide space left by the removal of the first figure to the right of the river god, it seems as if there was a seated figure in profile, perhaps similar to the first figures of the previous two sections. The figure was probably seated on a raised chair with a footstool because it is the same height as the accompanying standing figure.

A close inspection of the outline of the standing figure to the right reveals that it was shown facing the seated figure, like the other pairs of seated and standing figures in the frieze. The standing figure's facial profile and an edge of a mantle tossed back over the shoulder indicate its disposition.

The next figure on the right holds a set of scales over a tall wool basket, which is similar in shape to the container placed between Minerva and the

[9] Unfortunately, because of the lack of ancient and medieval sources on the frieze, it is not known when this figure and the two following it were removed from the frieze. Von Blanckenhagen, 128, observes that the cornice above this section is damaged, and suggests that perhaps the figures were taken off in connection with the replacement of the cornice.

old woman in the fourth section in the center. The headless figure stands with her weight resting on her right leg. She wears a tunic and a mantle falling across her hips and over her left arm.

The last figure lacks her upper torso, shoulders, and head. Standing in a three-quarter pose with her arms extended to the left, she holds out a piece of fabric or a few balls of wool caught up in a section of her mantle. The drapery is deeply undercut in voluminous folds. The corner of the relief block to the right of this figure is broken.

SECTION SIX

This panel, in an analogous position to that of the second panel, is placed over the second column of the bay of Le Colonnacce (figs. 65–67). It measures .98 m in length. Both corners of this block are broken off and much of its upper section, especially on the right side, is missing. The relief depicts four figures, one of which surmounts a hill or cliff like the figure in the second panel.

The first figure, which is almost completely defaced along with the broken corner of the relief, is shown moving to the right. All that remains is a triangular edge of the skirt, sandaled feet, and a cylindrical object extending upward from her side that could be her left arm or, perhaps, a torch that she carries. Above, a large lobed leaf, probably a fig leaf, is carved at the edge of the broken block. An object that may be a branch appears in the upper central section of the relief.

Above and to the right, a female figure is seen from behind a rocky ledge. Exceptionally well preserved for the frieze, she possesses one of the few extant heads and is the only female figure depicted undraped besides the Venus in the corresponding second panel. She has almond-shaped eyes set far apart, a long straight nose, full lips, and long straight hair parted in the middle and falling over her shoulders. She looks down at her chest where her right hand cups the milk trickling from her left breast in a pattern of wavy lines. A mantle covers part of her left arm, continues under her right elbow, and falls over the ledge.

The cliff ends abruptly halfway down the relief panel above a narrow, tapering basin on a tall stand. Actually only the bottom section of its stand and base is extant while the basin itself has been removed from the relief surface. Perhaps it served to collect the flow of milk.

To the left of the basin are two female figures working over a table or counter. The first of the pair, whose head, right shoulder, and arm are missing, stands .63 m tall and wears a tunic that exposes her right breast. A rich network of folds is visible in contrast to the areas where the fabric

is pulled taut around her leg. Her feet are clad in sandals like the figure to the left. She leans over the table or counter with her left hand gripping the opposite edge. Her missing right arm was probably raised to pound or strike at a substance on the table that now is unrecognizable.

The figure working across the table is almost entirely defaced. Traces of a draped mantle are evident in a rippling edge down the front of the figure. Probably assisting her colleague, she holds both hands clenched together in front of her as if steadying something with an oblong utensil.

SECTION SEVEN

This section, measuring 2.36 m in length, forms the part of the entablature that returns to the precinct wall (figs. 68–72). It represents nine figures placed one alongside the other in a row. Gesture plays an important role in this composition that depicts pairs of figures symmetrically arranged.

The scene begins with a pair of seated and standing figures. The seated figure has been severely damaged along with the upper left corner of the relief block. She wears the tunic belted beneath the breasts with a mantle draped across her lap and over her arm. Below her left arm, the arm of the chair is decorated with an incised X pattern.[10] Only the chair's rear leg can be seen against the background, and it lacks a platform or footstool.

This seated figure's left arm is raised in front of her and holds a rounded object by a thick neck or attachment. An enlarged, incised outline around this object suggests that the sculptor had intended to render it in a greater size. Probably a ball of wool suspended from the frame above, it is held out for the standing figure whose hand reaches below in a gesture to the seated figure. This standing figure is posed in a three-quarter view with her left leg raised behind her as if she is approaching the seated figure. Lacking a left arm and a head, the figure shows signs of abrasion on her peplos, which is tied with a wide sash.

The third figure is seen from the back. Her height is approximately .69 m, allowing for the head. She may be winding wool on a large frame above (individual threads are marked by incised lines, and she seems to be adjusting a peg) or decorating a shrine. Like the previous figure, she is without a head and left arm and she wears a mantle rolled as a wide sash at her waist.

[10] G.M.A. Richter, *The Furniture of the Greeks, Etruscans, and Romans*, 122–23, figs. 290–94.

The next pair again consists of a seated and standing figure in positions reversed from those of the first pair. Although damaged, with peeling, cratered surfaces, the standing figure's coiffure is visible as a knot at the nape of the neck. The figure is shown in a three-quarter view, bending forward slightly to step up on her colleague's platform. Her right hand may have held the edge of her mantle while her left may have gestured to her seated companion to move closer, which, in fact, she seems to do.

The second seated figure, also damaged, lacks a head and lower right arm, and is dressed like the first figure. She rests on a backless stool supported by at least two finely carved outer legs. Her sandaled feet are raised on an elaborate platform.

Even though the upper portion of the relief block has been removed above this pair, one can see the edges of drapery hung with weights in the background.[11] The background, obscured by the close grouping of the figures on the left, may have been articulated with frames or racks from which hung garments or bundles of thread.

The second half of this section consists of four figures united by gesture and pose. A scenic divider occurs by placing two figures, the seated figure from the previous pair and the next standing figure, back to back. One large continuous drapery swag frames the group from above.

The figure seen from the back is again without a head, and the torso is wrapped in a mantle, which is abraded to the extent that no folds or surface articulation remain. Her right foot, clad in a sandal, is placed on the ground while her left is raised as if she has just taken a step. The figure seen from the back corresponds in position to the third figure in this section, who also stands between two pairs of seated and standing figures.

The last three figures of this section are linked through their gestures. The first figure is seated in a three-quarter pose on a chair that, unlike the one to the left, is without a platform or footstool. Her face is abraded although her hairstyle can be seen as a series of wavy locks swept towards the back of the head from a middle part. She looks towards the left. Although her right shoulder and arm are missing, the hand is placed over her left breast as if she was expressing surprise or taking an oath. Her left arm, broken off below the elbow, is extended to the figure standing next to her, who also turns and points to the left. Clearly this is the focus of their attention. It is worth noting that the two figures overlap one another, a motif that occurs in only one other scene in the frieze.

The next figure stands in the center of the group. She directs attention to the left while her companion to the right holds her by the wrist, as if

[11] M. Bieber, *Ancient Copies*, pl. 121, figs. 174 and 713, for a model with drapery weights.

leading her away. Like the seated figure beside her, the figure also has an extant head, which, however, is well preserved. The oval face has almond-shaped eyes, a straight nose, and full lips. A braid encircles her head, forming a knot at the nape of her neck. She wears a mantle tied low on her hips as a sash with the excess thrown over her left shoulder.

The last member of the group is badly defaced with its head merely a stump from which the carved features have been removed and its left arm missing below the elbow. She stands in a frontal pose, leaning to the right, and taking the hand of the figure on the left as if drawing her away from the event that absorbs her attention.

Like the two figures in this panel seen from the back, she also undermines the concentration of attention on the other side of the panel. Every third figure in this panel disrupts the orientation by being shown turning away from the left. The other figures are pairs of seated and standing figures engaged in some form of exchange.

As mentioned above, von Blanckenhagen has attributed this panel's stylistic differences, the slender figural proportions, the more compact grouping of the figures, and the linear, hard-edged carving of the drapery, to the work of a different sculptor.[12] The other panels also seem to have been carved by more than one hand and, in fact, the figures within this section are not uniformly treated. Probably one sculptor carved only several figures in a row in each panel.

SECTION EIGHT

The last extant section of the frieze, which measures 4.03 m in length, is incomplete and breaks off at the same point as the precinct wall ends (figs. 73–81). The section is located on the entablature of the precinct wall and formed the central section of a second bay. Assuming the length of this section and that of the fourth section were the same, this extant portion consists of about four-fifths of the original length.

The eighth section begins with a depiction of a rocky slope rising to the upper edge of the relief block. Four figures proceed down the slope towards the right. In the left corner at the base of the hill, a half-naked male figure reclines with his back to the viewer. His head, turned in profile to the right, is completely abraded along with the upper edge of his torso, his draped thigh, and legs. Both arms are missing below the elbow. It appears as if this figure is a personification of place because of his reclining pose and drapery covering only the lower half of his body.

[12] Von Blanckenhagen, 133.

On the ledge above this personification, a female figure stands with her weight supported by her right leg. Clad in the tunic and mantle like the other figures of this panel, she rests her left arm on the rocks, and her right arm may have held an object at her side. As the last member of a procession moving down the slope, she is placed farther in the background and higher up in the relief than some of the other figures.

The next pair of figures are on the ground line at the foot of the slope. One strides to the right in three-quarter pose and touches the arm of the figure ahead of her. This figure, who turns back in response, is stepping forward with her left leg. Both figures lack heads, necks, and lower arms while the second of the pair is also missing her left shoulder and entire arm as well. Her mantle is worn across her hips and over her arm, and the mantle of the other figure is draped from both shoulders and falls forward in a series of catenary folds.

The figure to the right, who is also clad in a tunic and mantle, is portrayed climbing down the rocks with her right leg extended to secure a footing. It is impossible to tell whether she looked to the left or to the right because, like the others, she is without a head.

The next figure at the base of the hill may have provided a transition between the group descending the hill and those on the ground to the right. With her right leg flexed and extended to the right, she pivots away from the hill. Her torso, along with her arms, is completely wrapped in a mantle drawn tightly around her.

The following figure is seated in a three-quarter pose on a rocky outcropping to a height of about .53 m. The extant upper portion of her left arm is raised towards the tree in front of her or towards Minerva, who is identified by the plume of her Corinthian helmet, her shield, and her high rocky throne. In the previous sections, two figures were also seated opposite one another with intervening figures, and, perhaps, this composition indicates a setting in a shrine or a sacred site. The tree is the olive, sacred to Minerva-Athena, and it is depicted at the height of the season with fruit on its branches.

Two standing female figures, dressed like the others, are shown in attendance before the goddess. The first one, without head, neck, and both arms, stands in three-quarter view with one leg crossed in front of the other, and leans on her companion's shoulder.

The figure closest to Minerva is one of the few in the frieze with an extant head, which is, however, poorly preserved. A knot at the nape of the neck is visible on the oval-shaped head turned in profile towards Minerva. Raising her left arm as if to offer something to the goddess, she may have once held a branch, a flower or a fillet of wool (the latter may

be less likely, given the traces left on the relief ground, although there appears to be a soft fold of fabric in her hand).

Minerva is seated in profile on a high rocky seat with a footrest situated on the outermost edge of the relief shelf. At .75 m in height, she is the tallest figure in this panel. The plume of her Corinthian helmet is all that remains to indicate the outline of her head. She wears the tunic without the aegis and a mantle draped across her lap. Her shield, clasped by her left arm, rests on the side of her throne.

The next figure, also without a head and lower arms, turns back to gesture toward the goddess. She links the groups on either side of the goddess through her disposition. Farther to the right another figure stands with her legs crossed and leans on a low pedestal. Drapery weights are visible on the section of excess mantle caught on the pedestal.

The last pair of figures in the extant frieze work at a vertical loom like the pair depicted in the fourth section in the center. One weaver stands in profile with her left leg flexed and her left arm reaching for a bundle of threads hung over the upper horizontal beam. The standing weaver is without a head or right arm, although there are supports for them on the relief ground. She wears a long belted peplos.

Her partner is seated on a cushion on the ground, with her legs drawn up in front of her and crossed at the ankles. Her right arm is raised towards her colleague's. She probably held either a tool or the lower end of a bundle of warp threads that her partner is threading, a task similar to that performed by the weavers depicted in the fourth section.[13] As discussed above, the threading of the loom is a complicated task that requires two weavers to divide the even and odd warp threads for the shed.

An arched opening or gateway (.60 m in height) is represented adjacent to the loom on the left. Like a similar architectural element depicted in one of the bay reliefs of the Arch of Titus, the passageway's position at an angle to the relief surface creates the illusion that the figures can pass through it. The panel, along with the perimeter wall, abruptly ends here.

ATTIC RELIEF

The attic relief (figs. 82 and 83) is placed within a framed panel in the center of the bay. It measures approximately 2.65 m in height. The relief depicts Minerva, standing frontally with her left leg flexed and her weight on the right. She wears a Corinthian helmet, and bears a shield in her left arm and, perhaps, a lance in her right. Her long mantle, identified as an

[13] Wild (supra n. 6), 69.

officer's military cloak, the *paludamentum*, is fastened at the right shoulder by its characteristic circular clasp and draped back over her left. Besides the distinctive cloak, she is also wearing a belt, a *cingulum militiae*, that broadens in width at the middle over her tunic. Her garments are unparalleled—Minerva is usually depicted wearing a belted peplos in Roman art. Von Blanckenhagen has interpreted the figure of Minerva as a *female* Roman general, outfitted in a uniform of a military cloak and belt.[14] Schürmann, however, recognizes the belt as an attribute of the muses, and interprets it as an allusion to the celebration of Minerva's festival, the Quinquatrus, with its contests in poetry, drama, and rhetoric at Domitian's Alban villa.[15] Schürmann's interpretation is not convincing because the iconography of Minerva is that of a warrior goddess in the relief. The goddess brings victory to the Flavians and Domitian, in particular (there is nothing to suggest her patronage of the arts here).

The figure is carved in high relief, with the crest of the helmet projecting out of the panel's frame. Minerva's hair is parted in the middle and swept off her face under the helmet. The goddess's eyes are set far apart, but little more can be said about the abraded oval face, turned slightly to one side.

The folds of her garments are richly undercut; the hem of the mantle falls in zigzag patterns on both sides, and the tunic maintains vertical pleats over the supporting leg, while it is stretched taut over the relaxed left leg. On her left shoulder, the mantle forms broad concentric folds that appear soft and pliable and are drenched in light, in contrast to the dark channels between the folds at the lower legs. The style is distinguished by higher relief carving, which enhances the modeling and optical effects of the larger figure, but does not significantly depart from that of the frieze below.

[14] von Blanckenhagen, 116–18. Domitian is depicted wearing the paludamentum in Relief A of the Cancelleria Reliefs.

[15] Schürmann, 12.

BIBLIOGRAPHY

ARCHITECTURE AND TOPOGRAPHY

Anderson, J. C., Jr. *Historical Topography of the Imperial Fora*, Coll-Latomus, vol. 182. Brussels, 1984.

———. "A Topographical Tradition in Fourth Century Chronicles: Domitian's Building Program." *Historia* 32 (1983): 93–105.

———. "Domitian, the Argiletum and the Temple of Peace." *AJA* 86 (1982): 101–10.

———. "Domitian's Building Program: Forum Julium and Markets of Trajan." *ArchNews* 10 (1981): 41–48.

Bauer, H. "Der Urplan des Forum Transitorium." *Bathron. Beitrage zur Architektur und verwandten Künsten für Heinrich Drerup zu einem 80 Geburtstag. Saarbrücker Studien zur Archäologie und alten Geschichte*, 41–57. Saarbrücker, 1988.

———. "Basilica Aemilia." In *Kaiser Augustus und die verlorene Republik*, ed. M. Hofter et al., 200–12. Mainz, 1988.

———. "Forum Transitorium und Porticus Absidata." *RM* 90 (1983): 111–84.

———. "Kaiserfora und Janustempel." *RM* 84 (1977): 301–29.

———. "Il Foro Transitorio e il tempio di Giano." *RendPontAcc* 49 (1976–1977): 117–49.

Bianchini, F. *De palazzo de' Cesari. Opera postuma.* Verona, 1738.

Bietti Sestieri, A. M., et al., eds. *LSA*, 6.1. *Roma. Archeologia nel centro.* Rome, 1985.

Blake, M. E. *Roman Construction in Italy from Tiberius through the Flavians.* Washington, 1959.

von Blanckenhagen, P. H. "The Imperial Fora." *JSAH* 13:4 (1954): 21–26.

Bourne, F. C. *The Public Works of the Julio-Claudians and Flavians.* Princeton, 1946.

Buchner, E. "Horologium solarium Augusti." *Kaiser Augustus and die verlorene Republik*, ed. M. Hofter et al. 240–45. Mainz, 1988.

Canina, L. *Esposizione storica e topographica del Foro Romano e sue adiacenze.* Rome, 1845.

Carettoni, G. "La costruzione di Augusto e il tempio di Apollo sul Pala-tino." *Quaderni del Centro di archeologia laziale* I (1978): 72–74.

———. "I problemi della zona augustea del Palatino." *RendPontAcc* 39 (1966–1967): 55–75; 44 (1971–1972): 123–39.

Carettoni, G., et al. *La pianta marmorea di Roma antica.* Rome, 1960.

Castagnoli, F. "Il culto di Minerva a Lavinium." *Probemi attuali di scienza e di cultura, Accademia nazionale dei Lincei* 376 (1979), *quaderno* 246, 3–14.

Castagnoli, F., C. Morselli, and E. Tortorici, "Progetto per lo scavo di un settore dei Fori di Cesare e di Nerva." In A. M. Bietti Sestieri et. al., eds. *LSA* 6.1. *Roma. Archeologia nel centro.* Rome, 1985, 245–71.

Coarelli, F. *Roma, Guide archeologiche.* Bari, 1981.

———. *Il Foro Romano, periodo arcaico.* Rome, 1983.

———. *Roma sepolta.* Rome, 1984.

Cock, H. *Praecipua aliquot romanae antiquitatis ruinarum monumenta, vivus prospectibus, ad veri imitationem affabre designata.* Antwerp, 1551.

Colini, A. M. "Forum Pacis." *BullComm* 65 (1937): 7–40.

Cozza, L. "Sul frammento 212 della Pianta marmorea." *JRA* 2 (1989): 117–19.

Delbrueck, R. *Hellenistische Bauten in Latium.* 2 vols. Strassburg, 1907–1912.

Dosio, G. A. *Le antichità di Roma.* Rome, 1569.

Du Perac, E. *I vestigi dell'antichità di Roma.* Rome, 1575.

———. *A Topographical Study in Rome in 1581; A Series of Views by Etienne Du Perac,* ed. T. Ashby. London, 1916.

Egger, H. *Codex Escurialensis.* Vienna, 1905–1906.

Gamucci, B. *Le antichità della città di Roma.* Venice, 1569.

Ganzert, J. "Der Mars-Ultor Tempel auf dem Augustusforum in Rom. Vorlaufiger Arbeitsbericht." *RM* 92 (1985): 201–19.

Ganzert, J. and V. Kockel. "Augustusforum und Mars-Ultor-Tempel." In *Kaiser Augustus und die verlorene Republik,* ed. M. Hofter et al., 149–99. Mainz, 1988.

Gatti, G. "Notizie di recenti ritrovamenti di antichità." *BullComm* (1904), 341–59.

Gros, P. *Aurea Templa. Recherches sur l'architecture religieuse de Rome à l'é-poque d'Auguste. BEFAR* 231. Rome, 1976.

Gros, P. and M. Torelli. *Storia dell'urbanistica, Il mondo romano.* Rome, 1988.

Heilmeyer, W.-D. *Korinthische Normalkapitelle. Studien zur Geschichte der römischen Architektur-dekoration. RM-EH* 16. Heidelberg, 1970.

Holland, L. A. *Janus and the Bridge. PAAR* 21. Rome, 1961.

Horster, M. "Der Minervatempel auf den Forum Transitorium in Zeich-
nungen der Renaissance." *Florenz Mitteilungen* 28 (1984): 133–72.

Huelsen, C. "Jahresbericht über Funde und Forschungen zur Topogra-
phie der Stadt Rom." *RM* 4 (1889): 249; *RM* 6 (1891): 101–103.

Huelsen, C., ed. *Il libro di Giuliano da Sangallo, codice vaticano barberiniano
latino* 4424. Lipsia, 1910.

———. *Le chiese di Roma*. Florence, 1927.

Jordan, H. *Topographie der Stadt Rom im Altertum*. Berlin, 1871–1907.

Kleiner, F. S. "The Arches of Vespasian in Rome." *RM* 97 (1990): 127–
36.

———. "The Arch in Honor of C. Octavius and the Fathers of Augus-
tus." *Historia* 37 (1988): 148–57.

———. *The Arch of Nero in Rome. A Study of the Roman Honorary Arch
before and under Nero*. Archaeologica 52. Rome, 1985.

Kockel, V. "Beobachtungen zum Temple des Mars Ultor und zum Fo-
rum des Augustus." *RM* 90 (1983): 421–48.

Lanciani, R. *Storia degli scavi di Roma*. Rome, 1902–1912.

———. *The Ruins and Excavations of Ancient Rome*. Boston and New
York, 1897.

———. *Ancient Rome in the Light of Recent Discoveries*. London, 1889.

———. "L'aula e gli uffici del Senato Romano; appendice 1: del Foro
Transitorio; appendice 2: del Giano befronte e del Giano quadri-
fronte." *MemLinc* 11 (1882–1883): 22–32.

———. "Su Semone Sanco," *BullComm* 9 (1881): 4–6.

Lazzarini, L., et. al. "Determination of the Provenance of Marbles used
in some Ancient Monuments in Rome." In *Classical Marble: Geo-
chemistry, Technology, Trade*, ed. N. Herz and M. Waelkens, 399–
409. Dordrecht, Boston, and London, 1988.

Leon, C. *Die Bauornamentik des Traiansforum und ihre Stellung in der früh-
und mittelkaiserzeitlichen Architekturdekoration Roms*. Vienna, 1971.

Linfert, A. "*Certamen Principium*. Über den propagandischen Zweck der
Kaiserfora." *BJb* 179 (1979): 177–86.

Lugli, G. *Fontes ad topographiam veteris urbis Romae pertinentes*. Rome,
1952.

———. *Roma antica. Il centro monumentale*. Rome, 1946.

———. "Nuove forme dell'architetura romana nell'età dei Flavi." *Atti del
III convegno nazionale di storia dell' architettura*. Rome, 1938.

———. "La villa di Domiziano sui colli albani." *BullComm* 45 (1917): 29–
78.

MacDonald, W. L. *The Architecture of the Roman Empire*, vol. 1: *An Intro-
ductory Study*. New Haven and London, 1982.

MacDonald, W. L. *The Architecture of the Roman Empire*, vol. 2: *An Urban Appraisal*. New Haven and London, 1986.

MacMullen, R. "Roman Imperial Building in the Provinces." *HSCP* 64 (1959): 207–35.

Morselli, C., et. al. *Il Foro di Nerva. Uno scavo archeologico nel centro di Roma*. Rome, 1989.

Morselli, C., and E. Tortorici, eds. *LSA*, 14.1: *Curia, Forum Iulium, Forum Transitorium*. Rome, 1989.

Nash, E. *Pictorial Dictionary of Ancient Rome*. 2nd ed. London, 1968.

Nichols, F. M. *The Marvels of Rome*. London, 1889.

Packer, J. "Politics, Urbanism, and Archaeology in *Roma Capitale*: A Troubled Past and a Controversial Future." *AJA* 93 (1989): 137–46.

Palladio, A. *I quattro libri di architettura*. Venice, 1570.

Palmer, R.E.A. "Jupiter Blaze, Gods of the Hills, and the Roman Topography of *CIL* 6, 377." *AJA* 80 (1976): 43–56.

———. "Roman Shrines of Chastity from the Caste Struggle to the Papacy of Innocent I." *RivStorAnt* 4 (1974): 113–59.

Panciera, S. "Nuovi documenti epigrafici per la topografia di Roma antica." *RendPontAcc* 43 (1970–1971): 109–134.

Platner, S. B., and T. Ashby. *A Topographical Dictionary of Ancient Rome*. London, 1929.

Richardson, L., Jr. "Curia Julia and Janus Geminus." *RM* 85 (1978): 359–69.

———. "The Villa Publica and the Divorum." In *Essays in Memoriam Otto J. Brendel*, ed. L. Bonfante Warren, 159–63. Mainz, 1976.

Robathan, D. "Domitian's Midas-touch." *TAPA* 73 (1942): 130–44.

Rodriguez Almeida, E. *Forma urbis marmorea: aggiornamento generale 1980*. Rome, 1981.

Rushforth, G. "Magister Gregorius de Mirabilibus Urbis Romae." *JRS* 9 (1919): 14–58.

Santangelo, M. "Il Quirinale nell'età classica." *MemPontAcc* 5 (1941): 77–214.

Stilwell, R., et. al. eds., *Princeton Encyclopedia of Classical Sites*. Princeton, 1976.

Tamm, B. *Auditorium and Palatium*. Stockholm, 1963.

Taylor, L. R., and L. A. Holland. "Janus and the Fasti." *CP* 47 (1952): 137–42.

Torelli, M. "Culto imperiale e spazi urbani in età flavia. Dai rilievo Hartwig all'arco di Tito." *Urbs. Espace Urbain et Histoire, 1er siecle avant J.C.–Ier siecle apres J.C. CEFR* 98. Rome, 1987, 563–82.

Ulrich, R. B. *The Temple of Venus Genetrix in the Forum of Caesar in Rome*:

the Topography, History, Architecture, and Sculptural Program of the Monument. Ph.D. diss. Yale University, 1984.

Valentini, R., and G. Zucchetti. "Codice topografica." *Fonti per la storia d'Italia,* vol. 81. Rome, 1940.

Ward-Perkins, J. B. *Roman Imperial Architecture.* Harmondsworth, 1981.

Zanker, P. "Das Trajansforum in Rom." *AA* 85 (1970): 499–544.

———. *Forum Augustum.* Tübingen, 1968.

———. "Der Apollotempel auf dem Palatin Ausstattung und politische Sinnbezüge nach der Schlacht von Actium." *Città e architettura nella Roma imperiale, AnalRom* Suppl. 10 (1983): 21–40.

ART HISTORY AND RELATED STUDIES

Alföldi, A. *Aion in Merida und Aphrodisias.* Mainz, 1979.

Amelung, W. "Über ein Relief im Museo Nazionale Romano." *RM* 14 (1899): 3–7.

———. "Bemerkungen zur Sorrentiner Basis." *RM* 15 (1900): 198–210.

Amelung, W., and G. Lippold. *Die Skulpturen des Vatikanischen Museums.* 4 vols. Berlin, 1903–1956.

Andreae, B. *The Art of Rome.* Trans. R. E. Wolf. New York, 1977.

———. " 'Igni et aqua accipi': Zur Aldobrandinischen Hochzeit." *Festschrift für Engelbert Kirschbaum, Römische Quartalschrift für christliche Altertumskunde und für Kirchengeschichte,* 57 (1962): 3–16.

Angelicoussis, E. "The Panel Reliefs of Marcus Aurelius." *RM* 91 (1984): 141–205.

Anti, C. "Atena marina e alata." *MemLinc,* 26 (1920): 269–318.

Ashby, T. "Drawings of Ancient Paintings in English Collections." *PBSR* 7 (1914): 1–62.

Bartoli, P. S. *Admiranda Romanarum Antiquitatum . . . Notis Io. Petri Bellorii illustrata.* Rome, 1693.

Becatti, G. "Le tre Grazie." *BullComm* 65 (1937): 41–60.

Bendinelli, G. "An Underground Tomb with Important Fresco Decoration Recently Discovered in Rome." *Art and Archaeology* 11 (1921): 169–72.

Benndorf, O., and R. Schöne. *Die antiken Bildwerke des Lateranenischen Museums:* Leipzig, 1867.

Berard, C. "Le liknon d'Athena." *AntK* 19 (1976): 101–14.

Bergmann, M. "Zum Fries B der flavischen Cancelleriareliefs." *MarbWPr* 1981 (1982): 19–31.

Bergmann, M., and P. Zanker, " 'Damnatio Memoriae.' Umgearbeitete

Nero- und Domitiansporträts. Zur Ikonographie der flavischen Kaiser und des Nerva." *JdI* 96 (1981): 317–412.

Bianchi-Bandinelli, R. *Roma. L'arte romana nel centro del potere.* Rome 1981.

Bie, O. *Die Musen in der antiken Kunst.* Berlin, 1887.

Bieber, M. *The Sculpture of the Hellenistic Age.* Rev. ed. New York, 1961.

———. *Ancient Copies.* New York, 1977.

von Blanckenhagen, P. H. "Daedalus and Icarus on Pompeian Walls." *RM* 75 (1968): 106–43.

———. "Narration in Hellenistic and Roman Art." *AJA* 61 (1957): 78–83.

———. "Elemente der römische Kunst am Beispiel des flavischen Stils." In *Das neue Bild der Antike*, ed. H. Berve, 2:310–41. Leipzig, 1942.

———. *Flavische Architektur und ihre Dekoration, untersucht am Nervaforum.* Berlin, 1940.

Blamberg, J. E. *The Public Image Projected by the Roman Emperors (A.D. 69–117) As Reflected in the Imperial Coinage.* Ph.D. diss. University of Indiana, 1976.

Blümel, C. *Greek Sculptors at Work.* London, 1955.

Blümner, H. "Il fregio del portico del Foro di Nerva." *AnnInst* (1877): 5–36; *MonInst* 5, pls. 40, 41, and 41a.

Bonfante, L. "Caligula the Etruscophile." *Liverpool Classical Monthly* 15 (1990): 98–100.

———. "Iconografia delle madri: Etruria e Italia antica." In *Le donne in Etruria*, ed. A. Rallo, 85–106. Rome 1989.

Braun, E. *Handbook of the Ruins and Museums of Rome.* Brunswick, 1856.

Breglia, L. *L'Arte romana nelle monete dell'età imperiale.* Milan, 1968.

Brendel, O. "The Great Frieze in the Villa of the Mysteries." In *The Visible Idea, Interpretations of Classical Art*, ed. O. Brendel, 90–138. Washington, 1980.

———. *Prolegomena to a Study of Roman Art.* New Haven and London, 1979.

Brilliant, R. *Visual Narratives: Storytelling in Etruscan and Roman Art.* Ithaca and London, 1984.

———. *Gesture and Rank in Roman Art.* New Haven, 1963.

Brinkerhoff, D. M. "Hypotheses on the History of the Crouching Aphrodite Type in Antiquity." *GettyMusJ* 6–7 (1978–1979): 83–96.

———. "Figures of Venus, Creative and Derivative." In *Studies Presented to George M.A. Hanfmann.* Ed. D. G. Mitten, J. G. Pedley, and J. A. Scott, 9–16. Harvard, 1971.

Brommer, F. *Der Parthenonfries.* Mainz, 1977.

———. *Die Skulturen der Parthenon-Giebel.* Mainz, 1963.

————. *Die Giebel des Parthenon*. Mainz, 1959.

Brunn, H. "Giunone Lucina, bassorilievo del Museo Vaticano." *AnnInst* (1948): 430–38.

Bryson, N. "Two Narratives of Rape in the Visual Arts, Lucretia and the Sabine Women." In *Rape*, ed. S. Tomaselli and R. Porter, 52–72. London, 1986.

Calza, G. *La necropoli del Porto di Roma nell'Isola Sacra*. Rome, 1940.

Carettoni, G. "Il fregio figurato della basilica Emilia," *RivIstArch* 10 (1961): 5–78.

Carradice, I. *Coinage and Finances in the Reign of Domitian, A.D. 81–96*. B.A.R. Int'l. Series, vol. 178. Oxford, 1983.

Cohen, H. *Description historique des monnaies frappées sous l'empire romain*, Paris, 1880.

Colini, A. M. "Officina di *fabri* tignarii nei frammenti di un'ara monumentale rinvenuti fra il Campidoglio e il Tevere." *Capitolium* 22 (1947): 21–28.

Daltrop, G., U. Hausmann, and M. Wegner, *Das römische Herrscherbild*. Vol. 2, pt. 1: *Die Flavier*. Berlin, 1966.

D'Ambra, E. "Pudicitia in the Frieze of the Forum Transitorium." *RM* 98 (1991): 243–48.

————. "The Cult of Virtues and the Funerary Relief of Ulpia Epigone." *Latomus* 48 (1989): 392–400.

————. "A Myth for a Smith: A Meleager Sarcophagus from a Tomb in Ostia." *AJA* 92 (1988): 85–100.

Deonna, W. "Le groupe des trois Graces nues et sa descendance." *RA* 31 (1930): 274–332.

Di Vita, N. "Atena Ergane in una terracotta dalla Sicilia ed il culto della dea in Atene." *ASAtene* 30–32 (1952–1954): 146–54.

Dohrn, O. "Antike Flussgotter." In *Festschrift O.H. Forster*, 69–72. Munich, 1960.

Edwards, C. M. *Greek Votive Reliefs to Pan and the Nymphs*. Diss. New York University, 1985.

Enking, R. "Minerva Mater." *JdI* 59–60 (1944–1945): 111–24.

Fehr, B. "Die 'gute' und die 'schlechte' Ehefrau: Alkestis und Phaidra auf den Sudmetopen des Parthenon." *Hephaistos* 8 (1982): 37–66.

Felletti Maj, B. M. *La tradizione italica nell'arte romana, Archaeologica* 3. Rome, 1977.

Froning, H. *Marmor-Schmuckreliefs mit griechischen Mythen im 1 Jr. v. Chr.* Mainz, 1981.

Furtwängler, A. *Beschreibung der Glyptothek König Ludwig I*. Munich, 1900.

Furuhagen, H. "Some Remarks on the Sculpted Frieze of the Basilica Ae-milia in Rome." *OpRom* 3 (1961): 139–55.

Gais, R. M. "Some Problems of River God Iconography," *AJA* 82 (1978): 355–70.

Galt, C. M. "Veiled Ladies." *AJA* 35 (1931): 373–93.

Garcia Y Bellido, A. *Arte romano.* Madrid, 1972.

Gatti, L., and L. Guzzo. *Il deposito votiva dall'Esquilino detto di Minerva Medica.* Florence, 1978.

Gauer, W. "Was geschieht mit dem Peplos?" In *Parthenon-Kongress Basel,* ed. E. Berger, 220–29. Mainz, 1984.

Gehrig, U. *Hildesheimer Silberfund.* Berlin, 1967.

Ghedini, F. "Riflessi della politica domizianei rilievo flavi di Palazzo della Cancelleria." *BullComm* 91 (1986): 291–389.

Giuliano, A., ed. *Museo Nazionale Romano, Le sculture,* vols. 1–2. Rome, 1979.

Gordon, E. *The Panel Reliefs of Marcus Aurelius.* Diss. New York University, 1979.

Grueber, H. A. *Coins of the Roman Republic in the British Museum.* London, 1910.

Hamberg, P. G. *Studies in Roman Imperial Art, with Special Reference to the State Reliefs of the Second Century.* Copenhagen, 1945.

Hannestad, N. *Roman Art and Imperial Policy.* Aarhus, 1986.

Hartwig, P. "Ein römisches Monument der Kaiserzeit mit einer Darstel-lung des Tempels des Quirinus." *RM* 19 (1904): 23–37.

Hekler, A. "Römische weibliche Gewandstatuen." *Münchener Archäolo-gische Studien.* Munich, 1909, 109–247.

Higgins, R. A. *Greek Terracottas.* London, 1967.

Hill, D. K. "Nymphs and Fountains." *Antike Kunst* 17 pt. 2 (1947): 107–8.

Hill, P. V. "Notes on the Ludi Saeculares of A.D.88." In *Atti congresso int'l. di numismatica,* 275–82. Rome, 1967.

Himmelmann, N. *Über Hirten-Genre in der antiken Kunst.* Tübingen, 1980.

Himmelmann-Wildschutz, N. *Studien zum Ilissos-Relief.* Munich, 1956.

Hinks, R. P. *Myth and Allegory in Ancient Art.* London, 1939.

Hölscher, T. *Staatsdenkmal und Publikum.* Konstanz, 1984.

———. "Geschichtsauffassung in römischer Repräsentationskunst." *JdI* 95 (1980): 265–321.

Horn, R. *Stehende weibliche Gewandstatuen.* RM-EH 2. Heidelberg, 1931.

Hutton, C. A. "Votive Reliefs in the Acropolis Museum." *JHS* 17 (1897): 306–18.

Jensen, W. M. *The Sculptures from the Tomb of the Haterii*. Diss. Michigan, 1978.

Kähler, H. *The Art of Rome and Her Empire*. Trans. J.R. Foster. New York, 1963.

Kampen, N. B. "Between Public and Private: Women as Historical Subjects in Roman Art." In *Women's History and Ancient History*, ed. S. B. Pomeroy, 218–48. Chapel Hill and London, 1991.

———. "Reliefs of the Basilica Aemilia: A Redating." *Klio* 73 (1991): 448–58.

———. "The Muted Other." *ArtJ* 47 (1988): 15–19.

———. *Image and Status: Roman Working Women in Ostia*. Berlin, 1981.

———. "Observations on the Ancient Uses of the Spada Reliefs." *AntCl* 48 (1979): 583–600.

Kapossy, B. *Brunnenfiguren der hellenistischen und römischen Zeit*. Zurich, 1969.

Kaschnitz-Weinberg, G. *Sculture del magazzino del Museo Vaticano*. Rome, 1937.

Keller, E. "Studien zu den Cancelleria-Reliefs. Zur Ikonographie der Personifikationen und Profectio-bzw. Adventus-Darstellungen," *Klio* 49 (1967): 183–217.

Kellum, B. "Sculptural Programs and Propaganda in Augustan Rome: The Temple of Apollo and the Palatine." In *The Age of Augustus*, ed. R. Winkes, 169–76. Providence and Louvain-la-Neuve, 1986.

Keuls, E. C. "Attic Vase-Painting and the Home Textile Industry." In *Ancient Greek Art and Iconography*, ed. W. G. Moon, 209–30. Madison, 1983.

———. *The Water Carriers in Hades: A Study of Catharsis Through Toil in Classical Antiquity*. Amsterdam, 1974.

Keyes, C. W. "Minerva Victrix? A Note on the Winged Goddess of Ostia." *AJA* 16 (1912): 490–94.

Kleiner, D.E.E. *Roman Imperial Funerary Altars with Portraits*. Archaeologica, vol. 62. Rome, 1987.

———. "Second-Century Mythological Portraiture: Mars and Venus." *Latomus* 40 (1981): 512–44.

———. "The Great Friezes of the Ara Pacis Augustae. Greek Sources, Roman Derivatives, and Augustan Social Policy." *MEFRA* 90 (1978): 753–85.

Koch, G., with K. Wight. *Roman Funerary Sculpture: Catalogue of the Collections*. Malibu, 1988.

Koeppel, G. M. "Die historischen Reliefs der römischen Kaiserzeit 2: Stadtrömische Denkmäler unbekannter Bauzugehörigkeit aus flavischer Zeit." *BJb* 184 (1984): 1–66.

Koeppel, G. M. "Die historischen Reliefs der römischen Kaiserzeit 1: Stadtrömische Denkmäler unbekannter Bauzugehörigheit aus augusteischer und julisch-claudischer Zeit." *BJb* 183 (1983): 61–144.

———. "Fragments from a Domitianic Monument in Ann Arbor and Rome." *Bulletin of the Museums of Art and Archaeology, U. of Michigan,* 3 (1980): 14–29.

———. "Profectio und Adventus," *BJb* 169 (1969): 130–94.

Lameere, W. "Un symbole pythagoricien dans l'art funéraire de Rome." *BCH* 63 (1939): 43–85.

Langlotz, E. *Aphrodite in den Garten.* Heidelberg, 1954.

LaRocca, E. "Un frammento dell'arco di Tito al Circo Massimo." *BollMC* 21 (1974): 1–5.

Leander Touati, A.-M. *The Great Trajanic Frieze.* Stockholm, 1987.

Lehmann, K. "A Roman Poet Visits a Museum." *Hesperia* 14 (1945): 259–69.

Lehmann-Hartleben, K. "L'Arco di Tito." *BullComm* 62 (1934): 95–97.

———. "Ein Siegesdenkmal Domitians." *RM* 38–39 (1923–1924): 185–92.

Lexicon Iconographicum Mythologiae Classicae, Zurich and Munich, 1974–.

Ling, R. *Roman Painting.* Cambridge and New York, 1991.

McCann, A. M. "A Re-Dating of the Reliefs from the Palazzo della Cancelleria." *RM* 79 (1972): 249–76.

Magi, F. "Ancora sull'Arco di Tito." *RM* 84 (1977): 331–48.

———. "Brevi osservazioni su di una nuova datazione dei rilievi della Cancelleria." *RM* 80 (1973): 289–91.

———. "L'Adventus di Trimalchione e il fregio A della Cancelleria." *ArchCl* 23 (1971): 88–92.

———. "Un rilievo di Anacapri." *RendPontAcc* 28 (1954–1955): 45–54.

———. *I rilievi flavi del Palazzo della Cancelleria.* Rome, 1945.

Laubscher, H. P. *Fischer und Landleute: Studien zur hellenistischen Genreplastik.* Mainz, 1982.

di Manzano, P. "Note sulla monetazione dei Ludi secolari dell 88 d.c." *BullComm* 89 (1984): 297–304.

Mark, I. S. "The Gods on the East Frieze of the Parthenon." *Hesperia* 53 (1984): 289–342.

Martin, H. G. "Die Tempelkultbilder." In *Kaiser Augustus und die verlorene Republik,* ed. M. Hofter et al., 251–63. Mainz, 1988.

Mattingly, H. *Coins of the Roman Empire in the British Museum.* vol. 1. London, 1923–.

Morawiecki, L. "The Symbolism of Minerva on the Coins of Domitianus." *Klio* 59 (1977): 185–93.

Muscettola, S. A. "Una statua per due imperatori. L'eredità difficile di

Domiziano." In *Domiziano/Nerva. La statua equestre da Miseno. Una proposta di ricomposizione*, ed. E. Pozzi, 39–66. Naples, 1987.

Neumann, G. *Gesten und Gebärden in der griechischen Kunst*. Berlin, 1965.

Neutsch, B. "Archäologische Grabungen und Funde im Bereich der Soprintendenzen von Sizilien vor 1949–1954." *AA* (1954): 490–91.

Orsi, P. "Latium et Campania, nuove scoperte nella città e nel suburbio." *NSc* (1890): 239.

Panella, C. "Iconografia delle muse sui sarcofagi romani." *StMisc* 12 (1967): 11–39.

Paribeni, E. "Ninfe, charites e muse su rilievi neoattici." *BdA* 36 (1951): 105–11.

Perdrizet, P."De quelques monuments figurés du culte d'Athena Ergane." In *Mélanges Perrot, L'archéologie classique*, 259–267. Paris, 1903.

Pernice, E., and F. Winter. *Der Hildesheimer Silberfund*. Berlin, 1901.

Peters, W.J.T. *Landscape in Romano-Campanian Mural Painting*. Assen, 1963.

Petersen, E. "Athena unter den neun Musen im Fries des Nervaforums." *RM* 4 (1889): 88.

Pfanner, M. *Der Titusbogen*. Mainz, 1983.

———. "Technische Beobachtungen an den Cancelleria." *AA* (1981): 514–18.

Picard, C. "Le châtiment de Tarpeia et les frises historico-légendaires de la Basilique Aemilia." *RA* 49 (1957): 181–88.

Picard, C., "Phèdre à la balançoire et le symbolisme des pendaisons." *RA* 5 (1928): 47–64.

Picard, M.-T. "La frise du Forum de Nerva, á Rome, et l'iconographie latine des Parques." *CollLatomus* 44 (1966): 607–16.

———. "Quelques observations au sujet de la frise du 'Forum de Nerva' á Rome." *Atti del settimo Congresso internazionale di archeologica classica*, 2:433–50. Rome, 1961.

Picard-Schmitter, M.-T. "Sur le 'châtiment d'Arachnè': A propos d'une frise du Forum de Nerva, á Rome." *RA* 1 (1965): 47–63.

———. "Recherches sur les métiers à tisser antiques: à propos de la frise du Forum de Nerva, á Rome." *Latomus* 24 (1965): 296–321.

Pinkwart, D. *Archelaos von Priene und die 'Musen des Philiskos.'* Kallmünz, 1965.

Pollini, J. *The Portraiture of Gaius and Lucius Caesar*. New York, 1987.

———. "Gnaeus Domitius Ahenobarbus and the Ravenna Relief," *RM* 88 (1981): 117–40.

———. *Studies in Augustan "Historical" Reliefs*. Ph.D. diss. Berkeley, 1978.

Pollitt, J. J. *Art in the Hellenistic Age*. Cambridge, 1986.

Poulsen, F. *Catalogue of Ancient Sculpture in the Ny Carlsberg Glyptotek*, Copenhagen, 1951.

Premerstein, O. "Der Parthenonfries und die Werkstatt des panathenaischen Peplos." *OJh* 15 (1912): 1–35.

Pozzi, E., ed. *Domiziano/Nerva. La statua equestre da Miseno. Una proposta di ricomposizione.* Naples, 1987.

Rawson, P. B. *The Myth of Marsyas in the Roman Visual Arts, An Iconographical Study. B.A.R. Int'l. Series*, vol. 347. Oxford, 1987.

Richmond, I. A. "Two Flavian Monuments." In *Roman Archaeology and Art*, ed. P. Salway, 218–28. London, 1969.

Richter, G.M.A. *The Furniture of the Greeks, Etruscans, and Romans.* London, 1966.

————. *Catalogue of Greek Sculptures in the Metropolitan Museum of Art.* Cambridge, 1954.

Ridgway, B. S. *Hellenistic Sculpture* I. *The Styles of ca. 331–200 B.C.* Madison, 1990.

————. *Fifth Century Styles in Greek Sculpture.* Princeton, 1981.

Ritter, H.-W. "Ein neuer Deutungsvorschlag zum Fries B der Cancelleriareliefs," *MarbWPr* 1982 (1983): 25–36.

Rizzo, G. E. "La base di Augusto." *BullComm* 60 (1932): 7–109.

Robertson, M. "The South Metopes: Theseus and Daidalos." In *Parthenon-Kongress Basel*, ed. E. Berger, 206–8. Mainz, 1984.

————. "Two Question-Marks on the Parthenon." In *Studies in Classical Art and Archaeology. A Tribute to P.H. von Blanckenhagen*, ed. G. Kopcke and M. B. Moore, 78–87. Locust Valley, 1979.

Rockwell, P. "Preliminary Study of the Carving Techniques of the Column of Trajan." *Marmi antichi, problemi d'impiego, di restauro e d'identificazione, StMisc* 26 (1985): 101–05.

Rodenwaldt, G. "Spinnende Hetaeren." *AA* 47 (1932): 7–22.

————. "The Three Graces on a Fluted Sarcophagus." *JRS* 28 (1938): 60–64.

Rohden, H. and H. Winnefeld. *Die antiken Terrakotten*, vols. 1 and 2. Berlin and Stuttgart, 1911.

————. *Architektonische römische Tonreliefs der Kaiserzeit.* Berlin, 1911.

Rose, C. B. "Princes and Barbarians on the Ara Pacis." *AJA* 94 (1990): 453–67.

Ryberg, I. S. *The Panel Reliefs of Marcus Aurelius.* New York, 1967.

————. *Rites of the State Religion in Roman Art. MAAR* 16 (1955).

Salerno, L., and E. Paribeni. *Palazzo Rondanini.* Rome, 1965.

Sampson, J. "Notes on Theodor Schreiber's *Hellenistische Reliefbilder*." *PBSR* 62 (1974): 27–45.

Savignoni, L. "Minerva Vittoria." *Ausonia* 5 (1910): 69–108.

Schefold, K. *Vergessenes Pompeji*. Berlin and Munich, 1962.

Schneider, R. M. *Bunte Barbaren. Orientalstatuen aus farbigem Marmor in der römischen Repräsentationskunst*. Worms, 1986.

Schrader, H. *Die archaischen Marmorbildwerke der Akropolis*. Frankfort, 1939.

Schreiber, T. *Hellenistische Reliefbilder*. Leipzig, 1889.

Schürmann, W. *Typologie und Bedeutung der stadtrömischen Minerva-Kultbilder, RdA Supp.* 2. Rome, 1985.

Sieveking, J. "Zwei Kolosse vom Palatin in Parma." *JdI* 56 (1941): 72–90.

Simon, E. *Augustus. Kunst und Leben in Rom um die Zeitenwende*. Munich, 1986.

———. "Virtus und Pietas. Zu den Friesen A und B von der Cancelleria." *JdI* 100 (1985): 543–55.

———. *Festivals of Attica*. Madison, 1983.

———. *Ara Pacis Augustae*. Greenwich, Conn., 1967.

———. "Zu den flavischen Reliefs von der Cancelleria." *JdI* 75 (1960): 134–56.

Smith, R.R.R. "The Imperial Reliefs from the Sebasteion of Aphrodisias." *JRS* 77 (1987): 88–138.

Stemmer, K. "Fragment einer Kolossalen Panzerstatue Domitians? Zur Kolossalität in flavischer Zeit." *AA* 86 (1971): 563–80.

Stern, H. "Les calendriers romains illustrés," *ANRW* 2.12.2 (1981): 431–75.

Stoop, M. W. *Floral Figurines from South Italy*. Assen, 1960.

Stewart, A. *Greek Sculpture*. 2 vols. New Haven and London, 1990.

Strocka, V. M. "Beobachtungen an den Attikareliefs des severischen Quadrifrons von Lepcis Magna." *AntAfr* 6 (1972): 147–72.

———. "Die Brunnenreliefs Grimani." *AntP* 4 (1965): 87–102.

Strong, D. E. *Roman Art*. Harmondsworth, 1976.

Strong, E. *Roman Sculpture from Augustus to Constantine*. London, 1907.

———. "Terra Mater or Italia," *JRS* 27 (1937): 114–26.

Stuart Jones, H. *A Catalogue of the Ancient Sculptures Preserved in the Municipal Collections of Rome. The Sculptures of the Museo Capitolino*. Oxford, 1912. *The Sculptures of the Palazzo dei Conservatori*. Oxford, 1926.

Stucchi, S. "Una recente terracotta siciliana di Atena Ergane ed una proposta interno all'Atena detta di Endoios." *RM* 63 (1956): 122–28.

Sutton, R. F. *The Interaction Between Men and Women Portrayed on Attic Red-Figure Pottery*. Ph.D. diss. Chapel Hill, 1981.

Sweeney, J., T. Curry, and Y. Tzedakis. *The Human Figure in Early Greek Art.* Athens and Washington, D.C., 1988.

Thompson, H. A. "Dionysos Among the Nymphs in Athens and Rome," *JWalt* 36 (1977): 73–84.

Torelli, M. *Typology and Structure of Roman Historical Reliefs.* Ann Arbor, 1982.

Toynbee, J.M.C. *The Flavian Reliefs from the Palazzo della Cancelleria in Rome.* London, 1957.

———. *Roman Medallions.* New York, 1944.

———. *The Hadrianic School.* Cambridge, 1934.

Trillmich, W. "Die Charitengruppe als Grabrelief und Kniepenschild." *JdI* 98 (1983): 311–49.

Vermeule, C. *Greek Sculpture and Roman Taste.* Ann Arbor, 1977.

———. "Graeco-Roman Statues: Purpose and Setting-I." *The Burlington Magazine* 110 (1968): 545–57.

Visconti, C. L. "Trovamenti di oggetti d'arte e di antichità figurati." *BullComm* 18 (1890): 226.

———. "Trovamenti di oggetti d'arte e di antichità figurati." *BullComm* 17 (1889): 401.

———. "Di una statua in bronzo rappresentante Afrodite-Cloto; di un'altra in marmo rappresentante atti-sole; di una cista mistica pure in marmo; rinvenuti nel campo sacro di Cibele in Ostia," *AnnInst* 41 (1869): 208–17.

Voelkel, L. "The Selection of Coin Types during the Reign of the Emperor Domitianus." *Studies Presented to D.M. Robinson,* ed. G. E. Mulanas, 2:243–47. St. Louis, 1953.

Wace, A. J. "The Reliefs in the Palazzo Spada." *PBSR* 5 (1910): 167–200.

Weinburg, G. D., and S. S. Weinberg, "Arachne of Lydia at Corinth." In *The Aegean and the Near East, Studies Presented to H. Goldman,* ed. S.S. Weinberg, 262–67. New York, 1956.

Wrede, H. *Consecratio in Forman Deorum: Vergöttliche Privatpersonen in der römischen Kaiserzeit.* Mainz, 1981.

Zadoks, A. N., and J. Jitta. "Athena and Minerva: Two Identifications." *BABesch* 59 (1984): 69–72.

Zanker, P. *Die trunkene Alte: Das Lachen der Verhöhnten.* Frankfurt, 1989.

———. *The Power of Images in the Age of Augustus.* Trans. A. Shapiro. Ann Arbor, 1988.

Zevi, F. "Proposta per un'interpretazione dei rilievi Grimani." *Prospettiva* 7 (1976): 38–41.

Zimmer, G. *Römische Berufsdarstellungen.* AF 12. Berlin, 1982.

Apollodorus, *Bibliotheca*
Apuleius, *Apologia*
Artemidorus, *Oneirokritika*
Aurelius Victor, *Caesares*
Cicero, *Orationes Philippicae*
Columella, *De re rustica*
Dio Cassius
Dionysius of Halicarnassus, *Antiquitates Romanae*
Festus, *Glossaria Latina*
Gellius, Aulus, *Noctes Atticae*
Horace, *Odes* or *Carmina*
Hyginus, *Fabulae*
Josephus, Flavius, *Bellum Judaicum*
Juvenal, *Satires*
Livy, *Ab urbe condita libri*
Lydus, *De Mensibus*
Macrobius, *Saturnalia*
Martial, *Epigrams*
Ovid, *Ars Amatoria*
 Fasti
 Heroides
 Metamorphoses
 Tristia
Pausanias
Philostratus, *Vita Apollonii*
Pindar, *Pythian Odes*
Plato, *Cratylus*
 Leges
Pliny (the Elder), *Naturalis Historia*
Pliny (the Younger), *Epistulae*
 Panegyricus
Plutarch *Cato Maior*
 De fortuna Romanorum
 Quaestiones Romanae
Propertius
Quintilian, *Institutio oratoria*
Scholia on *Euripides Hecuba*
Scholia on *Persius*
Scriptores Historiae Augustae, Alexander Severus

Seneca, *Epistulae*
Servius, *ad Aeneum*
Statius, *Silvae*
Suetonius, *Divus Augustus*
 Vespasianus
 Domitianus
Tacitus, *Annales*
 Dialogus de Oratoribus
 Historiae
Valerius Maximus
Varro, *De Lingua* Latina
 De Re Rustica
Virgil, *Aeneid*
 Georgics
Vitruvius, *De Architectura*

HISTORY

Audin, A. "Le palladium de Rome" *RA* 30 (1929): 46–57.

Ballentine, F. G. "The Cult of the Nymphs as Water Deities Among the Romans." *APA Proceedings* 34 (1903): 6–9.

Balsdon, J.P.V.D. *Roman Women*. London, 1962.

Beard, M. "The Sexual Status of the Vestal Virgins." *JRS* 70 (1980): 12–27.

Bengston, H. *Die Flavier*. Munich, 1979.

Blümner, H. *Technologie und Terminologie der Gewerbe und Künste bei Griechen und Römern*, 4 vols. Leipzig and Berlin, 1912.

Bonfante Warren, L. "Roman Triumphs and Etruscan Kings." *JRS* 60 (1970): 49–66.

Born, L. K. "The Perfect Prince According to the Latin Panegyrists." *AJPh* 55 (1934): 20–35.

Bradley, K. R. "Remarriage and Structure of the Upper-Class Family at Rome." *In Discovering the Roman Family*, ed. K. R. Bradley, 156–76. Oxford, 1991.

Brewster, E. H. *Roman Craftsmen and Tradesmen of the Early Empire*. Philadelphia, 1972.

Burchett, B. *Janus in Roman Life and Cult*. Madison, 1918.

Burford, A. *Craftsmen in Greek and Roman Society*. London, 1972.

Burkert, W. *Homo Necans: The Anthropology of Ancient Greek Sacrificial Ritual and Myth*. Trans. P. Bing. Berkeley and Los Angeles, 1983.

Cantarella, E. *Pandora's Daughters*. Trans. M. B. Fant. Baltimore and London, 1987.

———. "Dangling Virgins: Myth, Ritual, and the Place of Women in Ancient Greece." In *The Female Body in Western Culture*, ed. S. Suleiman, 57–67. Cambridge, 1986.

———. "Adulterio, omicidio legittimo e causa d'onore in diritto romano." In *Studi in onore di Gaetano Scherillo*, 243–74. Milan, 1972.

Castritius, H. "Zu den Frauen der Flavier," *Historia* 18 (1969): 492–502.

Chambalu, A. "Flaviana." *Philologus* 44 (1885): 106–31, 502–17.

Coarelli, F. *I santuari del Lazio in età repubblicana*. Rome, 1987.

Cole, S. G. "The Social Function of Rituals of Maturation: the Koureion and the Arkteia." *ZPE* 55 (1984): 233–44.

Crowfoot, G. "Of the Warp-Weighted Loom." *BSA* 37 (1936–1937): 36–47.

Csillag, P. *The Augustan Laws on Family Relations*. Budapest, 1976.

Devreker, J. "La continuité dans le Consilium Principis sous les Flaviens." *AncSoc* 8 (1977): 223–43.

Dixon, S. *The Roman Mother*. Norman, Oklahoma, and London, 1988.

Dorey, T. A. "Agricola and Domitian," *GaR* 7 (1960): 66–71.

Euing, L. *Die Sage von Tanaquil*. Frankfurt, 1933.

Evans, E. *The Cults of the Sabine Territory*. New York, 1939.

Evans, J. K. "The Dating of Domitian's War against the Chatti again." *Historia* 24 (1975): 121–24.

Fears, J. R. "The Cult of Virtues and Roman Imperial Ideology." *ANRW* 2.17.2 (1981): 827–948.

Franklin, A. M. *The Lupercalia*. New York, 1921.

Friedländer, L. *Roman Life and Manners under the Early Empire*. 4 vols. London 1913.

Gagé, J. "Matronalia, essai sur les dévotions et les organisations cultuelles des femmes dans l'ancienne Rome." *Coll. Latomus* 40 (1963): 7–286.

———. "La propaganda serapiste et la lutte des empereurs flaviens avec les philosophes (stoicens et cyniques)." *RPh* 149 (1959): 73–100.

Galinsky, K. "Augustus' legislation on Morals and Marriage," *Philologus* 125 (1981): 124–44.

———. *Aeneas, Sicily, and Rome*. Princeton, 1969.

Gardner, J. F. *Women in Roman Law and Society*. Bloomington and Indianapolis, 1986.

Garland, R. *The Greek Way of Death*. London, 1985.

Girard, J. L. "Domitien et Minerva: une prédilection impériale." *ANRW* 2.17.1 (Berlin and New York 1981), 233–45.

———. "Les origines du culte de Minerve." *REL* 48 (1970): 469–72.

Gordon, A. E. "The Cults of Aricia." *CPCA* 2 (1953): 1–20.

Grelle, F. "La 'correctio morum' nella legislazione flavia." *ANRW* 2.13 (1980): 340–65.

Grosso, F. "Aspetti della politica orientale di Domiziano, I," *Epigraphica* 16 (1954): 117–19.

Gsell, S. *Essai sur le règne de l'empereur Domitien.* Paris, 1894.

Gullberg, E. and P. Astrom, *The Thread of Ariadne: Studies in Mediterranean Archaeology*, vol. 21. Goteborg, 1970.

Hallett, J. P. *Fathers and Daughters in Roman Society.* Princeton, 1984.

Harmon, D. P. "The Family Festivals of Rome." *ANRW* 2.16.2 (1978): 1592–603.

———. "The Public Festivals of Rome," *ANRW* 2.16.2 (1978): 1440–468.

Hoffmann, M. *The Warp-Weighted Loom.* Oslo-Bergen, 1964.

Hopkins, K. "Age of Roman Girls at Marriage." *Population Studies* 18 (1965): 309–27.

———. "Contraception in the Roman Empire." *Comparative Studies in Society and History* 8 (1965): 124–51.

Hughes, M., and M. Forrest. *How the Greeks and Romans Made Cloth.* London, 1984.

Humphreys, S. C. *The Family, Women and Death.* London, 1983.

Johl, C. H. *Die Webestühle der Griechen und Römer.* Leipzig, 1917.

Jones, A.H.M. "The Cloth Industry under the Empire." *Economic History Review* 2:13:2 (1960): 183–92.

Jones, B. W. *Domitian and the Senatorial Order: A Prosopographical Study of Domitian's Relationship with the Senate, A.D. 81–96.* Philadelphia, 1979)

———. "Domitian's Attitude to the Senate." *AJPh* 94 (1973): 79–91.

———. "The Dating of Domitian's War against the Chatti." *Historia* 22 (1973): 79–90.

———. "A Note on the Flavians' Attitude to the Censorship." *Historia* 21 (1972): 128.

Jory, E. J. "Associations of Actors in Rome." *Hermes* 97 (1970): 224–53.

King, H. "Bound to Bleed: Artemis and Greek Women." In *Images of Women in Antiquity*, ed. A. Cameron and A. Kuhrt, 109–27. Detroit, 1983.

Lana, I. "I ludi capitolino di Domiziano." *RivFil* 29 (1951): 145–60.

Latte, K. *Römische Religionsgeschichte: Handbuch der Altertumswissenschaft*, vol. 4. Munich 1960.

Lefkowitz, M., and M. Fant, *Women's Life in Greece and Rome.* London, 1982.

Levi, M. A. "I Flavi." *ANRW* 2.2 (1975): 177–207.

Levick, B. "Domitian and the Provinces." *Latomus* 41 (1982): 50–73.

Ling Roth, H. *Studies in Primitive Looms. Bankfield Museum Notes.* Halifax, England, 1918.

Loane, H. J. *Industry and Commerce of the City in Rome, 50 B.C.-200 A.D.* Baltimore, 1938.

Lysapustin, B. S. "Women in the Textile Industry: Production and Morality." *Journal of Ancient History* (Moscow, 1985), 36–46, English summary 45–46.

McCrumm M., and A. G. Woodhead. *Select Documents of the Principates of the Flavian Emperors.* Oxford, 1961.

MacMullen, R. "Women in Public in the Roman Empire." *Historia* 29 (1980): 208–18.

Makin, E. "The Triumphal Route with Particular Reference to the Flavian Triumph." *JRS* 12 (1922): 25–36.

Maurin, J. "Labor matronalis: aspects du travail féminin à Rome." In *La Femme dans les sociétés antiques,* ed. E. Lévy, 139–55. Strasbourg, 1983.

Maxey, M. *Occupations of the Lower Classes in Roman Society.* Chicago, 1938.

Moeller, W. O. *The Wool Trade in Ancient Pompeii.* Leiden, 1976.

———. "The Male Weavers at Pompeii." *Technology and Culture* 10 (1969): 561–66.

Nichols, J. *Vespasian and the Partes Flavianae.* Wiesbaden, 1978.

Ninck, M. "Die Bedeutung des Wassers im Kult und Leben der Alten." *Phililogus, Supp.* 14,2 (1921): 1–60.

Ogle, M. B. "The House-Door in Greek and Roman Religion and Folk-Lore." *AJPh* 32 (1911): 251–71.

Palmer, R.E.A. *Roman Religion and Roman Empire: Five Essays.* Philadelphia, 1974.

———. *The Archaic Community of the Romans.* Cambridge, 1970.

Parke, H. W. *Festivals of the Athenians.* London, 1977.

Pauly-Wissowa, *Real-Encyclopädie der klassischen Altertumswissenschaft.* Stuttgart, 1894–1978.

Pearce, T.E.V. "The Role of the Wife as Custos in Ancient Rome." *Eranos* 72, 1–2 (1974): 17–33.

Piccaluga, G. "Fides nella religione romana di età imperiale." *ANRW* 2.17 (1981): 703–35.

Pomeroy, S. B. "The Relationship of the Married Woman to her Blood Relatives in Rome." *AncSoc* 7 (1976): 215–27.

———. *Goddesses, Whores, Wives, and Slaves: Women in Classical Antiquity.* New York, 1975.

Raditsa, L. "Augustus' Legislation Concerning Marriage, Procreation, Love Affairs and Adultery." *ANRW* 2.13.1 (1980): 278–339.

Rawson, B., ed. *The Family in Ancient Rome: New Perspectives*. London and Sydney, 1986.

———. *Marriage, Divorce, and Children in Ancient Rome*. Canberra and Oxford, 1991.

Richlin, A. "Approaches to the Sources on Adultery at Rome." In *Reflections of Women in Antiquity*, ed. H. P. Foley, 379–404. New York, 1981.

Rogers, P. "Domitian and the Finances of State." *Historia* 33 (1984): 60–78.

Rostovtzeff, M. *The Social and Economic History of the Roman Empire*: Oxford, 1957.

Scott, K. *The Imperial Cult under the Flavians*. Stuttgart, 1936.

———. "Le Sacrarium Minervae de Domitien." *RA* 6 (1935): 69–72.

———. "Tacitus and the Speculum Principis." *AJPh* 53 (1932): 70–72.

———. "Honorific Months in Greek and Roman Calendars." *YCS* 2 (1931): 199–278.

———. "Plutarch and the Ruler Cult." *TAPA* 60 (1929): 117–135.

———. "The Identification of Augustus with Romulus-Quirinus." *TAPA* 56 (1925): 82–105.

Scullard, H. *Roman Festivals of the Republic*, London, 1981.

Shaw, B. D. "The Age of Roman Girls at Marriage: Some Reconsiderations." *JRS* 77 (1987): 30–46.

Sherwin-White, A. N. *The Letters of Pliny*. Oxford, 1966.

Sissa, G. *Greek Virginity*. Trans. A. Goldhammer. Cambridge, 1990.

Sittl, C. *Die Gebärden der Griechen und Römer*. Leipzig, 1890.

Smethurst, S. E. "Women in Livy's History." *GaR* 19 (1950): 80–7.

Stehle, E. "Venus, Cybele, and the Sabine Women: The Roman Construction of Female Sexuality." *Helios* 16 (1989): 143–64.

Strong, D., and D. Brown, eds. *Roman Crafts*. London, 1976.

Sullivan, P. B. "A Note on the Flavian Accession." *CJ* 49–50 (1953–1954): 67–70.

Sutherland, C.H.V. "The State of the Imperial Treasury at the Death of Domitian." *JRS* 25 (1935): 150–62.

Syme, R. "Domitius Corbulo." *JRS* 60 (1970): 27–39.

———. "Flavian Wars and Frontiers." *CAH* 11 (Cambridge, 1936): 172–79.

Temporini, H. *Die Frauen am Hofe Trajans. Ein Beitrag zur Stellung der Augustae im Principat*. Berlin and New York, 1978.

Thompson, L. A. "Domitian and the Jewish Tax." *Historia* 31 (1982): 329–42.

Torelli, M. *Lavinio e Roma, riti iniziatici e matrimonio tra archeologia e storia*. Rome, 1984.

Townsend, G. "Some Flavian Connections." *JRS* 51 (1961): 54–62.

Treggiari, S. M. *Roman Marriage*. Oxford, 1991.

———. "Urban Labour in Rome: Mercenarii and Tabernarii." In *Non-Slave Labour in the Graeco-Roman World*, ed. P. Garnsey, ed., 48–64. Cambridge, 1980.

———. "Jobs for Women." *AJAH* 1 (1976): 7–104.

———. "Jobs in the Household of Livia." *PBSR* 43 (1975): 48–77.

———. "Libertine Ladies." *CW* 64 (1971): 196–98.

van Deman, E. B. *The Cult of Vesta Publica and the Vestal Virgins*. Diss., U. of Chicago, 1898.

Veyne, P. ed. *A History of Private Life*. Vol. 1. Trans. A. Goldhammer. Cambridge, Mass. and London 1987).

Vinson, M. P. "Domitia Longina, Julia Titi, and the Literary Tradition." *Historia* 38 (1987): 431–50.

Viscusi, P. L. *Studies on Domitian*. Diss., U. of Delaware, 1973.

Wallace-Hadrill, A. "Family and Inheritance in the Augustan Marriage Laws." *PCPS*, 27 (1981): 58–80.

———. "The Emperor and his Virtues." *Historia* 30 (1981): 298–323.

Warde Fowler, W. *Roman Festivals*. London, 1899.

Wardman, A. *Religion and Statecraft Among the Romans*. London, 1982.

Waters, K. H. "Trajanus Domitiani Continuator." *AJPh* 90 (1969): 385–405.

———. "The Character of Domitian." *Phoenix* 18 (1964): 49–77.

———. "The Second Dynasty in Rome." *Phoenix* 17 (1963): 198–218.

Wild, J. P. *Textile Manufacture in the Northern Roman Provinces*. Cambridge, 1970.

———. "Two Technical Terms used by Roman Tapestry-Weavers." *Philologus* 3 (1967): 151–55.

Wilson, L. M. *The Clothing of the Ancient Romans*. Baltimore, 1938.

Wiseman, T. P. Review of J. C. Anderson, Jr., *The Historical Topography of the Imperial Fora. CollLatomus* 182. Brussels 1984. In *JRS* 75 (1985): 232.

Wissowa, G. *Religion und Kultus der Römer*. Munich, 1912.

Wolters, P. *Faden und Knoten als Amulett, Archiv.* 8. Leipzig, 1905.

Wolters, X. *Notes on Antique Folklore, on the Basis of Pliny's Natural History, Books 28.22–29*. Amsterdam, 1935.

Wyss, K. *Die Milch im Kultus bei den Griechen und Römern*. Giessen, 1914.

Ziehen, L. "Palladium." *RE* 17, 3 (1949): 171–201.

LITERARY STUDIES

Ahl, F. "The Art of Safe Criticism in Greece and Rome." *AJPh* 105 (1984): 174–208.

Ahl, F. "The Rider and the Horse: Politics and Power in Roman Poetry from Horace to Statius." *ANRW* 2.32.1 (1984): 40–124.

Bardon, H. "Le gout à l'époque des Flaviens." *Latomus* 21 (1962): 732–48.

Bonner, C. "A Study of the Danaid Myth." *HSCP* 13 (1902): 129–73.

Bright, D. F. *Elaborate Disarray: The Nature of Statius' Silvae.* Meisenheim 1980.

Croisille, J.-M. "Poésie et art figuré de Neron aux Flaviens: Recherches sur l'iconographie et la correspondance des arts à l'époque impériale." *Coll.Latomus,* 179. Brussels, 1982.

Curran, L. C. "Transformations and Anti-Augustanism in Ovid's Metamorphoses." *Arethusa* 5 (1971): 71–92.

Delarue, F. "Stace et ses contemporains." *Latomus* 33 (1974): 536–48.

Detienne, M. "Les Danaides entre elles ou la violence fondatrice du mariage." *Arethusa* 21 (1988): 159–75.

Donaldson, I. *The Rapes of Lucretia: A Myth and its Transformations.* Oxford, 1982.

duBois, P. *Sowing the Body. Psychoanalysis and Ancient Representations of Women.* Chicago and London, 1988.

Eitrem, S. "Venus Calva and Venus Cloacina." *CR* 38 (1923): 14–16.

Garthwaite, J. *Domitian and the Court Poets Martial and Statius.* Ph.D. diss., Cornell University, 1978.

Griffith, J. "Juvenal, Statius, and the Flavian Establishment." *GaR* 16 (1969): 134–50.

Harries, B. "The Spinner and the Poet: Arachne in Ovid's *Metamorphoses.*" *PCPS* 216:36 (1990): 64–82.

Hazelton Haight, E. *The Symbolism of the House Door in Classical Poetry.* New York, 1950.

Hemker, J. "Rape and the Founding of Rome." *Helios* 12 (1985): 41–48.

Howell, R. *Commentary on Book I of the Epigrams of Martial.* London, 1980.

Keuls, E. *The Water Carriers in Hades: A Study of Catharsis through Toil in Classical Antiquity.* Amsterdam, 1974.

Klindienst Joplin, P. "Ritual Work on Human Flesh: Livy's Lucretia and the Rape of the Body Politic." *Helios* 17 (1990): 51–70.

———. "The Voice of the Shuttle is Our." *Stanford Literature Review* 1 (1984): 25–53.

La Penna, A. "Tipi e modelli femminili nella poesia dell' epoca dei Flavi." *Atti del congresso int'l. di studi vespasianei,* 1, 223–51. Rieti, 1981.

Lattimore, R. *Themes in Greek and Latin Epitaphs.* Urbana, Ill., 1942.

Leach, E. W. *The Rhetoric of Space.* Princeton, 1988.

———. "Ekphrasis and the Theme of Artistic Failure in Ovid's Metamorphoses." *Ramus* 3 (1974): 102–42.

Litchfield, H. W. "National *Exempla Virtutis* in Roman Literature." *HSCP* 25 (1914): 1–71.

Lugli, G. "La Roma di Domiziano nei versi di Marziale e di Stazio." *StRom* 9 (1961): 1–17.

Mitchell, R. N. "The Violence of Virginity in the Aeneid." *Arethusa* 24 (1991): 219–38.

Pomeroy, S. B. "Supplementary Notes on Erinna." *ZPE* 32 (1978): 17–22.

Reekmans, T. "Juvenal's Views on Social Change." *AncSoc* 2 (1971): 117–61.

Richlin, A. *The Garden of Priapus: Sexuality and Aggression in Roman Humor.* New Haven and London, 1983.

Roscher, W. H. *Ausführliches Lexicon der griechischen und römischen Mythologie,* 6 vols. Leipzig. 1884–1937.

Sauter, H. "Der römische Kaiserkult bei Martial und Statius." *Tübinger Beiträge zur Altertumswissenschaft,* 21 (Stuttgart and Berlin, 1934).

Steele, R. B. "Interrelation of the Latin Poets under Domitian." *CP* 25 (1930): 328–42.

Sullivan, J. P. "Martial's Sexual Attitudes." *Philologus* 123 (1979): 288–302.

Sullivan, J. P., and P. Whigham. *Epigrams of Martial Englished by Divers Hands.* Berkeley and Los Angeles, 1987.

Thiele, G. "Die Poesie unter Domitian." *Hermes* 51 (1916): 233–60.

Thompson, L. "Domitianus Dominus: A Glossary on Statius Silvae 1.6.84." *AJPh* 105 (1984): 469–75.

Tupet, A. M. *La magie dans la poésie latine.* Paris, 1976.

Vessey, D. *Statius and the Thebaid.* Cambridge, 1973.

Warner, M. *Monuments and Maidens: The Allegory of the Female Form.* New York, 1985.

Weaver, P.R.C. "The Father of Claudius Etruscus: Statius *Silvae* 3.3." *CQ* 15 (1965): 145–54.

White, P. "The Friends of Martial, Statius, and Pliny, and the Dispersal of Patronage." *HSCP* 79 (1975): 265–300.

———. "The Presentation and Dedication of the Silvae and the Epigrams." *JRS* 64 (1974): 40–61.

———. *Aspects of Non-Imperial Patronage in the Works of Martial and Statius.* Ph.D. diss., Harvard 1972.

Williams, G. *Change and Decline: Roman Literature in the the Early Empire.* Berkeley and Los Angeles, 1978.

INDEX

Acqua Paola, 32

Actium, 90

adultery, 5, 9–10, 62, 83, 86, 105, 107; legal definition and procedures of, 98–99

Aegyptus, 92

Aeneas, 63; in Augustan program as *exemplum pietatis*, 87; as subject of the Basilica Aemilia frieze, 80

Aequitas, 59, 79

African expedition, 7

Agrippa, 33

Alban hills, Domitian's estate in, 11, 15, 77, 126

allegorical figures, 59–60; for the stages of life, 52; weavers as, 79, 104. See also personifications

Alta Semita, 37, 38, 40, 45

Amazons, 89, 95

Anderson, James C., Jr., 21, 25–27

Antony, Marc, 90

Apollo, 41, 73, 77; analogy to Octavian, 107; Augustan temple on Palatine, 43, 73, 89–96; statuary of, 90–96; temple doors, 90–91

apotheosis, 40, 42

Ara Pacis, 12, 75, 87–99; imperial women and children represented on, 89; *lupa romana* on, 89; Roma panel, 89; Tellus panel, 88–89, 99

Arachne: artistry of, 49–51, 100; in central position in frieze, 16, 47; divine punishment of, 30, 47–59; rarity of depictions of, 12, 14, 105; transgression of, 12, 50–51, 78–79, 107; weaving of, 11, 12, 16–18, 39, 69, 116–18

Arae Incendii Neronis, 35, 44–45, 65

Arches: Arca Noe, 32; Arch of Nero, 21; Arch of Titus, 8, 46, 125; frieze and reliefs on, 109, 111; Arcus Aurae, 24, 30, 32, 112; Arcus Nervae, 32

Argiletum, 16, 20, 22, 30, 31, 35, 45, 80, 112; origins as a water crossing, 29

Artemis, 93; shrine at Brauron, 67

artisans, 51, 60. See also craftsmen

artist, 49, 51, 100, 102–103. See also Arachne

Asia Minor, 7

astragal players, 53

Athena, 74, 92; Athena Parthenos, 76

attic relief, 13, 16, 34, 47, 116–17, 125–26. See also Minerva

attributes, 55–56, 60, 65–66

Augustus: building program of, 43; as founder of empire, 35; iconographic models for Domitian, 12, 23, 72, 87; moral and social legislation of, 4–5, 57, 83–84, 89, 96, 105; as revivor of cults, 36, 44, 63; relationship with Apollo, 90

Aula Regia, 22. See also palace on the Palatine

Aventine hill, 41, 45, 62, 67, 71; personification of road on, 69; Temple of Diana on, 67; Temple of Minerva on, 77

balance, as attribute, 58–59, 119

Bartoli, Pietro Santi, 14

Basilica Aemilia, 24, 27; frieze of, 79–85, 95

Baths of Titus, 33

Bauer, Heinrich, 25–26, 27 n. 44, 31 n. 64, 32

beater-in, 52, 117. See also pin beater, 102; sword beater, 48 n. 3, 117

Bellori, Giovanni Pietro, 14–15, 18

von Blanckenhagen, Peter Heinrich, 16–17, 24–27, 48 n. 3, 54 n. 24, 56, 58, 60 n. 44, 62, 64–65, 69 n. 75, 76, 126; on style of relief carving, 110, 123

bloodletting in marriage and war, 93–94

Braun, Emil, 15, 18

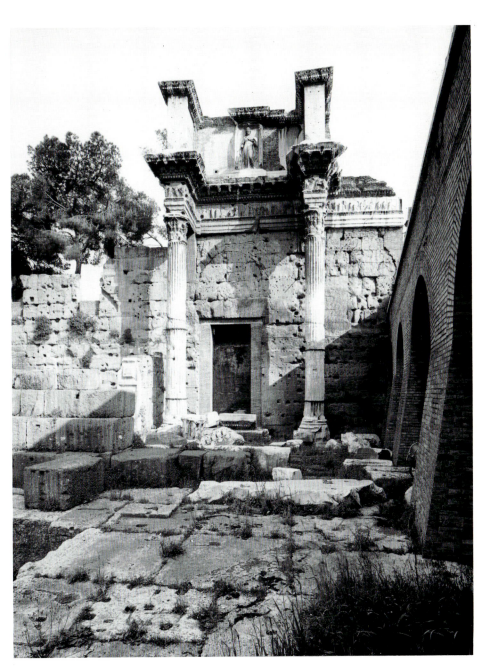

1. Le Colonnacce

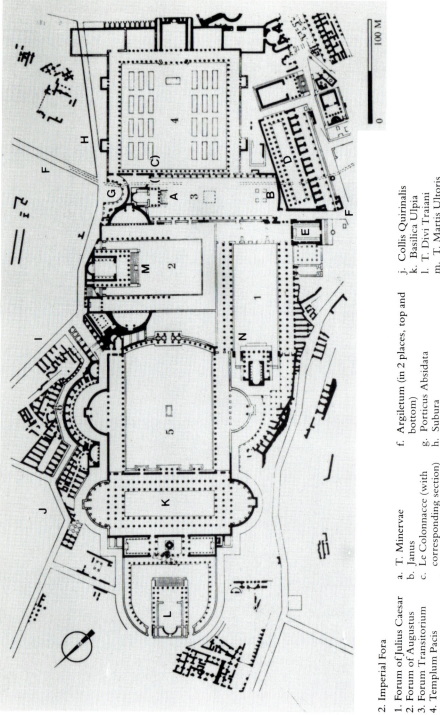

2. Imperial Fora

1. Forum of Julius Caesar
2. Forum of Augustus
3. Forum Transitorium
4. Templum Pacis
5. Forum of Trajan

a. T. Minervae
b. Janus
c. Le Colonnacce (with corresponding section)
d. Basilica Aemilia
e. Curia

f. Argiletum (in 2 places, top and bottom)
g. Porticus Absidata
h. Subura
i. Vicus Longus

j. Collis Quirinalis
k. Basilica Ulpia
l. T. Divi Traiani
m. T. Martis Ultoris
n. T. Veneris Genitricis

100 M

0

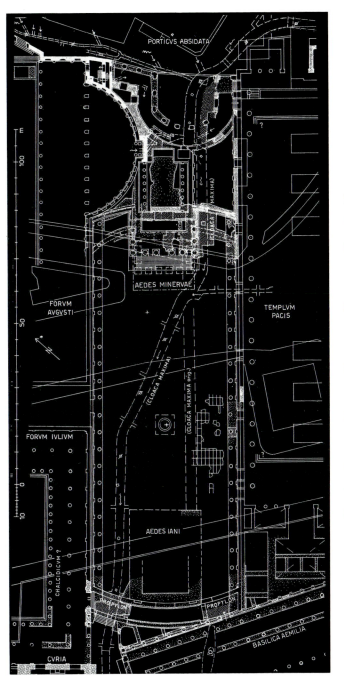

3. Plan of Forum Transitorium

1. Concrete foundations

2. Foundations in Ashlar masonry

3. Walls of stone from Gabii

4. Walls of peperino

5. Walls of brick

6. Marble structures

7. Hypothetical reconstructions

8. Underground structures

9. Original project for the Temple of Minerva and the north side of the Forum

4. Bartoli's engraving of Frieze, sections 5 and 6

C

6. Aula Regia

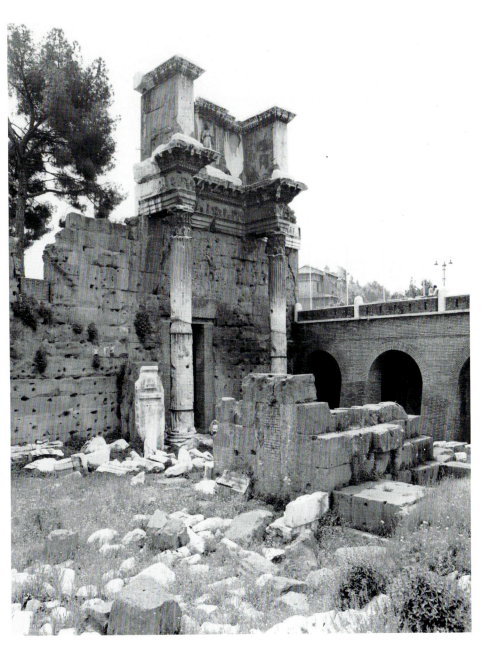

5. Le Colonnacce

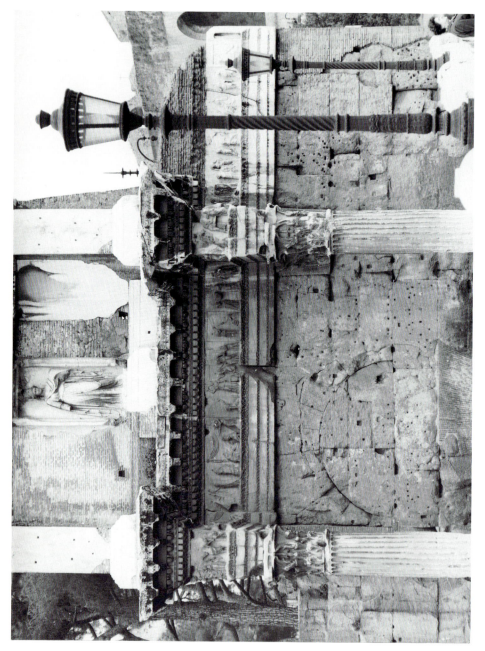

7. Le Colonnacce, detail

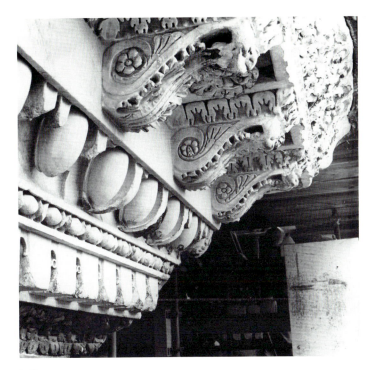

8. Sima

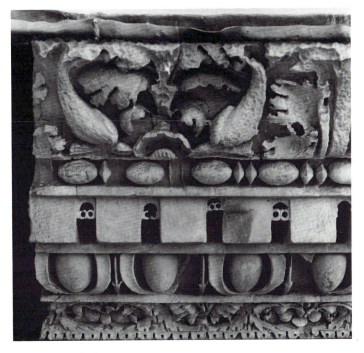

9. Sima Recta, Attic

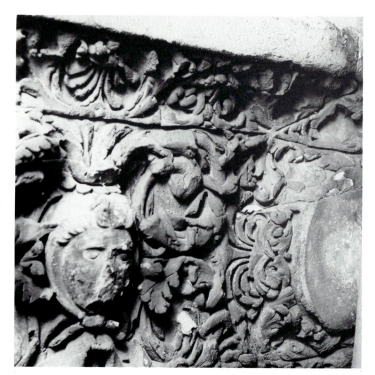

10. Soffit
of Ressauts

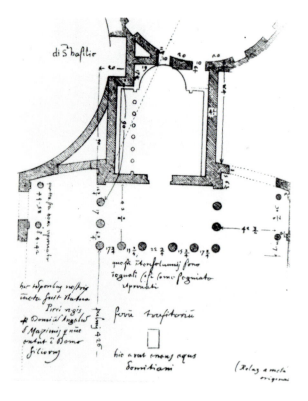

11. Sangallo the Younger,
plan of temple

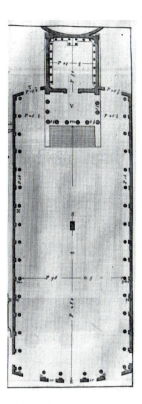

12. Palladio, plan of Forum
Transitorium

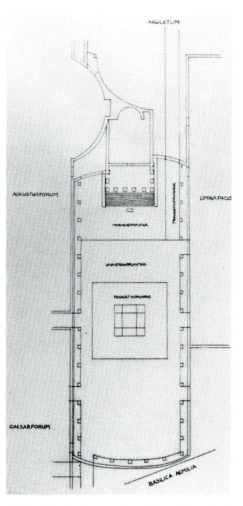

13. Von Blanckenhagen, plan of Forum Transitorium

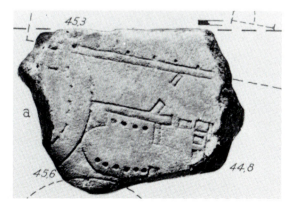

14. Marble Plan

15. Du Perac, view of temple and forum

16. Dosio, view of temple

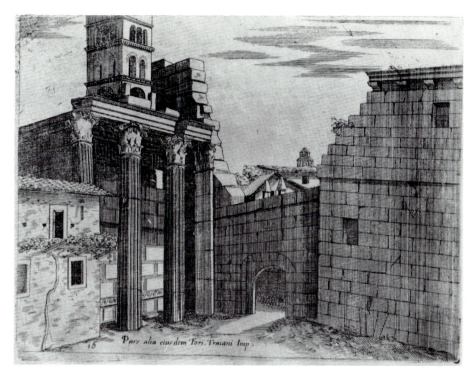

17. Dosio, view of temple flank

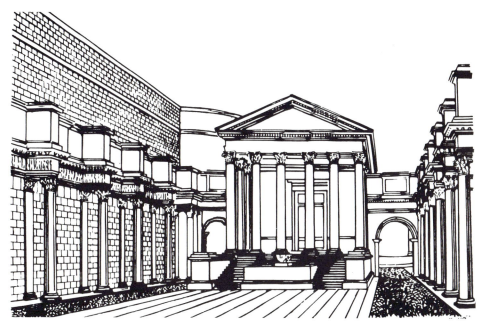

18. Temple of Minerva

19. Podium of Temple of Minerva

20. Remains of Porticus Absidata

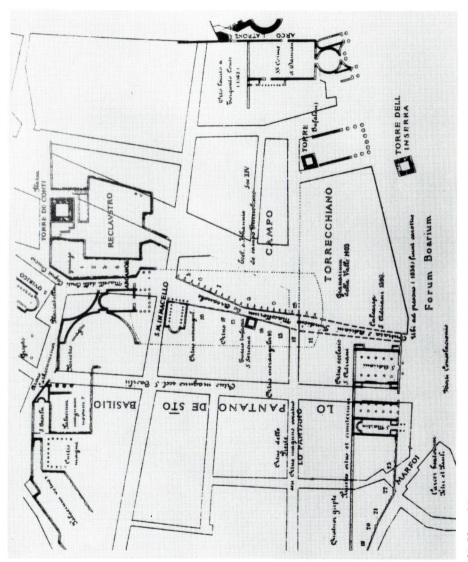

21. Plan of the Imperial Fora from the medieval period to the middle of the sixteenth century

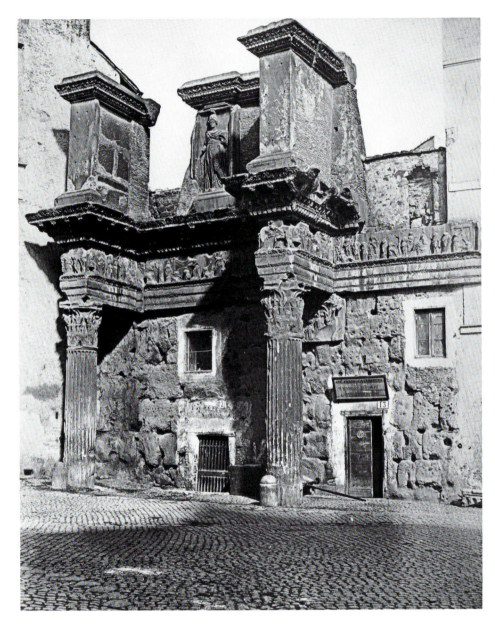

22. Le Colonnacce before the excavations

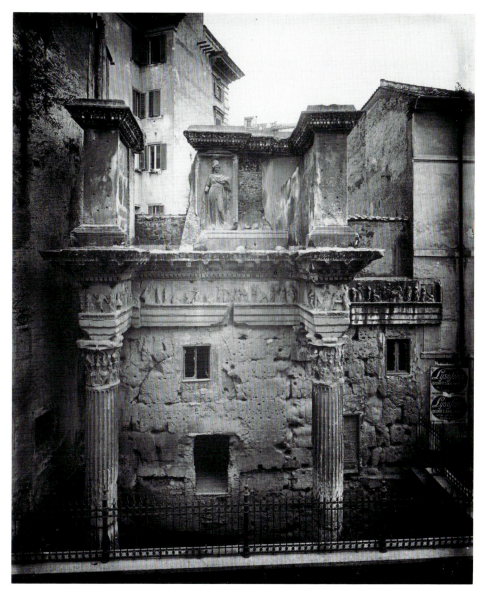

23. Le Colonnacce at the turn of the century

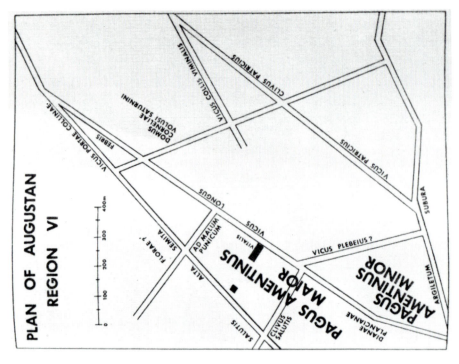

VICUS PORTAE COLLINAE

FEBRIS

DOMUS
CORNELIAE
VOLUSI SATURNINI

VICUS COLLIS VIMINALIS

CLIVUS PATRICIUS

FLORAE ?

ALTA SEMITA

AD MALUM PUNICUM

VICUS LONGUS

VITALIS

SALUTIS

CLIVUS SALUTIS

PAGUS AMENTIUS MAIOR

VICUS PLEBEIUS ?

VICUS PATRICIUS

SUBURA

DIANAE PLANCIANAE

PAGUS AMENTIUS MINOR

ARGILETUM

25. Plan of Vicus Longus

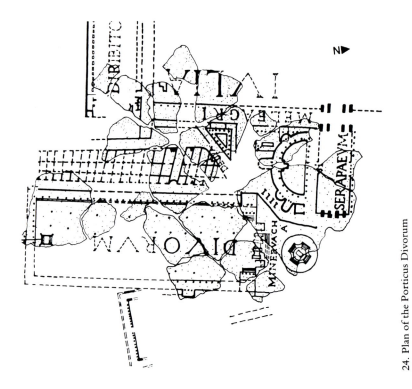

DIRIBITO

EGRI

IVLIS

MET

DIVORVM

MINERVAE VACH

SERAPAEVM

N▶

24. Plan of the Porticus Divorum

27. Ludi Saeculares Sestertius

29. Apotheosis Aureus

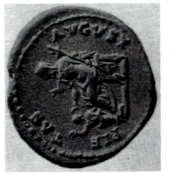

28. Pietas Augusti Denarius

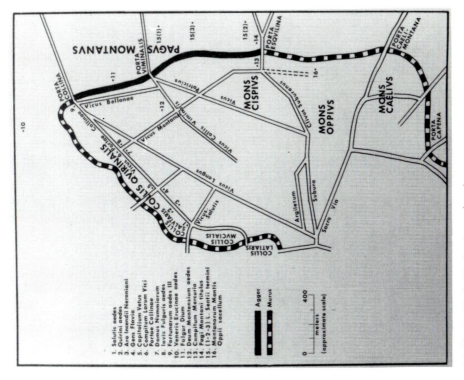

26. The Quirinal, Alta Semita, and environs

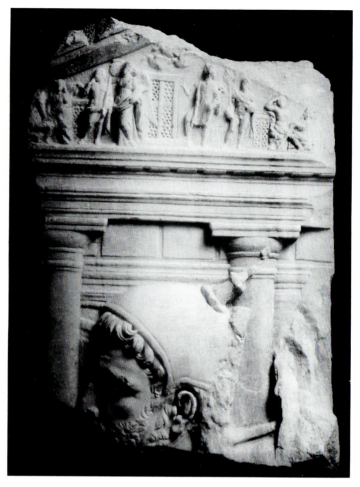

30. Hartwig Relief

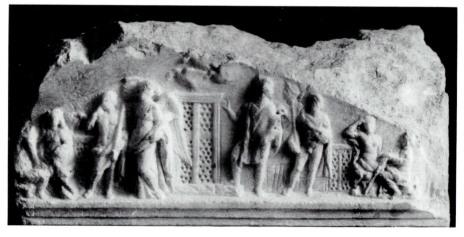

31. Hartwig Relief, detail

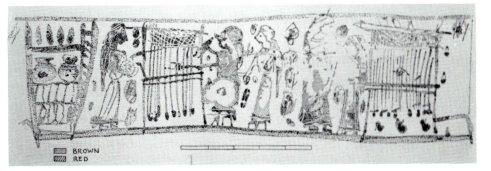

32. Corinthian Aryballos

33. Denarius depicting Minerva Chalcidica

34. Astragal Players

35. Votive relief of Athena Ergane

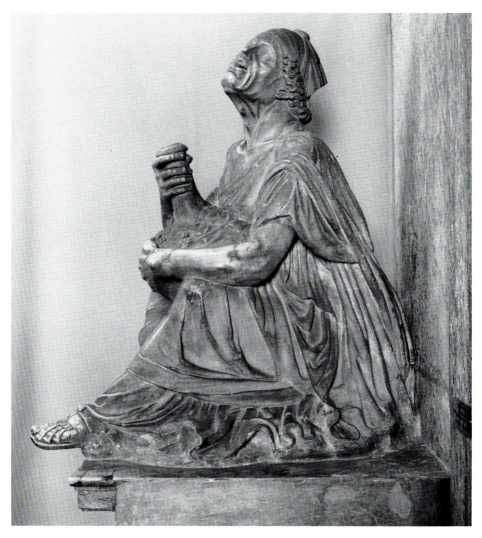

36. Drunken Woman

37. Undated Sestertius
of Faustina the Younger
depicting Pudicitia

38. Sestertius of Sabina
depicting Pudicitia

39. Domitianic As
depicting Moneta

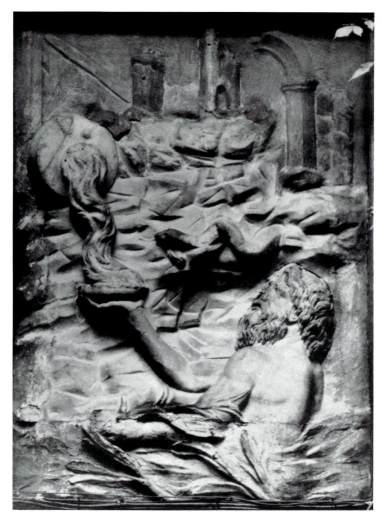

40. Palazzo Rondanini Relief

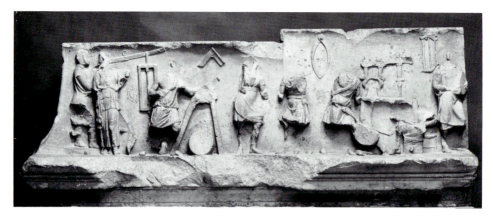

41. Relief of Minerva in a carpenter's workshop

42. Funerary relief of a fuller

43. Tomb painting from Rome

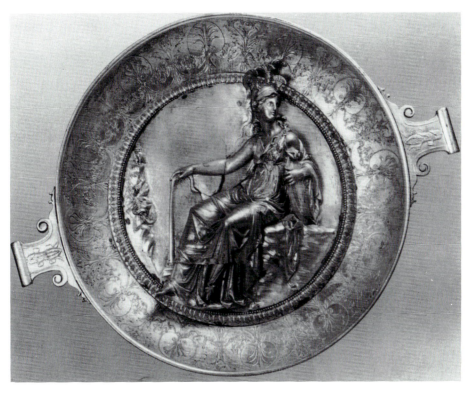

44. Hildesheim Plate

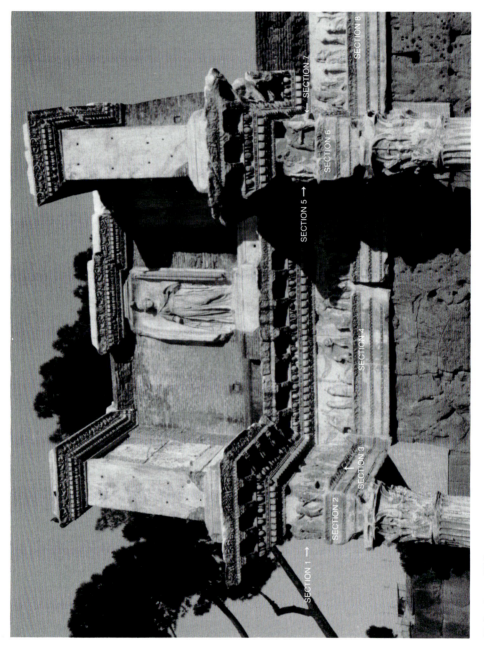

45. Sections of Frieze

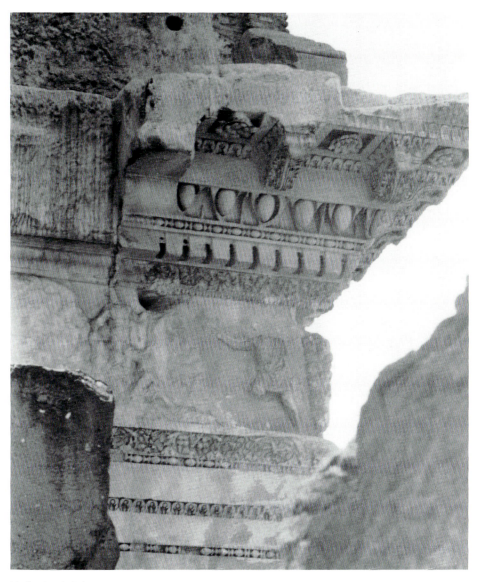

46. Section 1, Frieze

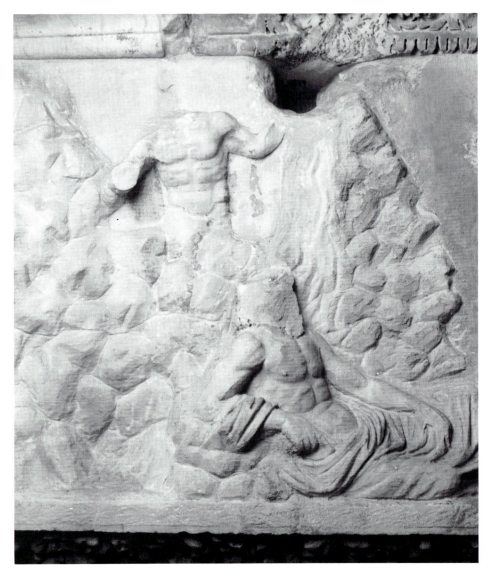

47. Section 1

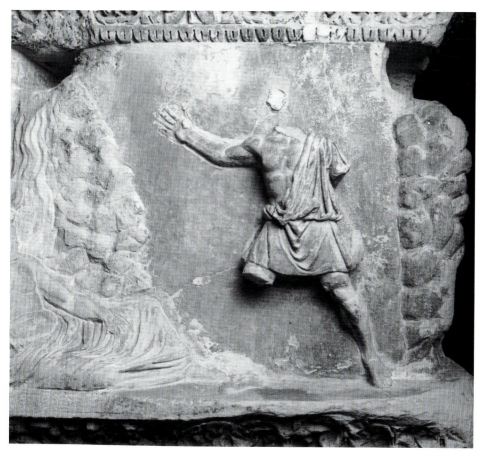

48. Section 1

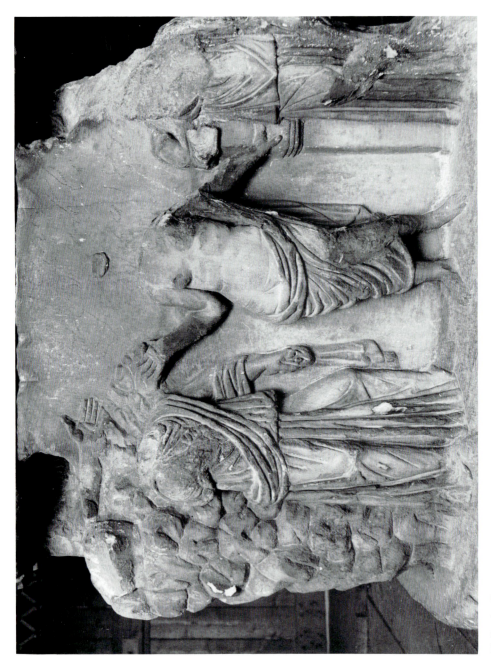

49. Section 2

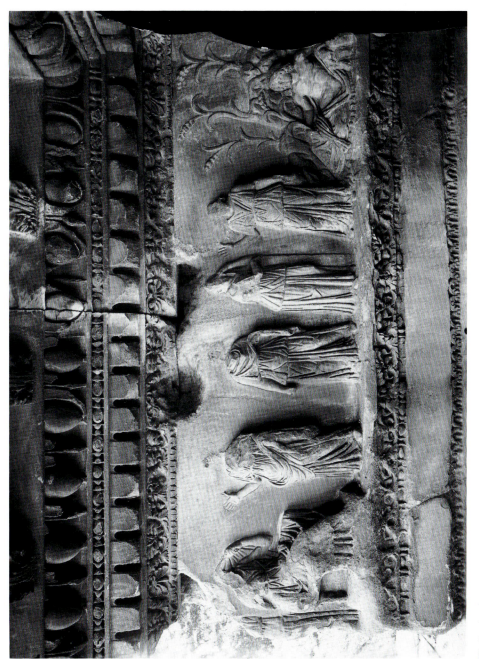

50. Section 3

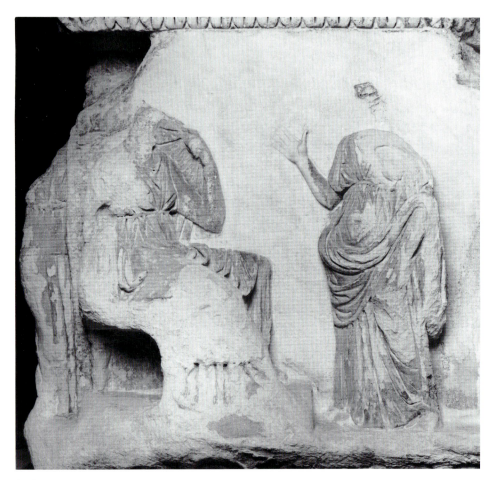

51. Section 3

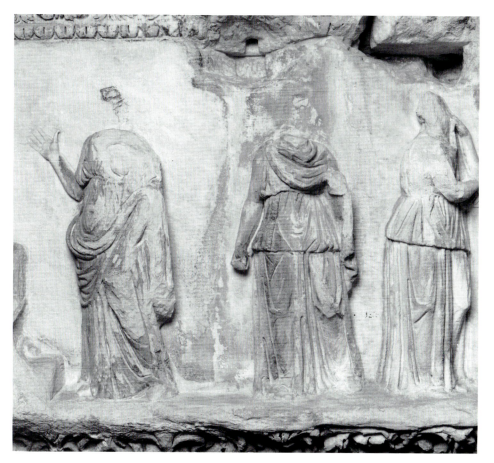

52. Section 3

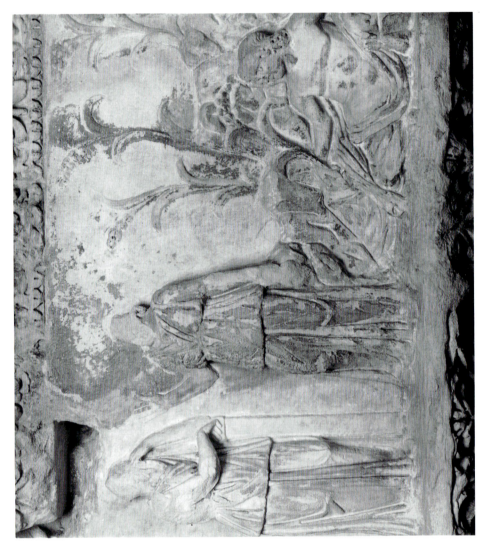

53. Section 3

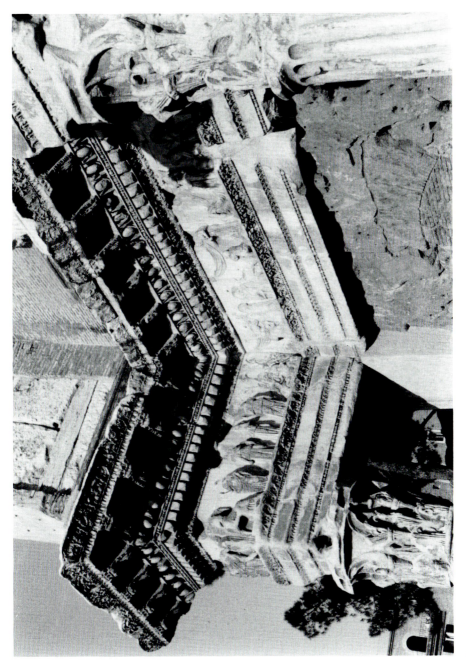

54. Section 4

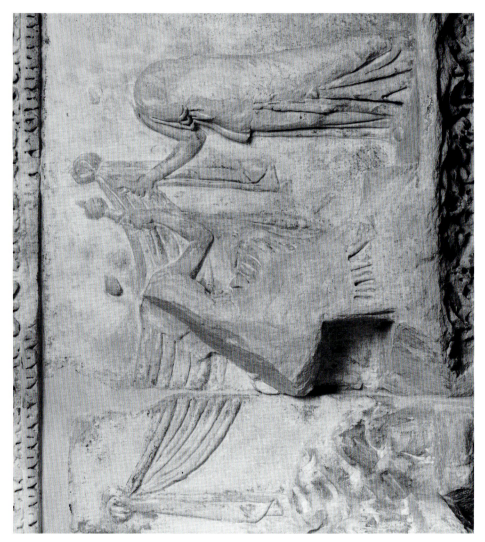

55. Section 4

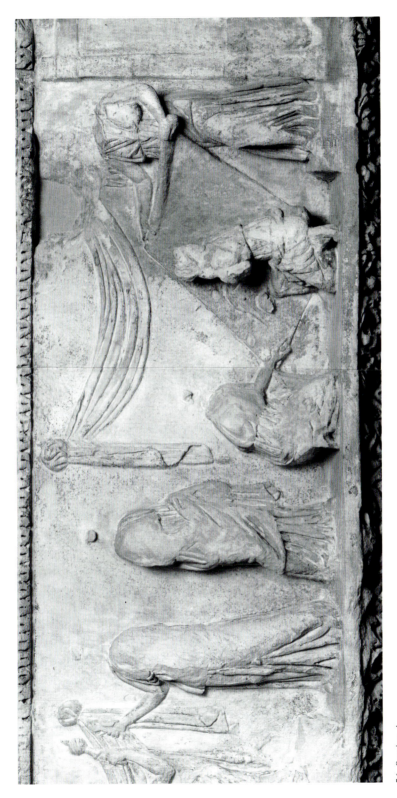

56. Section 4

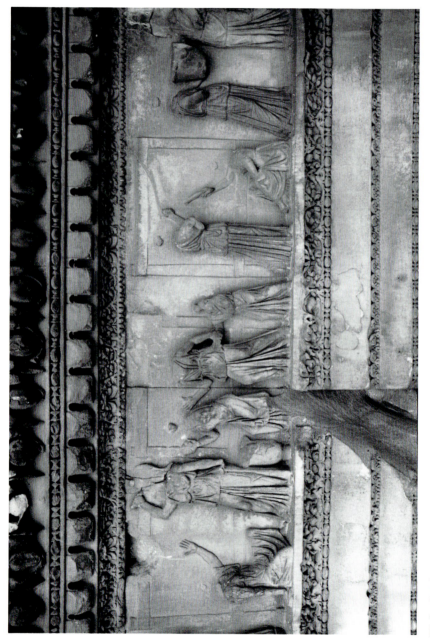

57. Section 4

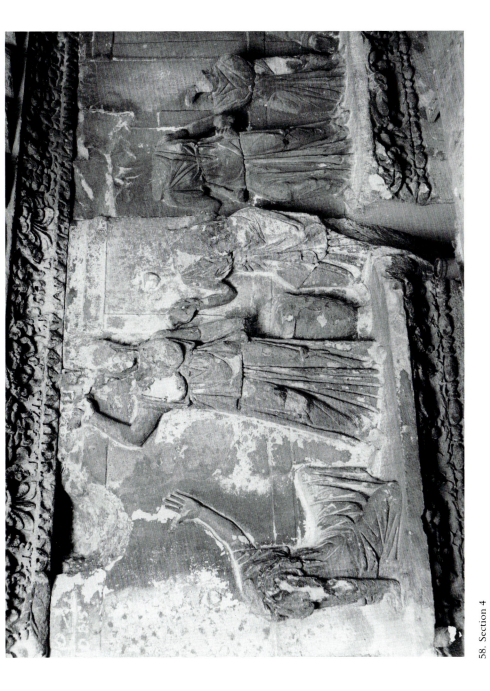

58. Section 4

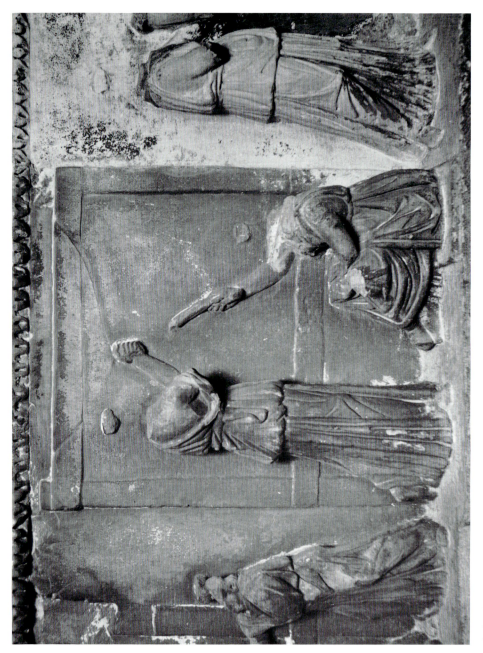

59. Section 4

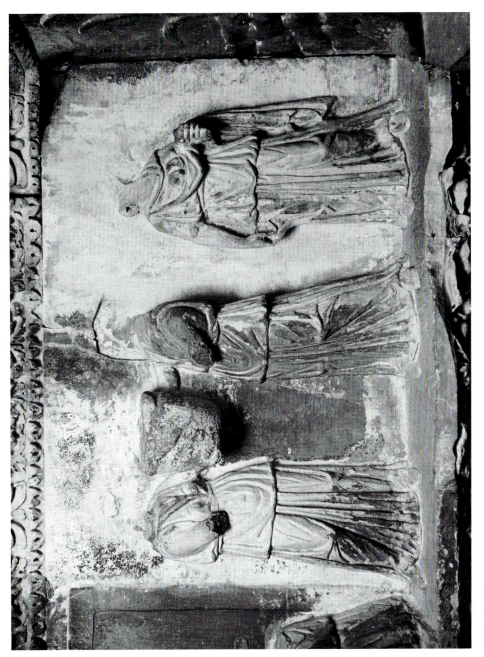

60. Section 4

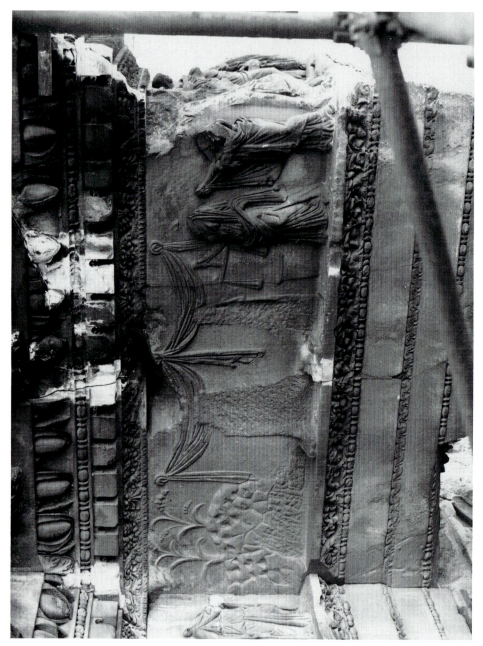

61. Section 5

62. Section 5

63. Section 5

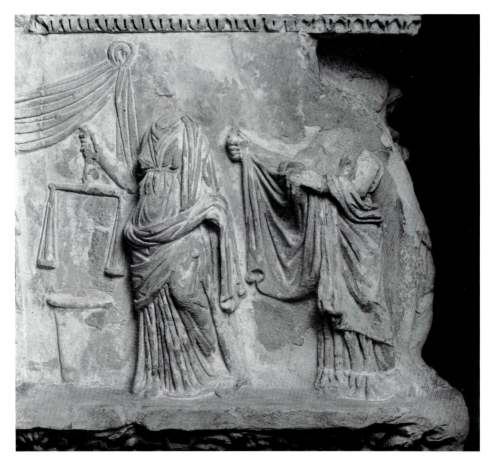

64. Section 5

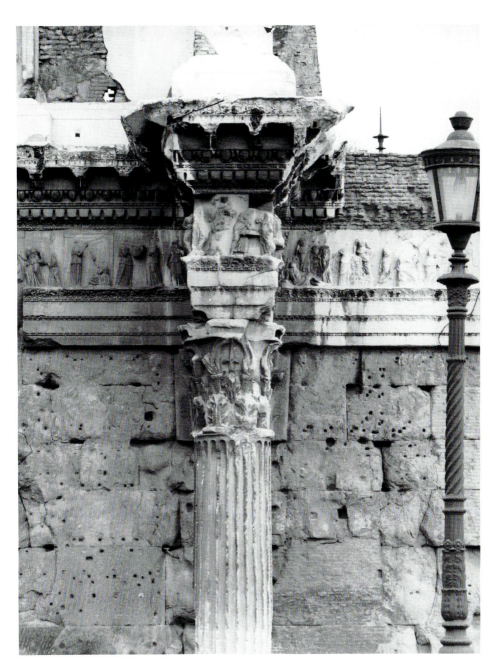

65. Section 6

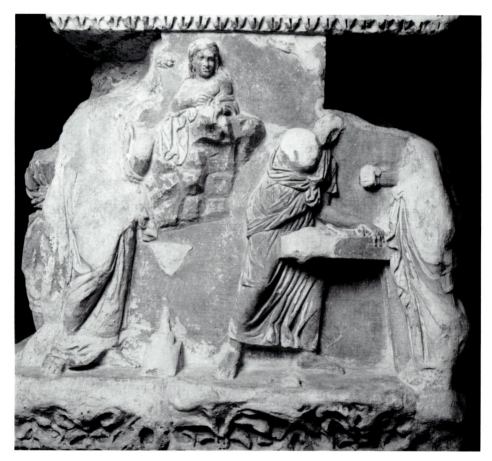

66. Section 6

67. Section 6

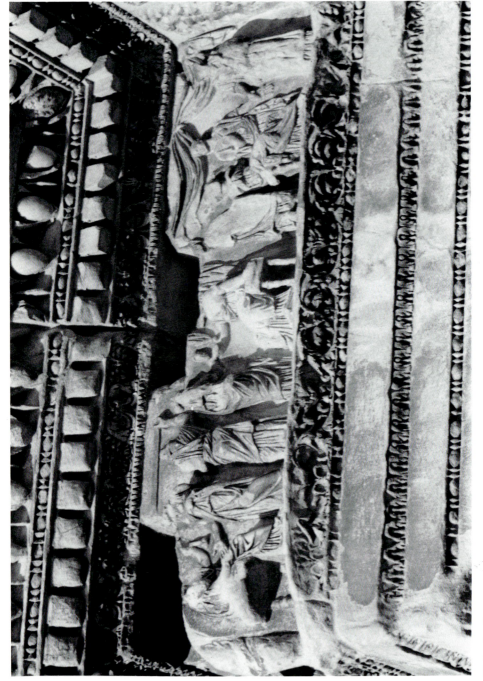

68. Section 7

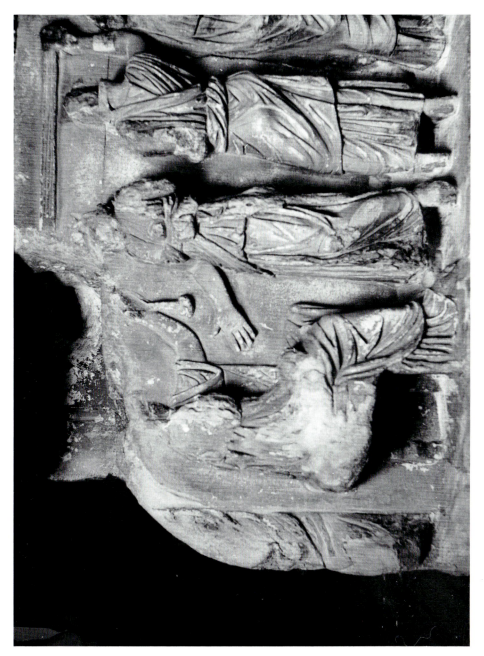

69. Section 7

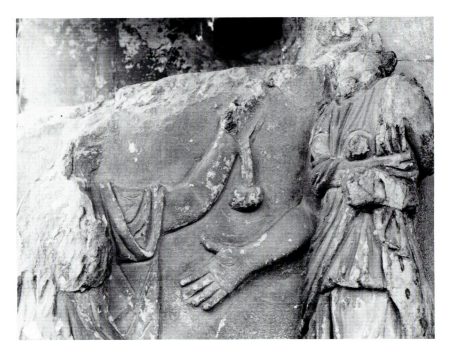

70. Section 7

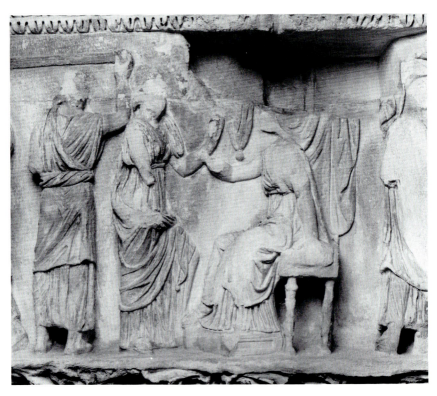

71. Section 7

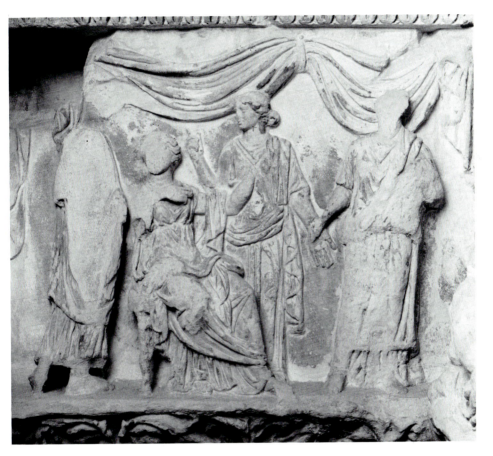

72. Section 7

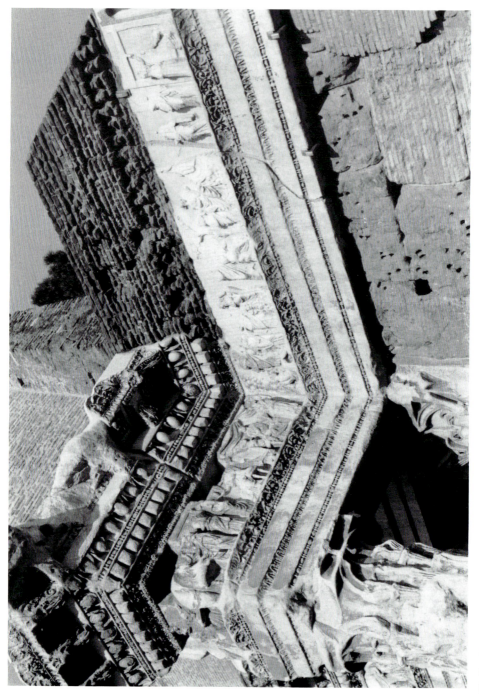

73. Section 8

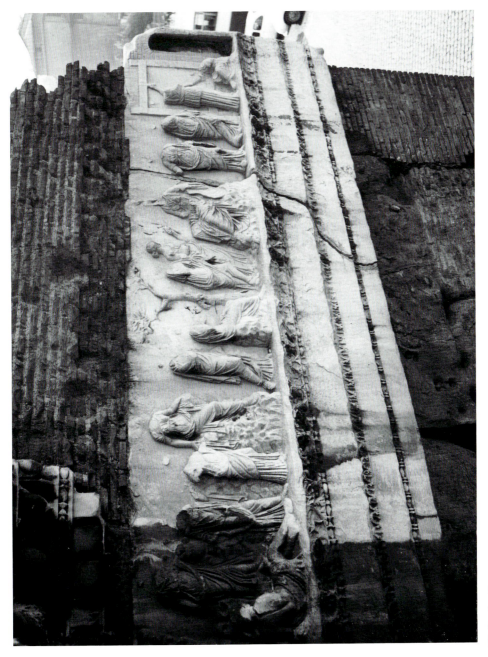

74. Section 8

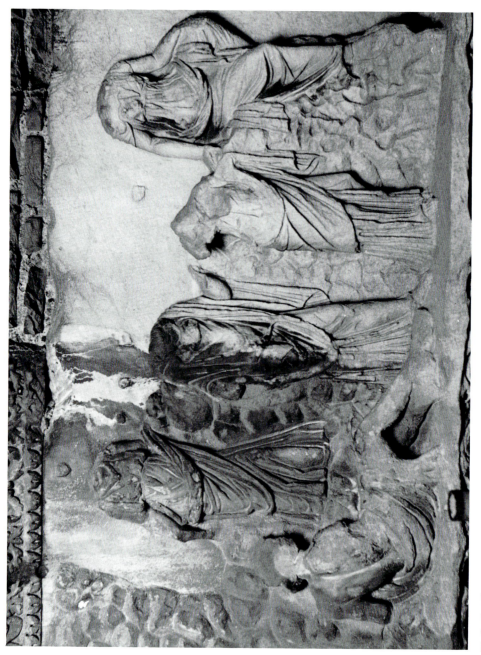

75. Section 8

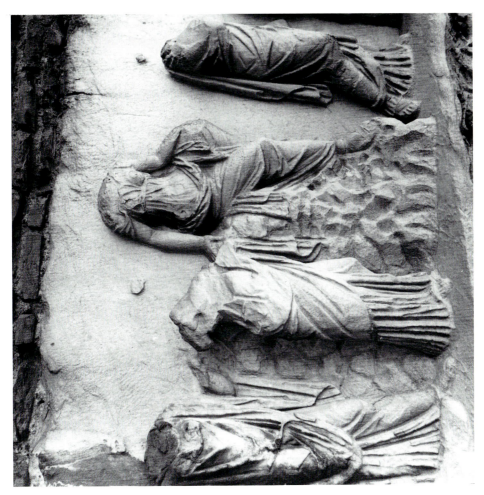

76. Section 8

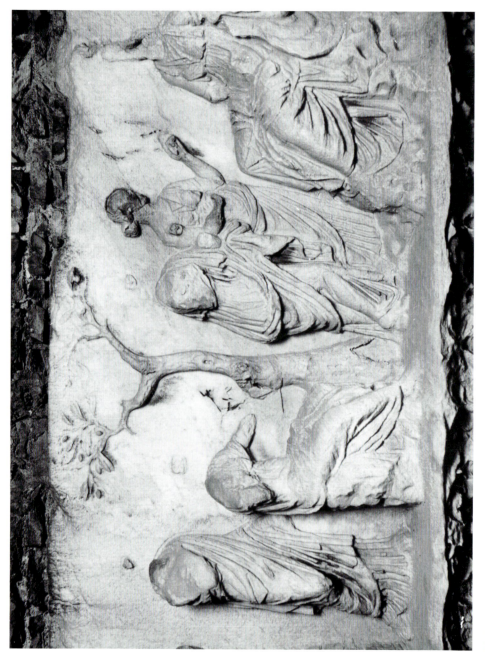

77. Section 8

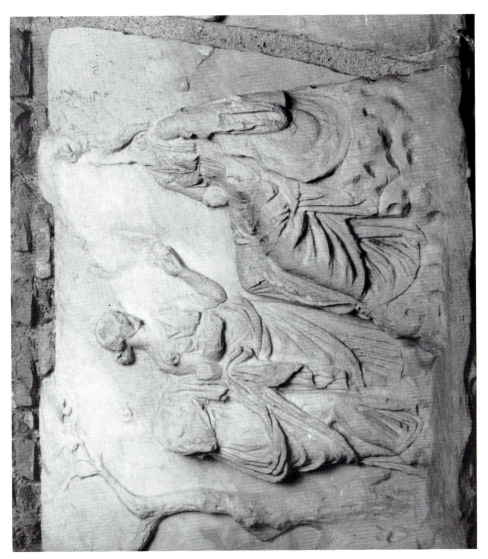

78. Section 8

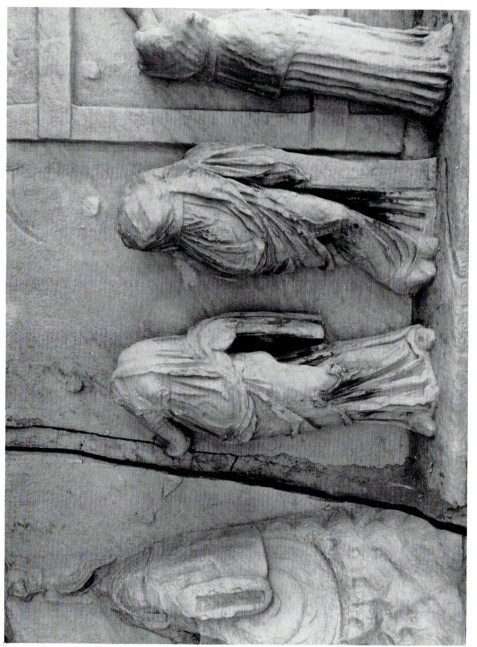

79. Section 8

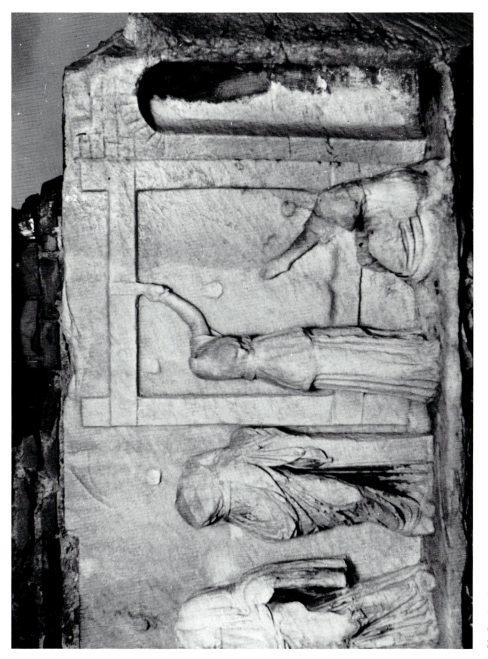

80. Section 8

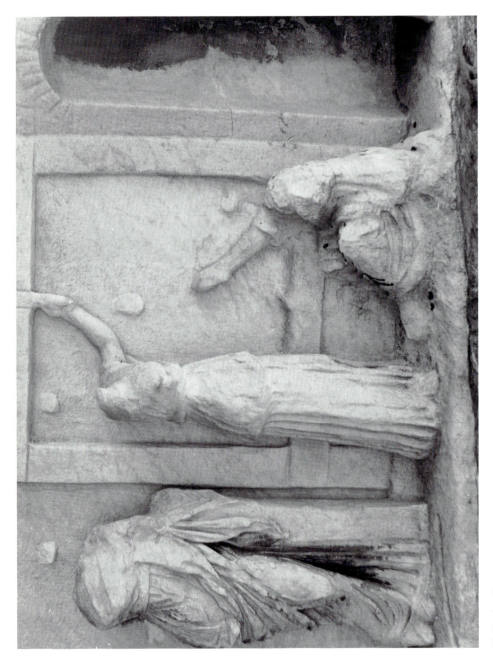

81. Section 8

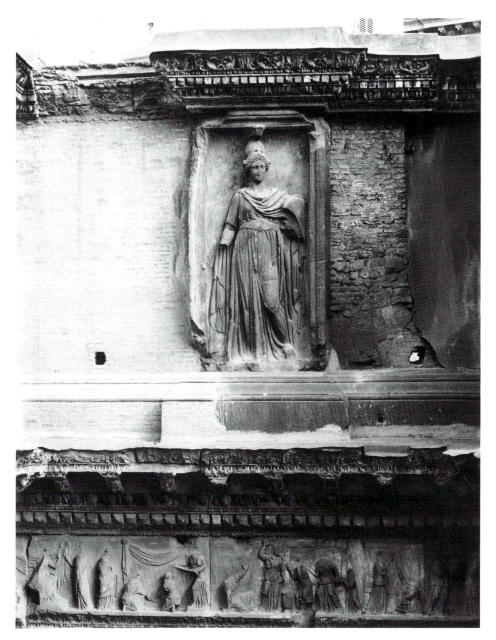

82. Attic relief and frieze

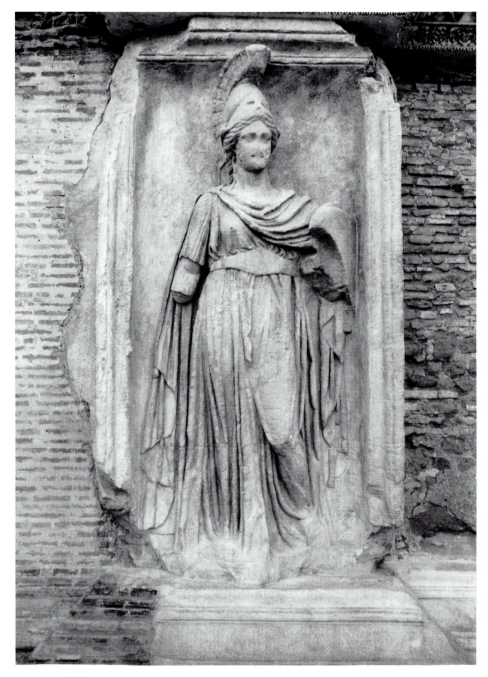

83. Attic relief

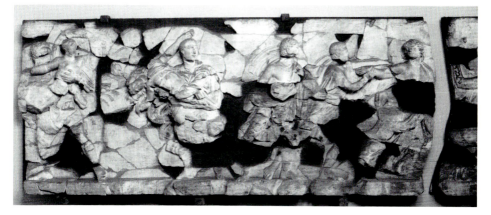

84. Frieze of the Basilica Aemilia, the Rape of the Sabine Women

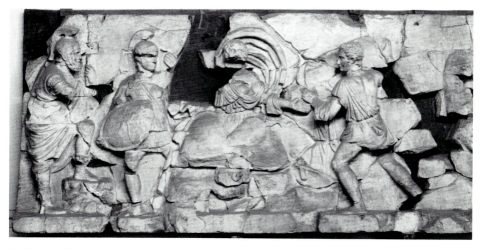

85. Frieze of the Basilica Aemilia, the Punishment of Tarpeia

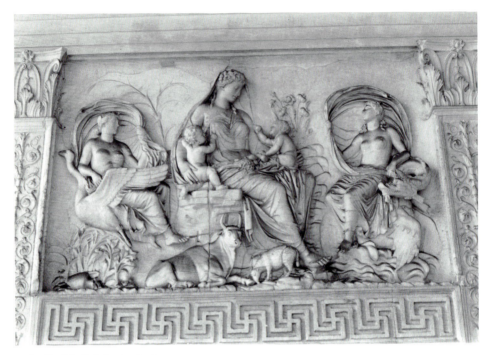

86. "Tellus" Relief, the Ara Pacis

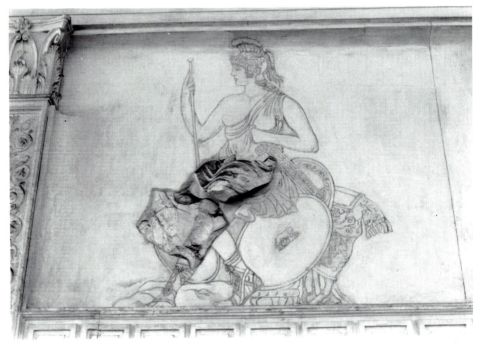

87. Roma Relief, the Ara Pacis

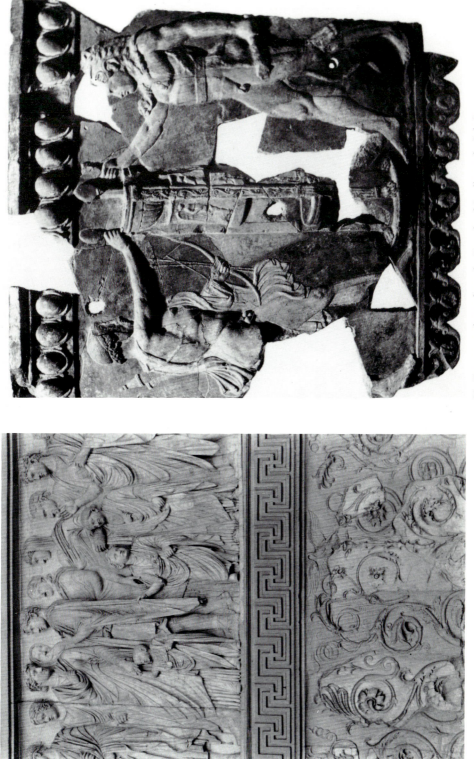

89. Terracotta plaque from the Temple of Apollo on the Palatine

88. Processional Frieze, the Ara Pacis

90. Frieze of the Arch of Titus

91. Section 1, profile view

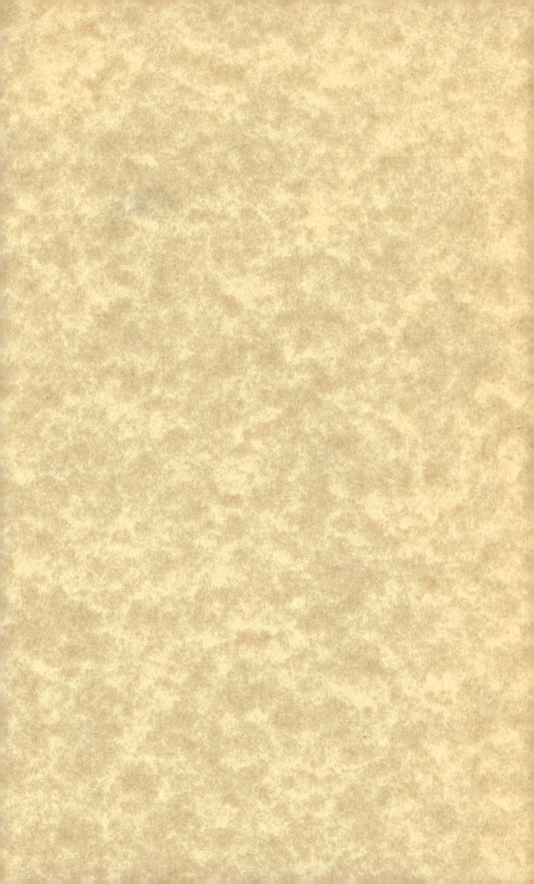